ANNOTATED
ART

ROBERT CUMMING

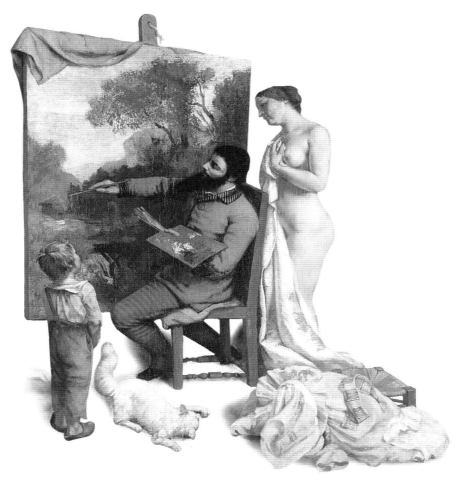

Detail from
The Painter's Studio
See page 82

COVENT
GARDEN
BOOKS

Detail from
The Artist's Studio
See page 58

Detail from
The Awakening Conscience
See page 80

DK

A DORLING KINDERSLEY BOOK
www.dk.com

Project editor Damien Moore
Art editor Stefan Morris
Assistant editor David T. Walton
Senior editor Gwen Edmonds
Senior art editor Claire Legemah
Managing editor Sean Moore
Managing art editor Toni Kay
DTP designer Zirrinia Austin
Production controller Meryl Silbert
Picture researchers Julia Harris-Voss,
Jo Walton

Detail from
Bacchus and Ariadne
See page 36

Detail from **The Marriage of Isaac and Rebekah** See page 54

This edition first published in 1999 by Covent Garden Books

ISBN 0 7513 0158 2

Colour reproduction by GRB Editrice s.r.l.
Printed in Spain by Artes Gráficas Toledo S.A .
D.L. TO: 808-1999

Detail from
The Experiment with an Air Pump
See page 68

Detail from
The Arnolfini Marriage
See page 14

Detail from
The Ambassadors
See page 38

CONTENTS

Detail from
A Dance to the Music of Time
See page 50

Detail from
*The Battle of
San Romano*
See page 20

Detail from
La Grande Jatte
See page 92

LOOKING AT PAINTINGS

*I*T IS A FEATURE OF OUR TIMES *that so many people can gain access to the paintings of the great artists and have opportunities to see and study their works. Yet many of the works shown in this book are most often seen in contexts far removed from art, such as in advertisements or greetings cards. In other words, they are not really looked at – for seeing is not the same as looking, just as hearing is not the same as listening. Seeing involves only the effort it takes to open your eyes; looking means opening your mind and taxing your intellect. Looking at paintings is like going on a journey – a journey with many possibilities, including the excitement of sharing the visions of another age. As with any journey, the better the preparation, the more fulfilling the expedition is likely to be. Travelling is best done with a guide who can help you while you acclimatize yourself to a new environment, and who can point out things that might otherwise go unnoticed – the purpose of this book is to provide just such a guide into the world of art.*

SIX GUIDELINES

Outlined below are six guidelines that are further developed in the commentaries on each of the 45 paintings in this book.

Subject All of the paintings have specific subjects, each with a meaningful message to deliver. Often, the subject is quite easy to recognize. But in many cases, notably in the early works, artists have selected Bible stories or stories of the gods of Antiquity as told in Greek and Roman mythology. When creating these works, the artists could assume that their audience was

Telling Tales

The stories that are illustrated in many of the paintings are often no longer familiar in our scientific age. Discover the legend of love at first sight as portrayed in Titian's beautiful painting Bacchus and Ariadne *(see p.36).*

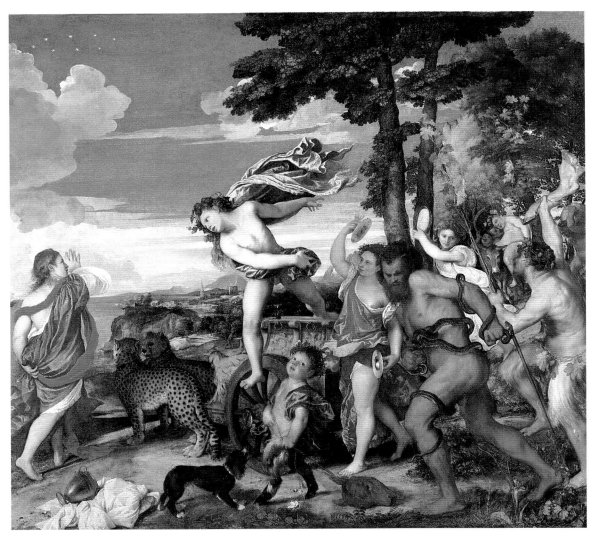

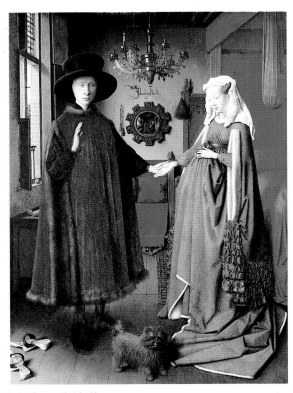

Technical Skills

Achieving standards of craftsmanship and mastery of physical materials are skills that many artists no longer possess or aspire to. Van Eyck's The Arnolfini Marriage *(see p.14) remains unsurpassed for displaying its creator's mastery in handling oil paints.*

The Lost Language of Symbols

Many paintings employ a complex language of symbolism where recognizable objects stand as symbols for abstract ideas and concepts. Interpreting symbols can increase our appreciation of Caravaggio's The Supper at Emmaus *(see p.44).*

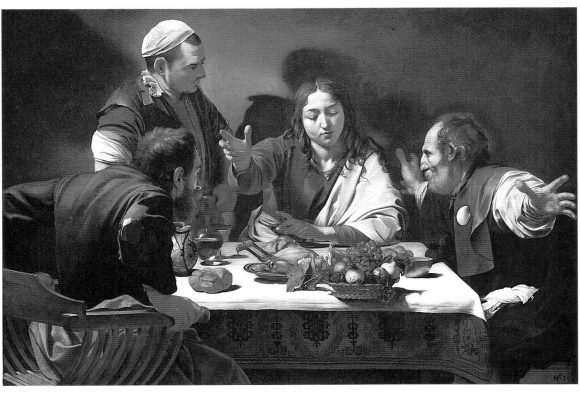

familiar with these stories. This is now no longer true, but rediscovering these great myths and legends can be one of the major pleasures of looking at paintings.

Technique Every painting must be physically created and an understanding of the skills employed, perhaps a handling of oil paint or use of fresco techniques, adds greatly to our appreciation of a work of art. Most of the works here are notable for their technical innovation and expertise.

Symbolism Many works use an extensive language of symbolism and allegory that was understood both by artists and their audiences. Recognizable objects, however finely painted, represented not just themselves but concepts of a much deeper or more abstract meaning. Familiarity with this language has greatly diminished, but it can be relearned or rediscovered through a study of the paintings and the beliefs of the society that nurtured the artist.

Space and light Artists seeking to recreate a convincing representation of the world on the flat surface of a panel or canvas need to acquire a mastery of the illusion of space and light. The variety of ways in which this illusion can be created is remarkable. In no two works in this book are they the same, and in some cases a painting's main visual delight lies in the way the painter has worked with these two elusive qualities.

Historical style Every historical period develops a recognizable style that can be traced in the works of its leading artists. The styles do not exist in isolation but are reflected in all the arts, and through

this book it is possible to trace the evolution of the history of art from the early Renaissance to modern times.

Personal interpretation Anyone who embarks upon the journey to explore the meanings of paintings will soon become

bewildered by the amount of points of view that are offered. A simple guideline is this: if you can see it for yourself, believe it – no matter what anyone else says. If you cannot see it, do not believe it (including the comments in this book). Everyone has the right to bring to a work of art whatever he or she chooses by way of seeing and experience, and to come away with whatever he or she chooses on a personal level. Knowledge of history, technical skills, and so on, should broaden that personal experience. But if the personal (or "spiritual") dimension is lost, then looking at a work of art becomes no more significant than looking at, and trying to solve, a crossword puzzle.

A Personal Vision
Courbet (see p.82) proclaimed that artists were free to set their own rules and fly in the face of convention. Similarly, viewers have the right to ignore the conventional dictates of interpretation and take from a work whatever he or she chooses.

WHAT MAKES A MASTERPIECE?

THE FUNCTION AND PURPOSE of a major work of art, the expectations that are placed upon it, and the role of the artist are not constant. They vary in different ages and societies. Yet a few works stand out because they have the ability to speak of more than their own age, and they offer inspiration and meaning across time. Before the Renaissance, an artist was considered primarily a craftsman, and a "masterpiece" was the work submitted to the trade guild as proof that the necessary technical skills had been mastered. However, the great masters of the Renaissance proposed that an artist should be judged more by the qualities of intellect and imagination than by manual skill. Today, the concept of the masterpiece is closely linked to that of the national gallery where great art treasures are displayed for all to see. However, until the French Revolution, such a concept was nonexistent, and it is worth remembering that not one of the paintings in this book was intended to be displayed in the setting in which it now appears.

VIRTUOSITY

In judging any outstanding performance, whether by an athlete, a musician, an actor, or an artist, technical ability is one of the prime considerations. A great artist must have complete mastery of the physical skills required plus the knowledge and imagination to push these skills, and the existing rules of art, to new limits. True virtuosity makes the mastery of these physical skills appear deceptively natural and simple. Almost all of the 45 paintings in this book are distinguished by such technical virtuosity.

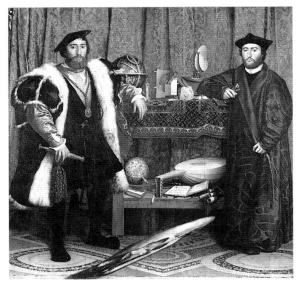

Holbein, *The Ambassadors*
Holbein's painting is a masterpiece of portraiture, in which the image and personality of the sitters are in perfect harmony with the artist's meticulous technique.

INNOVATION

Since the Renaissance, Western Society has striven for, praised, and rewarded innovation. To be first in any endeavour is to be remembered as a key figure in history. Giotto (see p.10) and Picasso (see p.98) are deemed to be giants of European art because they succeeded in rewriting the existing rules of art and offered an alternative visual language. Subsequent artists developed and built upon their achievements. A distinguishing feature of the paintings in this book is that, among their other virtues, each challenged the existing artistic boundaries and – in the majority of cases – extended them.

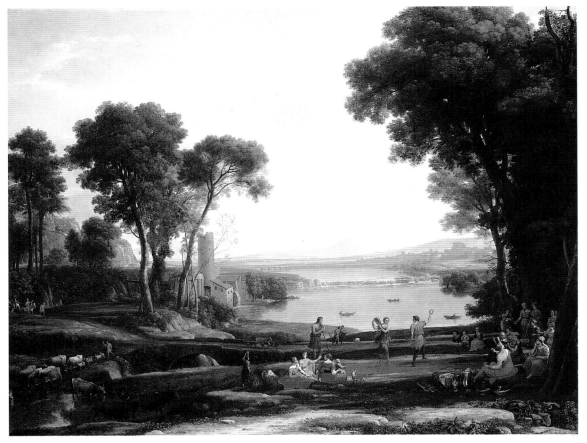

Claude, *The Marriage of Isaac and Rebekah*
Claude's harmonious images of pastoral landscapes made a strong appeal to the visual and intellectual imagination of his day, and he had many distinguished patrons. A century later, his work had an enormous influence on landscape artists, and on landscape gardeners who attempted to recreate the spirit of Claude's painted vision in actuality.

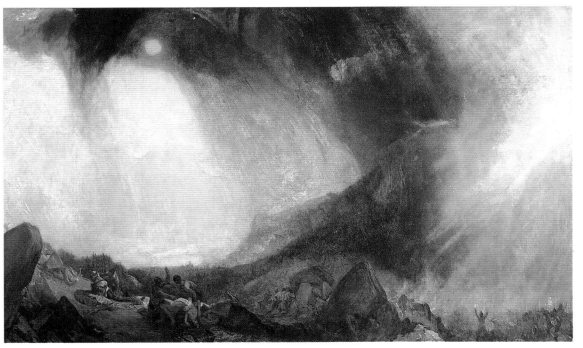

Turner, *Hannibal Crossing the Alps*
As a young artist, Turner drew heavily on the inspiration and example of the great masters of the past. But he was never content merely to follow, and he pioneered new subject matter and new techniques. The painting shown above was well received and generally admired, but his later works were often dismissed as the creations of a madman.

Goya, *The Third of May 1808*
Goya was a court painter in Spain, and this work was commissioned to commemorate a specific incident in the nation's history. He has interpreted the subject in such a way that it transcends its national, political, and historical setting. It stands even now as a universal vision of man's inhumanity to man.

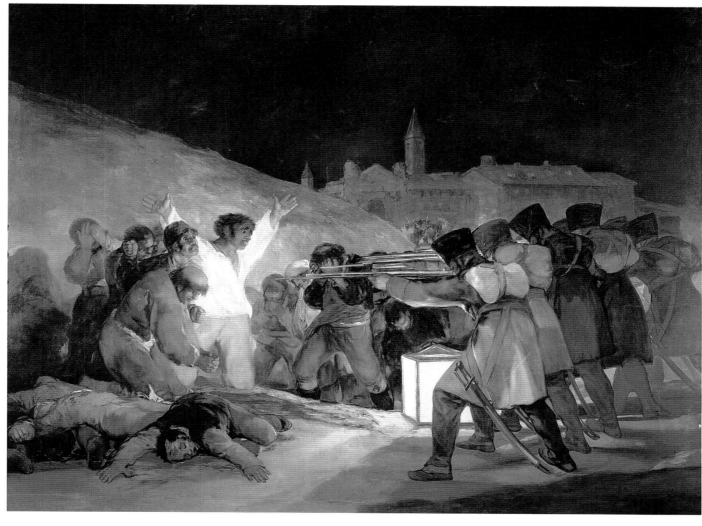

PATRONAGE

Before the 19th century and the development of the modern dealers' network, most major works of art were commissioned by a patron who would often specify exacting conditions or play an active role in shaping the subject matter and appearance of a work. The major early patrons were the Catholic Church and the royal courts of Europe. Only after the Romantic movement of the early 19th century does the role of the artist as a solitary individual creating a private vision begin to emerge.

ARTISTIC VISION

Few artists can survive unless they have the financial backing of patrons, dealers, and collectors, but it is also clear that such backing can never ensure the quality of the work produced. Giotto's Arena Chapel or Michelangelo's ceiling (see p.30) are truly great works of art because they express the artists' total belief in, and commitment to, what they were asked to do – that is, to produce works of art that were worthy of God Himself. This same quality – a belief in an idea, and a belief in the power of painting to express that idea – distinguishes nearly all the paintings that appear in this book, including those by lesser names. Without such belief and commitment all art remains, however accomplished technically, in the realm of decoration and illustration.

ROLE OF THE ARTIST

One of the most persistent myths is that of the genius who is neglected in his lifetime and whose true worth is not appreciated until many years after his death. It rarely happens, and then only in highly unusual circumstances. Much more common is the artist who is hailed in his lifetime as one of the great figures of all time, but who, fifty years later, is no more than a footnote in the history of art. It follows that neither popular acclaim nor rejection is any guarantee of fame in the future. Artists live and work within a complex framework peopled by patrons, collectors, dealers, art institutions, and fellow artists. To stand out from the crowd requires great courage and individuality. These qualities may provide success in the short term, but only those endowed with a depth of vision, and who use art, not as an end in itself but as a means of telling greater truths, are those who succeed in creating the masterpieces that can withstand the judgment of the sternest critic of all – time.

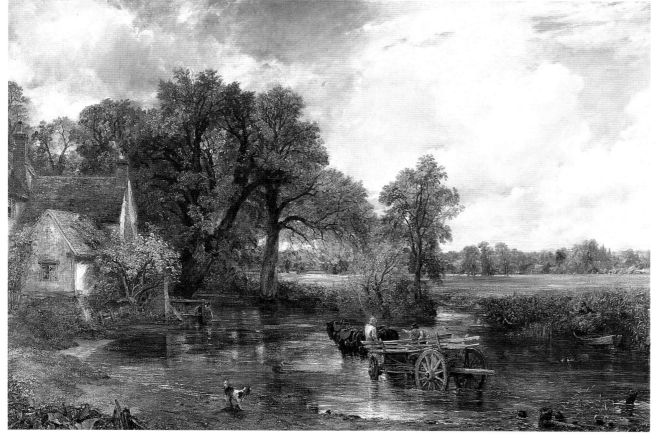

Constable, *The Hay Wain*
Constable is one of the very few artists who sought recognition in his lifetime only to be met with constant rejection in his own country. True recognition for this highly innovative work was accorded him only after his death. However, it seems set to endure the test of time: today, it is one of the world's most popular and familiar masterpieces.

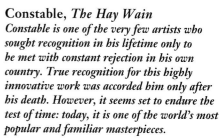

THE ADORATION OF THE MAGI

Shooting star
The Magi were led to the
Saviour by a star rising in
the East (Matt. 2:2).

GIOTTO'S PAINTING is one of the series that decorates the interior of the Arena Chapel at Padua in northern Italy. The theme linking the series together is the story of the life and Passion of Jesus Christ. Here Giotto celebrates one of the most joyful of Christian events, and a central incident in the Christmas story – the arrival of the Magi, the Wise Men from the East who came to worship the new-born Saviour, bearing gifts of gold, frankincense, and myrrh (Matt. 2). Giotto introduced a new dimension to art, which at the time seemed nothing short of miraculous – figures who seemed to exist in real space and who displayed recognizable human emotions. All the paintings in the Arena Chapel are true fresco, that is, they were painted directly onto the wall of the chapel while the plaster was still wet, so becoming an integral part of the building.

Tending the Camels
The young groom who anxiously tends the camel is a charming and personal detail carefully based on observation from real life. One aspect of Giotto's genius is his ability to suggest people's character and their position in life. The country lad in his ill-fitting garments is a foil for the regality of the Wise Men.

THE ARENA CHAPEL

The Arena Chapel in Padua, North Italy is a small private chapel; its owner was a rich man called Enrico degli Scrovegni. Every wall is covered with Giotto's brightly coloured frescoes, and even today, nearly 700 years after the chapel was built, it is like walking into a brightly coloured jewel casket. The atmosphere in the chapel is one of profound spiritual calm.

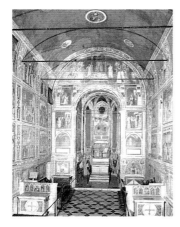

The altar, Arena Chapel

Exotic animal
The camels are delightful animals, indicating the exotic origins of the three Wise Men. It would seem, however, that Giotto had never seen a camel in real life. His blue-eyed camels have ears that are more like those of a donkey, and the feet are those of a horse.

Giotto; *The Adoration of the Magi;*
**1304–06; 200 x 185 cm (78½ x 73 in);
fresco; The Arena Chapel, Padua**

A wooden shelter
The simple wooden canopy has been observed from life, and Giotto has tried to give it a convincing three-dimensional look. It is the lack of art theory that gives his work such a direct and often "childlike" appearance. The canopy looks much like a table seen from below – it may well be this that Giotto studied so carefully.

Star
The star followed by the Magi appears in the background, and even here Giotto has tried to be as true to real life as he can. In 1301 Halley's Comet made one of its periodic appearances, and it is evidently this phenomenon, with its fiery tail, that Giotto has depicted.

Mountainous scenery
Giotto regularly uses these mountainous rock-like forms to create a "stage" where his people act out their narrative. The "mountains" often echo the grouping of the figures; here, it rises behind the Holy Family, which is the focus of attention in the picture.

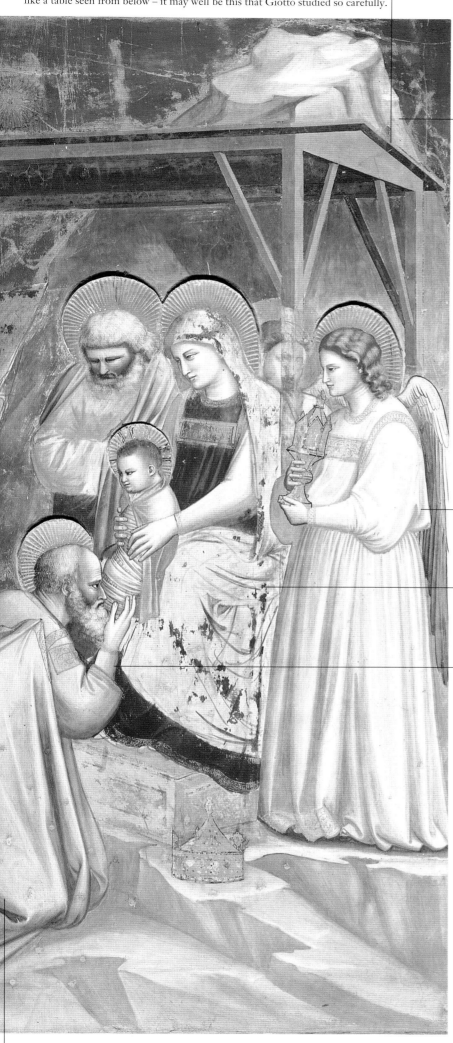

Expressive Features
Giotto conveys thought and emotion very directly through hand gestures and facial expression. Even when the emotion is intense, it is drawn from day-to-day experience – never overstated or theatrical. Here, the solemnity of the faces reflects the seriousness and dignity of this moment.

Attendant angel receiving gifts
Giotto shows an angel standing solemnly by the Virgin's side, holding an incense box containing frankincense, one of the Magi's precious gifts presented to Christ. The gifts brought by the kings were gold, symbolizing purity; frankincense, symbolizing divinity; and myrrh – an embalming ointment referring to Christ's eventual suffering and death.

The Queen of Heaven
The paint of the Virgin's mantle has deteriorated to reveal the drawing underneath. The original blue colour – which is the colour of the expanse of sky – and her regal bearing portray Mary in her symbolic role as Queen of Heaven. Although the Child is not true to life for a baby just a few days old, He is held convincingly and reassuringly by the Virgin.

Caspar's crown
Giotto emphasizes Christ's role as "King of kings" by stressing Caspar's humility. He has placed his crown at the feet of the angel, while he bows to kiss Jesus' feet.

Why are the blue areas in poor condition? They are not true fresco. It was technically impossible to paint the blue lapis lazuli pigment into wet plaster. It therefore had to be added onto dry plaster and, sadly, it has not stood the test of time.

❝ *Giotto was a man of such outstanding genius that there was nothing in the whole of creation he could not depict* **❞**
GIOVANNI BOCCACCIO

GIOTTO DI BONDONE (C.1267–1337)

Giotto is considered by many to be the founder of all modern painting and the father of the Italian Renaissance. The Florentine broke away from the linear style of the Byzantine era. He was appreciated as a revolutionary artist even in his own lifetime. Although little is known of his life, he was reputed to be a shrewd and witty character. His painting skill was acclaimed by the contemporary Italian poet Dante (1265–1321) in *Pergatorio*.

Giotto di Bondone (probable portrait)

The humble king, Caspar
The kneeling Magus, Caspar, is a good example of Giotto's celebrated simplification of form. He has a simple clear outline that is quickly read by the eye, and his action is immediately understood, both for itself and as part of the story told in the picture. The kneeling figure has volume and weight – we can sense the shape of the body under the cloak, and the knee pressing on the folds of cloth.

THE ANNUNCIATION

A Prophecy Fulfilled
The prophet Isaiah, who foretold the coming of the Messiah, is depicted as a sculptured portrait on a medallion above a column.

FRA ANGELICO'S altarpiece is a perfect illustration of the early Renaissance style, pioneered in Florence in the 15th century. It offers a fresh and invigorating interpretation of the Annunciation (Luke 1:26–38). The New Testament story tells of the appearance of the Angel Gabriel to the Virgin Mary to proclaim that she has been chosen to be the Mother of Christ. It is a work of the highest craftsmanship, conceived as a window on the world and full of sharp observation of things that the artist has seen and recorded at first hand. It experiments with new Renaissance ideas, such as scientific perspective, but Fra Angelico's graceful style is charged with the serenity of his Christian faith, and he dedicated his art to the glory of God.

Classical architecture
The rediscovery of classical architecture, sculpture, and literature was one of the hallmarks of the Renaissance. Here, Fra Angelico has invented a classical-style portico, with slender Corinthian columns, based on actual antique examples.

"A closed garden"
A fence and a hedge of flowers separate the garden setting for the Annunciation from the cruel outside world, dominated by the scene of the expulsion of Adam and Eve from Paradise. A fenced garden such as this symbolizes Mary's purity. She was called "the rose without thorns"; that is, she was without sin. A white rose can be seen clearly in the hedge.

This painting is the central panel of a complex altarpiece with an elaborate carved frame and small subsidiary panels showing scenes from the life of the Virgin. The architecture portrayed in the picture harmonizes with that of the frame, and links the main characters with those in the subsidiary theme of the expulsion.

Company of angels
Angels are always young and neither specifically male or female. They were divided into different companies and ranks like a modern-day army.

The Expulsion
Fra Angelico includes this scene of the expulsion of Adam and Eve from the Garden of Eden as a reminder of Man's fall from grace and an affirmation that Christ was born into the world to save humanity from sin.

Adam and Eve
Adam and Eve are expelled from Eden into a barren landscape because of their original sin. They have clothed their nakedness with the skins of animals, which God provided. By contrast, the Annunciation takes place in a fertile garden, which signifies the hope of salvation through the birth of Jesus Christ.

Wings
The Angel Gabriel's wings are particularly beautiful, and it is likely that Fra Angelico made a close study of birds' wings. Each feather is depicted in wonderful glowing detail.

GUIDO DI PIETRO (1400–55)

Originally named Guido di Pietro, Fra Angelico was a Dominican friar who started his career decorating manuscripts. Although in popular tradition he has been seen as the Blessed Angelico, "an inspired saint", Fra Angelico was a professional and highly successful artist. He was in touch with the most advanced developments in contemporary Florentine art and travelled extensively to fulfil many commissions. His particular grace and delicacy had considerable influence on Italian painting.

Fra Angelico (probable portrait)

Flowers and stars
Delicate constellations of flowers echo the design of the star-spangled portico ceiling.

Arabesque pattern
The arabesque pattern on the hem is taken from designs on Ming porcelain.

Archangel Gabriel
One of the delights of this picture is that the Archangel Gabriel – who was God's chief messenger – is particularly youthful, energetic, and businesslike, and obviously excited by the message being delivered.

Doorway
The doorway leads to Mary's bed-chamber, which is behind a rich red curtain. The drawn curtain is almost certainly a reference to her virginity.

"The power of the Highest"
The words issuing from the angel's lips are "The Holy Spirit shall come upon thee, and the power of the Highest shall overshadow thee" (Luke 1:35).

"Handmaiden of the Lord"
Mary responds by saying "Behold the handmaiden of the Lord; be it unto me according to thy word" (Luke 1:38). It has been suggested that her words are painted upside down so that God, who looks down on the scene from above, can read them.

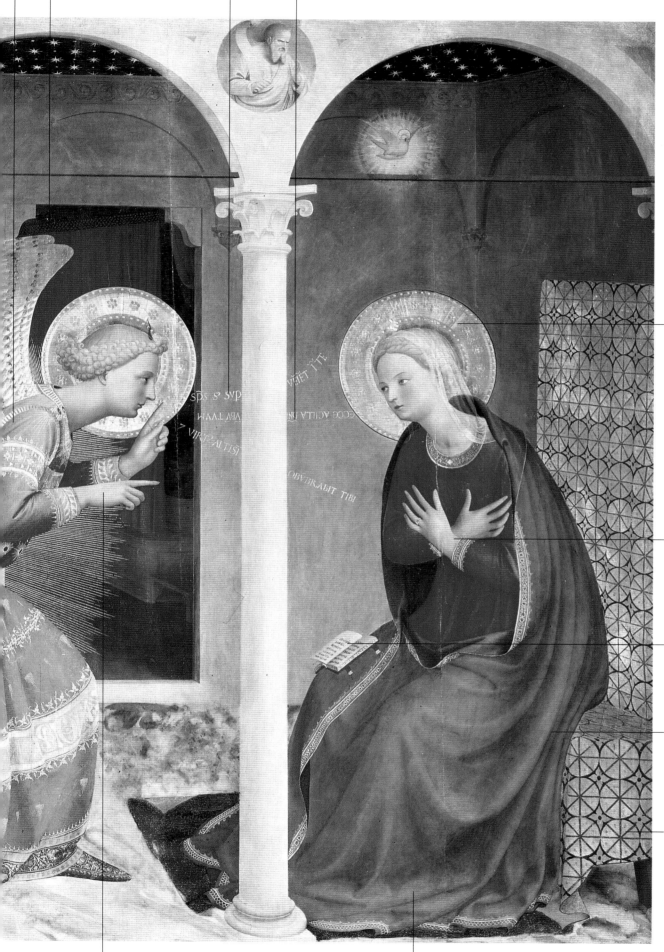

Holy Spirit
The dove is the usual symbol for the Holy Spirit. Fra Angelico surrounds the dove with rays of golden light. The descent of the Holy Spirit symbolizes the moment of conception.

Circle of light
A halo represents the radiant aura of light surrounding the head of a holy person. The usual rule in Renaissance art was to show the Virgin Mary and the Archangel Gabriel with a round gold disc. Notice how Fra Angelico has emphasized the divinity of the angel by depicting rays of golden light shining from his robe.

"Fra Angelico is not an artist properly so called, but an inspired saint"
JOHN RUSKIN

Crossed hands
Mary crosses her hands across her breast to signal that she submits to the role and duty that God has placed upon her.

A passage from the Bible
Tradition states that when the Archangel Gabriel appeared, Mary was reading the Bible. She is said to have been contemplating the passage in the Book of Isaiah about a young woman bearing a son (Isaiah 7:14).

Queen of Heaven
The Virgin is clothed modestly in a mantle of blue – which is the colour of the Virgin as the Queen of Heaven – with gold braiding. Her hair is covered by a delicate veil. Her face is as pure and refined as the angel's.

Gothic grace
Although Fra Angelico was one of the leading artists of the early Renaissance style, with its emphasis on accurate observation of the world, he still retains traces of the graceful, but rather old-fashioned and artificial, Gothic style. For example, Mary's chair looks like a gold-leaf or mosaic background. The meadow of flowers on the opposite side of the painting imitates the design of a medieval tapestry.

Fra Angelico; *The Annunciation*; c.1434; 160 x 180 cm (63 x 71 in); tempera on panel; Museo Curico, Cortona

Painting gesture
The Archangel Gabriel is shown gesturing to Mary with both hands. Usually he holds a lily, which symbolizes the purity of the Virgin Mary.

Slender figure
Angelico's figures are slender and refined, but their movements, expressions, and their forms beneath their robes are taken from life.

THE ARNOLFINI MARRIAGE

VAN EYCK'S STUNNING DOUBLE PORTRAIT, most scholars agree, bears witness to the marriage of Arnolfini, a successful Italian banker who settled in Bruges in the Netherlands in about 1421. But more significantly it is testament to the revolution that was taking place in Netherlandish art, which paralleled the artistic innovations in Italy (see p.12). The painting, which is full of symbolism, works on several levels: as a portrait of two leading members of society by the foremost local artist; as a record of their marriage; and as a commentary on the obligations of marriage in general, as seen in the mid-15th century. Van Eyck is also showing off his supreme skill as a painter, fully in command of the latest artistic techniques (notably painting in oil), for which he was renowned throughout Europe. His works were much sought after in Renaissance Italy.

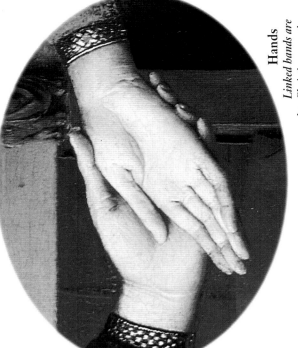

Hands
Linked hands are central to Christian marriage, signifying the uniting of the two people as one. The linked hands also unify the picture, and their shape is echoed above by the curved form of the chandelier.

St Margaret
Carved on the bedstead is a woman with a dragon at her feet. It is probably St Margaret, the patron saint of childbirth, whose attribute is the dragon, but the adjacent handbrush suggests that it could be St Martha, the patron saint of housewives, who shares the same attribute.

Signature
The signature, written in lavish Gothic script, reads *"Johannes de Eyck fuit hic 1434"* (Jan van Eyck was here in 1434). The artist has also included his reflection in the mirror below, indicating his presence at a specific moment. Some scholars suggest that he was a witness to the marriage.

Giovanna Cenami
Giovanna came from a wealthy Italian family, and the marriage had no doubt been carefully arranged as "a good match". Sadly it did not work out as hoped. There were no children, and in later life Arnolfini was taken to court by a mistress who sought compensation after he had spurned her.

Single Candle
A single candle burns in the chandelier. It represents the all-seeing eye of God. A single lighted candle was placed next to the bed of newlyweds to encourage fertility.

❝*Netherlandish painting attempts to do so many things well... that it does none well***❞**
MICHELANGELO

Crystal prayer beads
The beads were a typical engagement present from a prospective husband to his bride-to-be. Crystal is a sign of purity, and the beads suggest the virtue of the bride and her duty to remain devout.

Expensive fruit
Oranges, which were imported from the South, were luxury goods in Northern Europe, and they are perhaps a reminder of the Mediterranean origins of the sitters. Known as "Adam's apples", oranges are also used to represent the forbidden fruit in the Garden of Eden, so referring to the deadly sin of lust, which was thought to have led to Man's fall. Mankind's "sinful" instincts are sanctified through the Christian ritual of marriage.

The bed

Beds had symbolic significance, particularly in royal and noble households where the continuity of the line was important. The bed represents the place where we enter the world at birth and leave the world at death. The red draperies symbolize passion.

Symbols of wealth

Almost everything in the painting proclaims the wealth of the young couple, from their clothes and furniture, to the imported fruit by the window. By the bed is a luxurious and extremely expensive Anatolian rug, a further indication of their wealth and status.

The dress

Giovanna wears a fashionable green dress, suitable for a society portrait and a marriage picture – green is the symbolic colour of fertility. She is not pregnant – the pose simply emphasizes the stomach which at the time was regarded as a focus of beauty. It is possible that her pose and the exaggerated curvature of her stomach are meant to indicate fertility and future pregnancy

Jan van Eyck: *The Arnolfini Marriage;* 1434; 82 x 60 cm (32 x 23 in); oil on oak; National Gallery, London

JAN VAN EYCK (ACTIVE 1422–41)

Regarded as a founder of the Flemish School of painting, Jan van Eyck was one of two painter brothers born near Maastricht in modern-day Belgium. Little is known about his brother, Hubert (died 1426), but much of Jan's life is well documented. He worked for Philip the Good, the Duke of Burgundy, who was the most powerful ruler in Flanders. Besides painting, he undertook several dangerous diplomatic missions on behalf of the Duke. He was hailed on both sides of the Alps as one of the greatest artists of the day. His enormous influence is particularly evident in the work of Vermeer (see p.58).

Jan van Eyck (probable portrait)

A lighthearted touch

The dog adds a charming and lighthearted touch to a picture that is otherwise noteworthy for its solemnity. The detailed painting of its wiry coat is a technical *tour de force.* Dogs in portraits often represent faithfulness and earthly love, and this is almost certainly its symbolic purpose here.

Stations of the cross

Around the mirror are ten of the fourteen stations of the cross – incidents during Christ's journey to his death at Golgotha. Their presence suggests that the interpretation of the picture should be as much Christian and spiritual as legal and factual.

Marriage Ceremony

In the 15th century, marriage was the only Christian sacrament that did not require the attendance of a priest. It could be conducted in private with two witnesses. Given the reflection of two people in the mirror, it has been suggested that the picture is, in effect, a legal document certifying Arnolfini's marriage.

Giovanni de Arrigo Arnolfini

A wealthy Italian merchant who settled in Bruges in about 1421, Arnolfini held important posts in the Court of Philip the Good, Duke of Burgundy. The Netherlands were then part of the Burgundian Empire. Arnolfini later became Governor of Finance for Normandy and made a fortune collecting taxes on imported goods. He wears sober clothes, which were fashionable at Court.

Van Eyck demonstrates the full and flexible range of oil paint, allowing it to create large areas of glowing colour, such as the bed draperies and Giovanna's beautiful green robes. Oil paint was used widely early in Northern European painting, but its adoption by the Italians came later and more slowly.

Shoes

Discarded shoes were a sign that a religious ceremony was taking place – further evidence that the painting is possibly an elaborate marriage certificate. The prominent position of the shoes is perhaps important: Giovanna's red shoes are near the bed, her husband's nearer to the outside world. There was a belief at this time that touching the ground with bare feet ensured fertility.

OIL PAINTS

Paint consists of pigment – finely ground colouring matter such as earth or flowers – suspended in a liquid binding "medium" that eventually dries. Traditional media are egg yolk (tempera), water, and oils such as poppy or linseed. The advantages of oil paint, which became the most widely used paint medium, are its strength and flexibility. It creates a strong, lasting surface and can be used thinly in glazes, or thickly as impasto. It can be built up in transparent layers like varnish to produce large areas of rich glowing colour, or it can be worked in the finest detail. Van Eyck perfected the technique of oil painting and opened up many new possibilities, especially those subtle gradations of tone and colour that give the illusion of glowing sunlight.

15 ◆ THE ARNOLFINI MARRIAGE

THE DEPOSITION

ROGIER VAN DER WEYDEN'S altarpiece is a masterpiece of early Netherlandish painting. The Northern European artists brought an intensity of emotional expression and a minuteness of realistic detail to their work, which give it a quite different character and appearance to that of their Italian counterparts. This is the central panel of a three-part altarpiece (called a "triptych"). The two side-panels became detached at some time and, sadly, are now lost. Many Northern altarpieces in van der Weyden's time were made with carved wooden figures set in shallow box-like spaces. He seems to have accepted this convention, but through the new medium and technique of oil painting he has brought the figures to life.

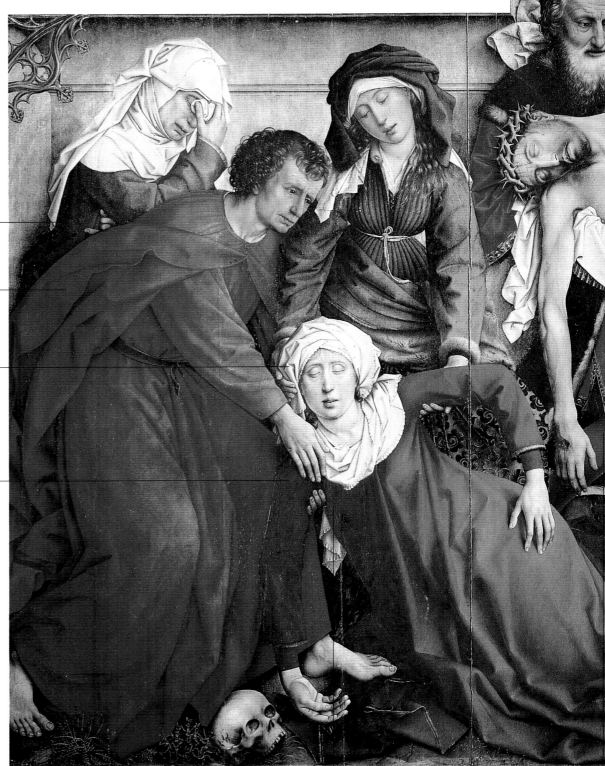

A Portrait of Grief
Van der Weyden was a celebrated portrait painter, and the individuality of the faces shows that the figures here are taken from life. The expressions of grief are highly individual. The face of St John, for example, is grave yet restrained as he struggles to control his emotions. Before He died, Christ entrusted the care of His mother to St John the Evangelist.

Mary, wife of Cleopas
This figure is probably intended to represent Mary, the wife of the disciple Cleopas, who was one of the women supposedly present at the Crucifixion of Christ.

The sorrow of St John
St John the Evangelist stoops to comfort Mary, Christ's Mother, who swoons with grief. His posture is echoed by the figure of Mary Magdalene, bowed with the weight of her sorrow, on the opposite side of the painting.

Symbol of purity
The Virgin's headdress is white, which is the colour of purity and innocence. Note the recurrence of white in the superbly balanced colour scheme.

Ultramarine robe
The robe of Mary, the Mother of Christ, is painted with ultramarine. This beautiful and precious pigment was the colour that determined the prices of pictures in van der Weyden's day. It is made from the rare mineral lapis lazuli, which had to be imported from Afghanistan.

The Skull of Adam
The skull represents Adam, who is thus symbolically present. Adam was cast out of Paradise after eating the forbidden fruit. Christ sacrificed Himself on the cross to redeem the world from Adam's original sin.

Mary, the Mother of Christ
The artist employs repetition throughout the painting to reinforce its visual impact. Most notably, the pose of the Virgin reiterates that of the dead Christ (the Virgin's right hand echoes the pose of Christ's left; her left echoes the pose of His right). While Christ has suffered the extremes of physical pain, His mother suffers the equivalent emotional agony.

Joseph of Arimathea
Christ's corpse is supported by Joseph of Arimathea. He was a rich man who obtained permission to take Christ's body down from the cross. He laid it to rest in the tomb that was originally intended to be his own burial place.

Carved trompe l'oeil details

The painted details in the upper corners may have linked in with a carved framework joining the panels of the triptych together. Van der Weyden obviously took great pleasure in such trompe l'oeil effects that initially fool the eye so that it is not sure if the carving is real or a painted illusion. The tracery contains emblematic crossbows, which were symbols of the Archer's Guild that commissioned the altarpiece.

Body of Christ

The marbled flesh tones of the dead Christ are contrasted with the white of the linen. The figure of Christ is tragic but beautiful: the fine trickles of blood from His five wounds, and the pale crown of thorns, somehow adorn His otherwise unblemished body. An interesting comparison may be made with Grünewald's Crucifixion scene (see p.34).

"You seem to be seeing living faces... and in Christ the semblance of death"
CIRIACO D'ANCONA

Ointment

This follower of Christ is holding a jar of ointment. It is the attribute of St Mary Magdalene, who is depicted in a violently contorted attitude of inconsolable anguish.

ROGIER VAN DER WEYDEN (C.1399–1464)

The most influential artist of the mid-15th century, van der Weyden was born in Tournai, in Belgium. After his apprenticeship he settled in Brussels and became the City Painter around 1436. He quickly established an international reputation and had commissions from several members of the Burgundian Court, including the renowned art collector Philip the Good. His religious painting reflects the strength of his personal conviction. His work had a profound effect on the course of art throughout Europe.

Rogier van der Weyden
(probable portrait)

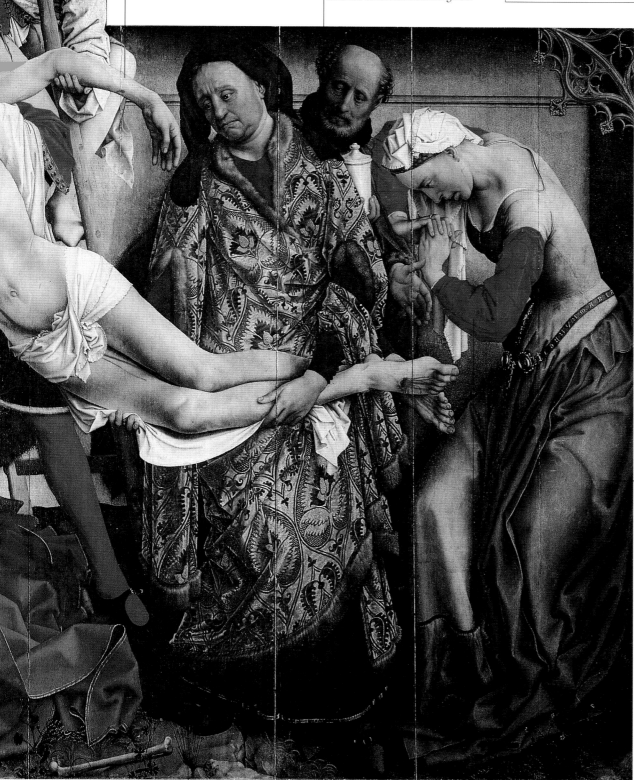

Exquisite Detail

There is an intriguing conflict between the deep and passionate emotion of the picture, which van der Weyden clearly feels and expresses, and his ability to look at an area such as the cloak of Nicodemus and record every detail with dispassionate objectivity.

Mary Magdalene

This anguished figure is Mary Magdalene, who was present at the Crucifixion. It is common practice to include three or four Maries in a Crucifixion, but there is no biblical authority for including so many.

CONFLICTS

Van der Weyden heightens the sense of tension by forcing the eye and mind to reconcile conflicting qualities. Much of the painting detail is intensely realistic, such as the red-rimmed eyes and the tears on the faces. This conflicts with the highly unnatural composition in which the almost life-size figures are packed into a narrow space beneath a tiny crucifix. The shrine-like background shown in the painting concentrates the viewer's attention on the figures and avoids the distractions of a true-to-life setting.

Nicodemus

The man holding the feet of Christ is Nicodemus. Like Joseph of Arimathea, he was a secret follower of Christ. He will wrap the body in the linen cloth that they both hold.

The colour of blood

There are strong accents of bright red on, for example, Mary Magdalene's sleeves and in the robes of St John. Apart from its symbolic value as the colour of the Passion of Christ, they carry the eye through the picture and are a visual reinforcement of Christ's wounds.

Rogier van der Weyden;
The Deposition; c.1435–40;
220 x 262 cm (86½ x 103 in);
oil on panel; Museo del
Prado, Madrid

THE BAPTISM OF CHRIST

PIERO'S PAINTING shows one of the rituals that is central to Christian belief. Baptism is an act of purification and rebirth, and, as well as being the formal occasion when names are given, it signifies the reception into the Church. Piero was a mathematician whose genius made an immense contribution to the early Italian Renaissance. Here, he presents this solemn event, the very moment of Christ's Baptism, as one of mysterious stillness, through a painting that displays all the austerity, balance, and perfection of a piece of geometry or a mathematical equation. The painting was an altarpiece in the chapel of St John the Baptist in Piero's native town, Sansepolcro, in northern Italy.

❝Painting is nothing but a representation of surface and solids... put on a plane of the picture... as real objects seen by the eye appear on this plane ❞
PIERO DELLA FRANCESCA

Divine Light
Piero has represented the presence of God the Father as a divine light depicted by fine golden rays. At the moment of Baptism, God's voice was heard saying, "This is my beloved Son, in whom I am well pleased" (Matt. 3:17).

Cloud formation
The horizontal formation of the clouds echoes the shape of the dove of the Holy Spirit.

Bare patches at the top of the arch confirm that Piero's painting was originally the central panel of an altarpiece with many panels.

Distant hills
The hills in the background form a graceful counterpoint to the line formed by the heads in the foreground. The two lines are skilfully bound together to form a rhythmic pattern across the painting.

The Baptist
St John lived in the desert, baptizing all those who came to the River Jordan. He was the forerunner or messenger of Christ. Typically, he is shown as an unkempt figure with a tunic made of animal skins.

An eye for detail
Piero's meticulous attention to detail is shown in the care he pays to incidental details such as the leaves on the trees and the reflections of the mountains in the water. Piero made accurate observations directly from nature, and incorporated them in his work.

Descending dove
The painting depicts the precise moment of Baptism. St John anoints Christ's head with water poured from a bowl, and as he does so the Holy Spirit descends from Heaven in the traditional form of the dove (see p.12).

Relaxed angels
Angels traditionally appear at Baptism scenes as bearers of Christ's garments. Here, their informality – the way one angel rests a hand on the shoulder of another – humanizes their statuesque appearance. The angel on the right makes direct eye contact with us, inviting us to join in this holy event. The resplendent colouring of the wings of the angel on the far left is balanced by the strong colours of the clothes of the prelates reflected in the River Jordan.

Rebirth

The young plants in the foreground symbolize rebirth, a concept that is central to the ritual of baptism.

Sansepolcro

Piero's native town, Sansepolcro, is shown nestling in the rolling Tuscan landscape. The artist has deliberately transferred the scene of the Baptism from Palestine to Italy. He did this to make the story more immediate for the townsfolk of Sansepolcro. This effect is further enhanced by placing the main characters squarely in the foreground.

Green underpainting

The flesh has a greenish tinge due to the green underpaint now showing through the layers of flesh-coloured paint. It was common practice to paint a *terra verde* (green earth) base under the flesh tones, since the visual result was a warm, glowing appearance.

Piero della Francesca;
The Baptism of Christ; c.1445;
167 x 116 cm (65 x 46 in);
egg tempera on poplar;
National Gallery, London

Middle distance

The river is shown winding off into the distance. Like other artists of his day, Piero has difficulty with landscape spaces. He can handle the foreground and far distance, but has difficulty linking them through the middle distance. The river bends are partly successful in making this link, but Piero cleverly masks the problem by grouping the figures to block out most of the middle distance.

Christ at the centre

The figure of Christ is central to the composition of the painting. The central line runs through his joined hands, along the line of the water trickling from the bowl, through the dove, and up to the apex of the arched top of the panel.

Riverbed

By the foreshortened feet of Christ, the waters of the Jordan suddenly cease. It is not clear if Piero intended this effect, or if it results from damage or careless restoration at some earlier time.

DIVINE COMPOSITION

The composition is based on a square and a circle. The square represents the Earth, and the circle is the symbol of Heaven. Baptism was the point when the divine spirit of God is said to have entered into the earthly body of His Son Jesus Christ.

PIERO DELLA FRANCESCA (C.1415–92)

Piero enjoyed a high reputation in his own lifetime and was employed by many of the most noble Italian patrons, including the Pope. The majority of his work, however, was commissioned by his native town of Sansepolcro. Due to failing eyesight (and, some suggest, an increasing interest in mathematical theory) he stopped painting in the 1470s. His influence is immeasurable, and although his fame was eclipsed after his death in 1492, he was never forgotten. His simplified forms and geometric compositions strongly appealed to progressive artists, and influenced artistic taste in the 20th century.

Piero della Francesca (self-portrait)

A Trinity of Angels

The angels, with three different hair styles, three colours, and three poses, symbolically reinforce the presence of the persons of God – the Father, the Son, and Holy Spirit – in one entity. *The Baptism of Christ by St John at the River Jordan was one of the rare manifestations of all three persons of the Godhead described in the Gospels.* The doctrine of the Trinity was vigorously debated in Piero's time; it professed the union of the three persons of the Godhead described in the Gospels.

THE BATTLE OF SAN ROMANO

UCCELLO'S PAINTING was commissioned in the 1450s by Piero de Medici as a decoration for the newly built Medici Palace in Florence. It celebrates an earlier historic victory in 1432 over the Sienese, and the central figure is the commander in chief, Niccolò da Tolentino, a friend and ally of the Medici. This was a golden age for Florence; successful in war and diplomacy, the Florentines were also pioneering new ideas in almost every field: commerce and banking, science and technology, art and literature. Uccello's painting captures this spirit by portraying a dramatic new type of subject, experimenting with modern perspective, and displaying a passionate interest in observing the form and movement of humans and animals.

"What a sweet mistress is this perspective"
PAOLO UCCELLO

Pageantry
Renaissance warfare was conducted with much ritual and pageantry, and princes and noblemen were expected to be equally well versed in the art of warfare as in their understanding of all the arts. By highlighting the pageantry, Uccello has endowed the scene with the atmosphere of a jousting tournament rather than a military engagement.

Knot of Solomon
The knot of Solomon was the insignia of Niccolò da Tolentino (died 1435) who led the Florentine army to victory in the Battle of San Romano.

Crossing lances
The criss-cross pattern of the lances in the top left corner heightens the painting's tapestry-like appearance. Other such decorative devices are found in the elaborately patterned clothes and the spectacular plumes on the knights' helmets. Such simple and effective devices serve to offset the elaborate foreshortened postures of the men and horses.

Arabesque insignia
The banner bearing the insignia of Niccolò da Tolentino is painted in an extravagant arabesque. It is held aloft by a youthful standard bearer, whose handsome face is unmasked.

Artists, who were considered to be little more than craftsmen in early Renaissance times, were dependent on the favour of cultured noblemen. Scenes of jousting tournaments and battle were popular themes, which were often depicted on tapestries – a craft that was considered by many to be superior to painting.

Paolo Uccello; *The Battle of San Romano*; c.1450; 182 x 320 cm (71½ x 126 in); egg tempera on poplar; National Gallery, London

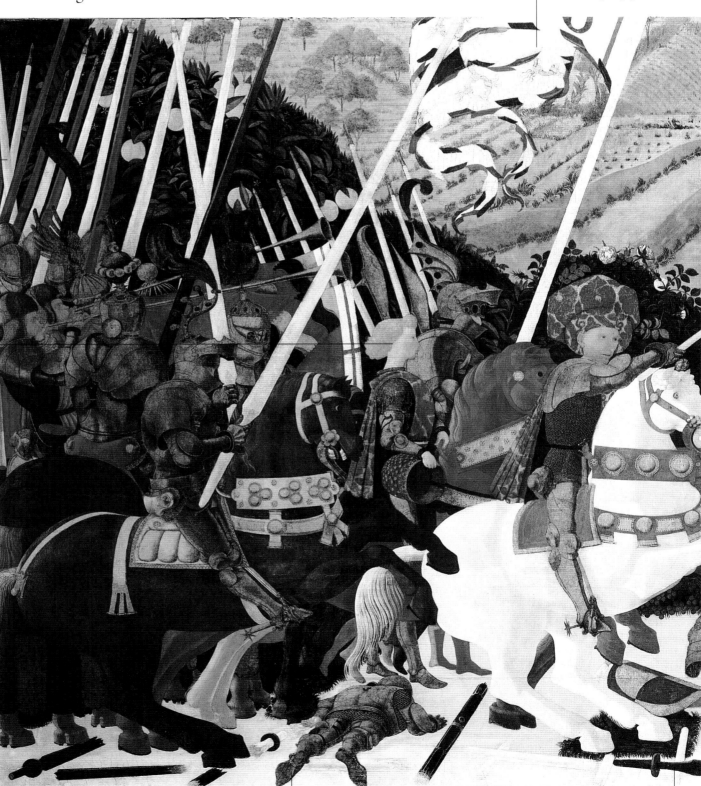

Embossed Gold
The round raised gold decorations on the harnesses are, in fact, embossed in gold on the surface of the painting.

A bloodless death
This soldier has conveniently dropped dead on an orthogonal along the perspective plane. Note that not a drop of blood is allowed to sully the glorious scene of the battle – even though there is a sizeable hole in the back of the unfortunate soldier's armour where he has presumably been run through with a lance.

The point of interest
Broken lances converge on a vanishing point by the head of Niccolò's horse. This device is often used to focus the viewer's attention towards the main action of a painting – in this instance the heroic figure of Niccolò.

Glorious Headdress
Niccolò da Tolentino sports a glorious red and gold hat. He would not, of course, have worn such an impractical hat in battle. Uccello adorns the hero of the painting to heighten the sense of pomp and ceremony. Due to wear and tear, it now appears rather flat, and many experts mistakenly claim the picture was composed out of flat, decorative shapes.

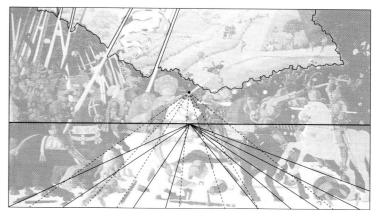

Busy backdrop
The skirmish continues in the background of the painting, which is patterned by the variegated shapes of fields. Foot soldiers bustle around, reloading their crossbows and sprinting hither and thither. Uccello was one of the first artists to include accurate depictions of landscapes in his work.

UCCELLO'S PERSPECTIVE
An acknowledged pioneer of perspective, Uccello arranges the lances on the ground so they create the receding lines, called orthogonals, in a perspective system that will meet at a single fixed vanishing point. In reproduction it appears overly schematic and rather contrived, and the foreground space looks very narrow. But it should be noted that this is one of three panels designed for a specific room where they were hung above eyelevel with the bottom edges of the paintings roughly 2 metres (7 feet) from the ground. That is why Uccello has arranged the space and perspective as he has. If you imagine that everything you look at starts well above eyelevel, the foreground appears much broader. Your eye travels up the lances on the left to the fields. Note how Niccolò's horse and arm are designed to be seen from below. To get an idea of Uccello's intention, hold the book at arm's length above eyelevel.

An ornamented hedgerow
Early Renaissance artists had difficulty depicting middle ground (see p.18). Uccello has avoided the problem by placing a hedge between the foreground and far distance. The hedge is ornamented with red and white roses and luscious oranges and pomegranates.

Frozen in combat
Despite the highly stylized depiction of the scene in general, the posture of the knights engaged in mortal combat is very well observed and realistic. The strong outlines tend to give the scene a "frozen" quality, so that the fairy-tale knight seems to have been turned to stone immediately before he delivers the death blow.

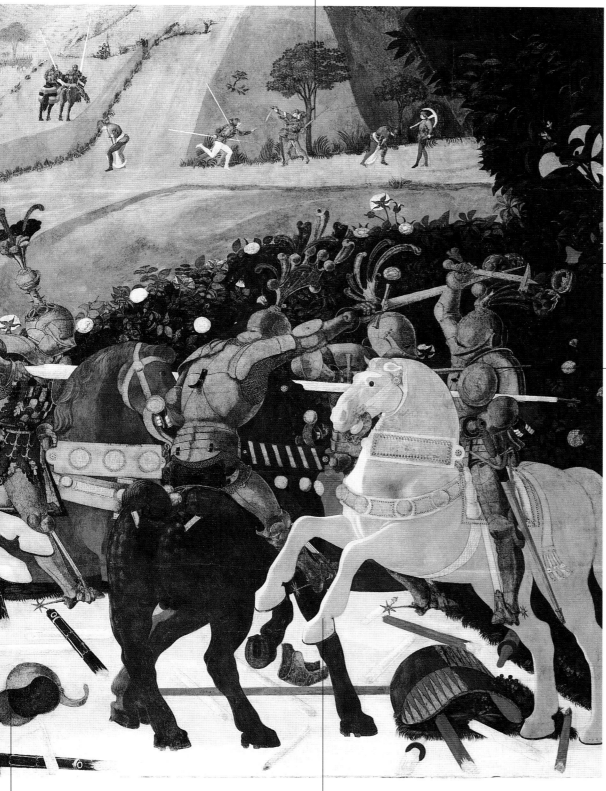

PAOLO DI DONO (c.1397–1475)

Uccello's real name was Paolo di Dono. He was called Uccello because of his love of animals (*uccello* is Italian for "bird"), which he sketched tirelessly. In the 1430s he became fascinated by perspective and focused all his energies on this fledgling discipline. He had many prestigious commissions in his lifetime, but his obsession with perspective led him into an eccentric and solitary old age.

Paolo Uccello (probable portrait)

Foreshortened helmet
The precisely constructed foreground of Uccello's painting is littered with discarded pieces of armour such as this helmet. Uccello was notorious for staying up late into the night making elaborate perspective studies of such objects as are seen here.

Horsemen
Uccello has gone out of his way to show his skill in depicting the human figure and horses. His masterly depiction of light and shade make the horse stand out as if in relief. In keeping with the rather fantastic stylization of the scene, however, the steeds have the "wooden" appearance of carousel horses.

THE BIRTH OF VENUS

BOTTICELLI'S FAMOUS PAINTING was revolutionary for its time, being the first large-scale Renaissance painting with an exclusively secular and mythological subject. Admiration for antiquity – Ancient Greek and Roman civilization – was a chief feature of the Renaissance, and it was an interest that was shared by many artists, scholars, statesmen, merchants, and collectors. The Medici family (see p.20) was an outstanding example of such intellectual patrons of the arts. *The Birth of Venus*, portraying one of the most picturesque of classical myths, transports us into a world of dreams and poetry. Venus, in the centre, is flanked by the West Wind and an attendant Hour. The elongated figures float against a simple flat background as though they were paper cutouts.

Hands and Feet
*Characteristics of Botticelli's art
are his use of clear, precise outlines full of
energy and tension, and the well-manicured
hands and feet with long fingers and toes.*

Venus' sacred roses
According to ancient mythology, the rose – which is the flower sacred to Venus – was created at the same time as the birth of the goddess of love. The rose, with its exquisite beauty and fragrance, is the symbol of love. Its thorns remind us that love can be painful.

The West Wind
Zephyr, the west wind, is the son of Aurora, the dawn (see p.50). He is the gentle breeze of spring that propels Venus to the shore, and he is shown entwined with his consort, Chloris.

The abduction of Chloris
The nymph Chloris was abducted by Zephyr from the Garden of the Hesperides. Zephyr fell in love with his victim, and she consented to be his bride. So the nymph was raised to the rank of goddess and became Flora who held "perpetual sway over flowers".

> **❝***If Botticelli were alive today he'd be working for* **Vogue❞**
> PETER USTINOV

THE BIRTH OF BEAUTY

Venus is one of the most important goddesses of antiquity, but the legend of her birth from the sea is gruesome. Uranus (Heaven) and Gaea (Earth) had mated to produce the first humans (who were called the Titans). But one of their sons, Cronus, or Saturn (Time), used a sickle to castrate his father. He then threw the genitals into the sea, and from the foam that resulted, Venus was born. Venus is her Roman name; the Greeks called her Aphrodite. She is the goddess of love, beauty, laughter, and marriage.

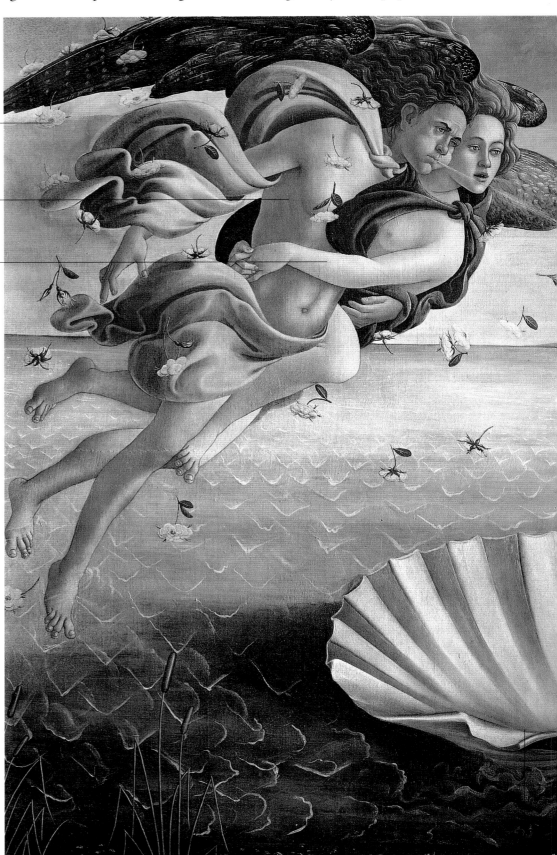

New Waves
*Botticelli makes no attempt to imitate real waves, but uses the
sea as an opportunity to create a pattern. The stylized V shapes
become smaller as they recede into the distance, but change at the
foot of the scallop shell.*

Bulrushes
The long, slender bulrushes mirror the pose and the golden hair of the goddess.

Classical cross-reference
Venus appears to be made from pure marble rather than flesh. She imitates the pose of a famous antique Roman statue, and Botticelli is making a learned cross-reference that he knew would be recognized.

SANDRO BOTTICELLI (1444–1510)

Botticelli spent almost his entire life in his native Florence, his only significant journey being in 1481–82, when he worked on the decoration of the Sistine Chapel . This commission shows how great his reputation was in his lifetime. However, he died in obscurity and his fame was not resurrected until the late 19th century.

Sandro Botticelli (probable self-portrait)

Bone structure
Botticelli always emphasizes the bone structure under the flesh, and his faces have elegant noses, high cheek bones, and strong jaw lines.

Botticelli's Venus represents an ideal of classical beauty that was greatly admired during the early Renaissance period, especially in intellectual circles in Florence. But Botticelli softens the severity of this image by surrounding Venus with long, flowing tresses.

Faraway Eyes
Botticelli's faces often have a faraway expression, as though they have withdrawn into their own inner world and are lost in their own thoughts.

Orange grove
The trees are hung with white blossoms, tipped with gold. The leaves have golden spines and the tree trunks are also tipped with gold, so that the grove seems to be infused with Venus' divine presence.

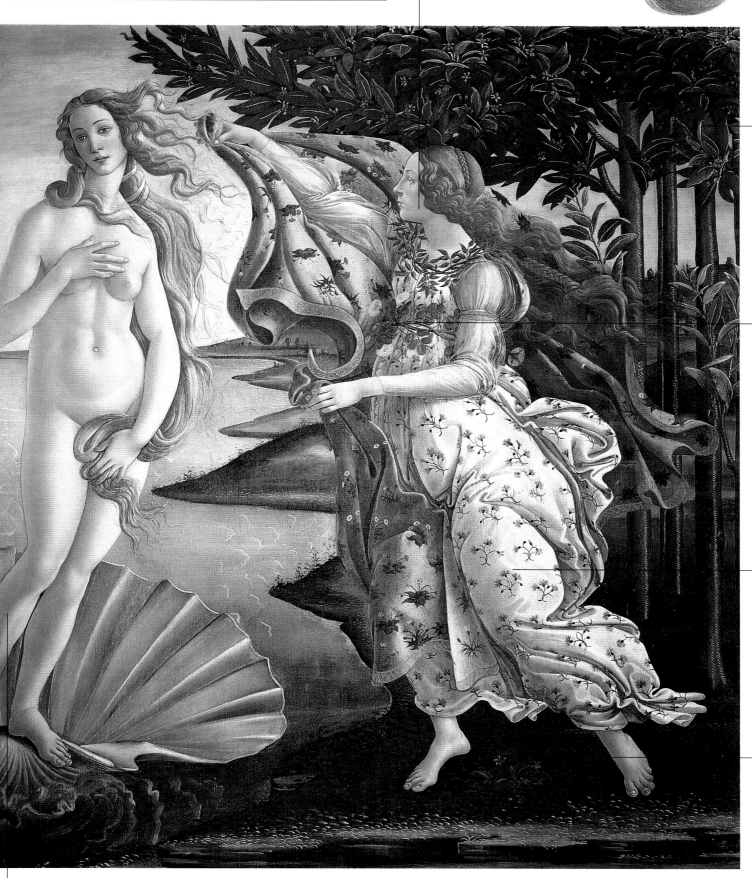

The height of fashion
A girdle of pink roses, which is worn fashionably high, is woven around the Hour's waist. Around her shoulders, she wears an elegant garland of evergreen myrtle, symbolic of everlasting love.

The colour scheme of the painting is as restrained and modest as the goddess herself – the cool greens and blues are set off by the areas of soft, warm pinks and accents of gold.

The waiting Hour
An elegant nymph steps forward to receive Venus. She is one of the four Hours, who were spirits personifying the seasons. Her flowing white robe, which is embroidered with delicately entwined cornflowers, billows in the wind. She represents spring, the season of rebirth and renewal.

Anemone
A single blue anemone blooms at the feet of the maiden. Its presence here reinforces the idea of the arrival of spring.

Modest Venus
Botticelli has chosen a pose called the "*Venus Pudica*" – modest Venus – in which the goddess chastely hides her body with her hands. Other artists chose a more sensual depiction called the "*Venus Anadyomene*" where she rises naked from the sea, wringing the water from her long tresses.

According to some accounts, Venus landed at Paphos in Cyprus. Other accounts suggest she alighted at Cythera, off the southern coast of Greece. Both islands were dedicated to the worship of Venus.

Sandro Botticelli; *The Birth of Venus*; c.1484; 172.5 x 278.5 cm (68 x 109½ in); tempera on canvas; Uffizi, Florence

THE GARDEN OF EARTHLY DELIGHTS

BOSCH IS THE LAST, and perhaps the greatest, of the medieval painters. The view of mankind and the world that he depicts is pessimistic and moralizing: humankind has been fundamentally flawed since the Expulsion of Adam and Eve from the Garden of Eden. In Bosch's philosophy, salvation is possible, but only with the greatest difficulty; and the probable fate of most humans is eternal damnation. Death, and the fear of death, is an ever-present reality in his art. In the three panels of *The Garden of Earthly Delights*, Bosch's greatest work, he illustrates the realities and consequences of the first (and, in his view, deadliest) sin – lust. The left panel shows Paradise, Man's home before the Fall from Grace; the central panel depicts Man's lustful activities; the right panel shows the results of lust – eternal damnation.

Fountain of Life
In the centre of the Garden of Eden is the Fountain of Life. On the rock below it there are precious stones. Surrounded by water, and inaccessible directly, it symbolizes the temptation and falsity that was present even in Paradise. In the circle is an owl, said to represent witchcraft.

Garden of Eden
The animals include those – like the unicorn – that were believed in, but had never existed; those Bosch would have heard about but not seen, such as the giraffe; and imaginary creations, such as the three-headed bird (at the bottom, by the pool).

Unforbidden fruit
The only forbidden fruit was on the Tree of Knowledge, seen half-way up the panel on the right, with a serpent coiled around the bottom of its trunk. God provided all manner of fruit for man to enjoy in the Garden, and the left-hand panel is swathed with fruit trees and exotic vines, such as this one behind Adam.

Although Bosch uses the formula of the triptych, the work was not created as an altarpiece – the imagery would have been wholly unsuitable. It was almost certainly created for a noble lay patron who enjoyed complicated and learned allegories.

The beast
Already the beasts feed off one another: the cat eats a rat; in the foreground, birds devour frogs and toads; and in the distance, a lion can be seen eating a deer. Man was meant to rise above this beastly behaviour.

Hieronymus Bosch; *The Garden of Earthly Delights (Triptych)*; c.1500; central panel 220 x 196 cm (86½ x 77 in); wings 220 x 96.5 cm (86 x 38 in); oil on panel; **Museo del Prado, Madrid**

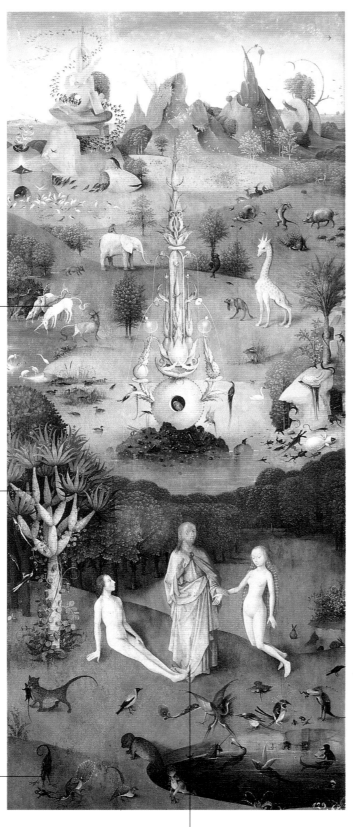

And God created Woman
In the foreground, God, in the youthful guise of Christ, brings about the union of Adam and Eve. God created Eve of a rib from the sleeping Adam (Gen. 2:21).

The left-hand panel shows the last day of the Creation. God has created the flowers and fruits, the animals, and the first humans, Adam and Eve.

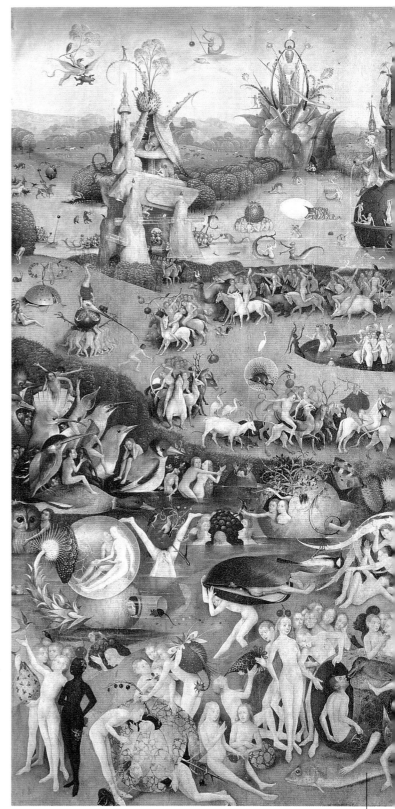

The Garden of Lust
The centre panel is a dissertation on lust in its many forms. For the medieval mind, the sexual act was proof of Man's fall from grace. *The Garden of Earthly Delights* is thus placed between the Garden of Eden where the first sin was committed, and Hell where all sin is punished.

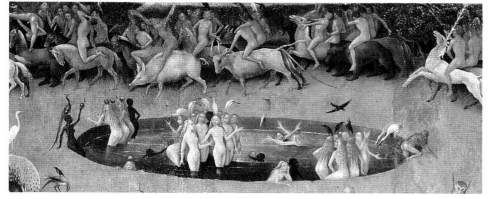

Symbolic structures
The four strange rocks inhabited by lovers have outcrops on them in the shape of sexual symbols. Bosch may have intended the four streams that converge around the structures to represent the four corners of the earth.

Bath of Venus
In the centre of the garden is a pool of bathing women, with men on horseback riding around them. Riding a horse was a metaphor for the sexual act, and the "bath of Venus" was a phrase that meant being in love.

HIERONYMUS BOSCH (C.1450–1516)

Probably the greatest fantasy artist ever, Bosch spent almost his entire life in the small Netherland town of 's-Hertogenbosch, from which his name is derived. The origin of his unusual style is unclear, and it bears little relation to van Eyck or van der Weyden (see pp.14–17) – the major Netherlandish painters of the time. He reached a wide audience through the many prints made from his paintings, and his work was avidly collected by King Philip II of Spain (1556–98). However, Bosch had no real successor until Bruegel (see p.40).

Hieronymus Bosch (self-portrait)

> *"Bosch... the discoverer of the unconscious"*
> CARL JUNG

The fires of Hell
At the top of this panel is a typical image of Hell, all blazing fires and brimstone. Below this, from the phallic, tank-like scythe made from a blade and two ears, to the vicious animals at the bottom, Bosch gives vent to the full force of his imagination.

At the geometric centre of the triptych is an egg perched on the head of a horseman. Together with the bubbles, glass, and brittle fruit shells, the emphasis is on the fragility of human pleasure. The underlying moral message is that beauty is two-faced – attractive but deadly; the pleasures of this world are a false paradise, and becoming too involved with them leads to eternal damnation.

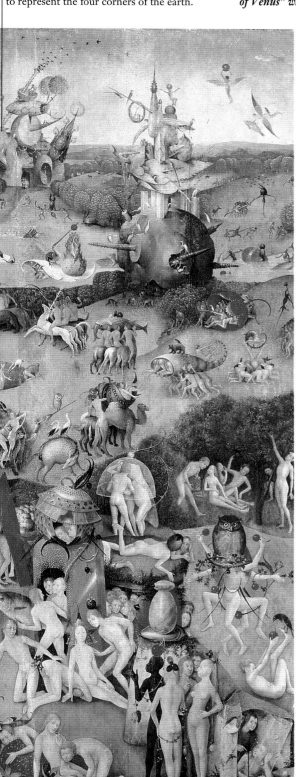

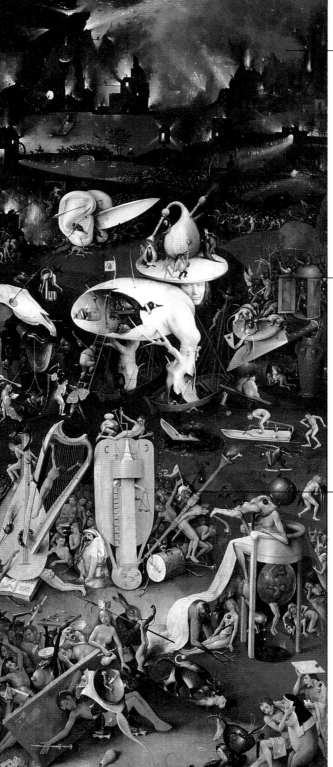

Imagery and word play
Bosch's visions of the punishments suffered in Hell are as gruesome as they are fantastic. Here a naked soldier is impaled on a spear; below him a soldier in armour is eaten alive by dragons. At the bottom left, a pack of devils hack at a group of sinners with knives, spears and swords: one triumphantly holds up an impaled heart, while another is about to smash the head of some poor unfortunate with a backgammon board. Bosch's imagination had a great influence on the Surrealist artists more than 400 years later.

Giant musical instruments
Musical instruments are traditional symbols of love and lust. Here, those who indulged in the pleasures of the flesh on Earth are crucified on these enormous instruments for eternity.

Strawberries
The huge fruits represent the pleasures of the flesh. Mankind's "original sin" was devouring the forbidden fruit and, in medieval language, plucking fruit was equated with the sexual act.

Adam and Eve
The only clothed person in the painting is Adam, who sits with Eve in the mouth of the cave in the lower right-hand corner. According to apocryphal writings, they took shelter in a cave after their expulsion from the Garden of Eden.

Hellish Punishment
In the bottom right-hand corner a magisterial bird-like creature eats up human victims, then defecates them into a well of excrement and vomit. This is the punishment for those who indulge in the deadly sin of gluttony. Note the huge cooking pot that serves as the creature's hat.

THE MONA LISA

LEONARDO'S *THE MONA LISA* can fairly claim to be the most famous painting in the world. It hangs in the Louvre Museum in Paris, protected by several inches of bulletproof glass. The picture is surprisingly small, yet for nearly 500 years *The Mona Lisa* has inspired poetry, songs, paintings, sculptures, novels, myth, rumour, forgeries, and theft, and her face currently appears in countless advertisements all over the world. When first seen, she was considered to have brought a new dimension of lifelike reality to the art of painting. As the artist and biographer Giorgio Vasari put it, "… the mouth joined to the flesh tints of the face by the red of the lips appeared to be living flesh rather than paint…. On looking at the pit of the throat one could swear that the pulses were beating…".

Missing Eyebrows
Why are there no eyebrows? The most likely explanation is that Leonardo did put in eyebrows as a final touch onto the dry paint of the face, but the first time it was cleaned (perhaps in the 17th century) the restorer used the wrong solvent and the eyebrows dissolved and were removed forever. It serves as a warning of how careful restorers must be.

Windows of the soul
Do the Mona Lisa's eyes, as is often stated, express an unearthly wisdom? Leonardo himself described the eye as the "window of the human body, through which it mirrors its way and brings to fruition the beauty of the world, by which the soul is content to stay in its human prison".

The enigmatic smile
What is the secret of the smile of the Mona Lisa? We will never know for certain, but the two landscapes have something to do with it. The left-hand landscape tends to pull the left eye downwards, and the right-hand landscape tends to push the right eye upwards. This visual pull and push meets in the middle of *The Mona Lisa* and causes the eye to "see" a flicker at the corners of the mouth. This flicker gives the impression that she is about to break into a broader smile.

Impossible scenery
Look carefully and you will see that there are two landscapes in the background. The horizon in the landscape on the right is higher, offering a bird's-eye view of the scenery, and there is no way that this landscape can connect with that on the left, which offers a lower viewpoint. The place where the landscapes would have to meet is hidden by the head of the Mona Lisa.

Intricate Loops
The dress has an intricate embroidered pattern of loops and knots. Leonardo was fascinated by such patterns, and many ingenious interpretations of their significance have been devised. Whether this pattern has any meaning remains a mystery, and so is fully in keeping with the spirit of The Mona Lisa.

Rocky landscape
The rocky landscape is a feature that was much loved by Leonardo and was often used by him – most notably in another masterpiece, *The Virgin of the Rocks* (1483–85). He was particularly fascinated by the movement of water.

Smoky contours – *sfumato*
The locks of hair falling lightly over the Mona Lisa's right shoulder blend with the rocky outcroppings, just as the diaphanous folds of the the scarf over her left shoulder are continued in the line of a distant aqueduct. The "smoky" contour line that blends with the mysterious background lends an ambiguity of mood and creates the illusion of movement, which gives this painting its uncanny sense of life.

"She is older than the rocks among which she sits; like the vampyre she has been dead many times, and learned the secrets of the grave"
WALTER PATER

The relaxed and informal pose of the Mona Lisa was one of the innovations that this portrait introduced. It made all earlier portraits seem stiff and artificial by comparison.

Sleeves

The sleeves are painted in a crisp style with relatively hard outlines. This is consistent with the style of Leonardo's early work. However, the drapery over the Mona Lisa's shoulder is painted in the much softer style that is akin to Leonardo's later work. This suggests that he worked on the painting over a considerable period of time; it was possibly finished as late as 1510.

Chair arm

The arm of the chair runs almost parallel to the picture plane and emphasizes the gentle turn of the torso and head.

Leonardo da Vinci; *The Mona Lisa;* c.1505; 77 x 53 cm (30 x 21 in); oil on panel; Musée du Louvre, Paris

Barren Landscape

The only signs of man in the landscape are the roads and the aqueduct. It is an inhospitable landscape, but suggestive of the elemental forces of life.

Sombre colours

Much of the flesh in the painting has a greenish hue caused by overly zealous cleaning. However, Leonardo employed a far more sombre colour scheme than his contemporaries.

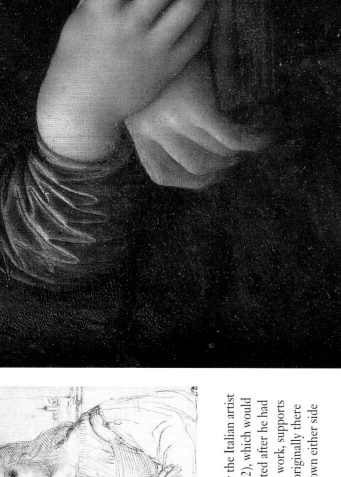

Exquisite hands

Note the beautiful modelling of the hands – one of the many triumphs of this painting. The hands are entirely relaxed and so accentuate the gentle majesty of the figure portrayed.

LA GIOCONDA

Who is she? She has always been called the Mona Lisa, that is, the Madonna Lisa di Antonio Maria Gherardini, wife of the wealthy Florentine citizen Francesco del Giocondo, who commissioned Leonardo to produce a portrait of his young wife in 1503. The painting is frequently referred to as *La Gioconda.* It is doubtful, however, that the ever-restless Leonardo completed this commission. It is likely that the painting began as a portrait of the nobleman's wife but became something much more – the image of Leonardo's idea of perfect beauty.

Columns

This odd shape serves no apparent purpose, and there is another one on the other side of the picture. However, they show that the painting was once enclosed by columns down either side to reinforce the illusion that the Mona Lisa is sitting in a loggia. The panel on which she was painted has been cut down on either side and the columns have been removed.

RAPHAEL

This drawing by the Italian artist Raphael (see p.32), which would have been executed after he had seen Leonardo's work, supports the theory that originally there were columns down either side of the painting.

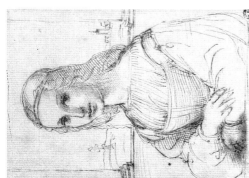

LEONARDO DA VINCI (1452–1519)

Painter, sculptor, architect, and engineer: Leonardo was the most versatile talent of the Italian Renaissance. However, the sheer diversity of his genius meant that he finished relatively few major paintings but his many drawings, combining scientific precision with intense imaginative power, reflect the extraordinary breadth of his interests, ranging over biology, physiology, hydraulics, and aeronautics. He invented the first armoured tank and even designed aircraft.

Leonardo da Vinci (self-portrait)

THE TEMPEST

GIORGIONE'S SMALL PAINTING is one of the treasures of the Accademia in Venice, and a rare work by this young genius. Few works by Giorgione are known for certain. He died aged 32, struck down by the plague, which regularly swept though Venice in the summer. Had he lived, he might have been one of the giants of Western art, such as Titian (see p.36). He was a few years older than Titian, and they collaborated on many projects. This painting is exceptional for its time in being primarily a landscape painting – indeed it is the seed from which the flower of the landscape traditions of the 17th and 18th centuries was to grow. As well as being an object of great visual delight, the painting also has a reputation for mysterious meaning. Many scholars have put forward theories and ideas as to who the figures in the landscape are, and what their significance might be, but the mystery has never been solved for certain. Fortunately it probably never will be, for ambiguity and mystery are one of the central qualities of great art.

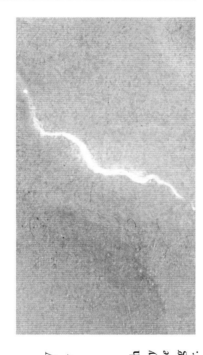

Lightning Flash
The painting would have been created by Giorgione in his studio, but the sky and the flash of lightning are so vivid and convincing that he must have made studies in the open air.

Giorgione (probable portrait)

GIORGIO BARBARELLI (c.1478–1510)

Giorgione, like the other great Venetian artist of his day, Titian (see p.36), emerged from the workshop of Giovanni Bellini who was famous for using colour and light to unify his paintings. Both Giorgione and the younger Titian continued to develop their master's style, often collaborating on the same commission. Only five paintings can be positively attributed to Giorgione working alone, yet the outstanding quality of these works secures him a place among the greatest artists of the Renaissance. Tragically, Giorgione died of the plague when he was only 32 years old, so he was unable to share in the enormous success achieved by his friend, Titian, who was to dominate Venetian art for the next 50 years.

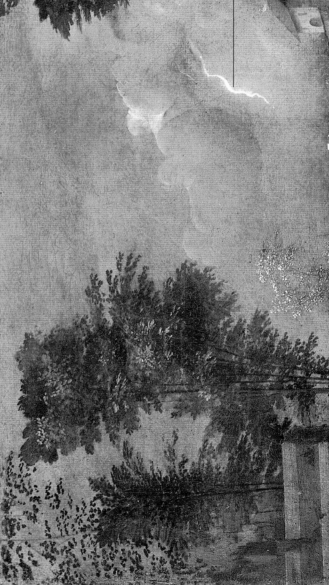

Imaginary trees
The great variation in the depiction of the foliage is beautifully observed. But although Giorgione made studies from nature, the landscape setting (like that of *The Mona Lisa*, see p.26) is imaginary.

Diagonal trunk
The trunks of the trees echo the diagonal of the staff held by the figure in the foreground.

Light and colour
A bolt of lightning, which gives the painting its title, illuminates the deserted town in the background. The lightning, often a symbol of the wrath of God, may well be a clue to any lost meaning of the painting. However, it is the innovative use of light and colour to unify the disparate images in the painting that creates the true magic of this work.

Giorgione's painting is often small-scale with a poetic air and rich and moody colours. It is likely he was patronized by scholarly collectors who shared the artist's own intellectual interests.

Deserted town
What is the significance of the strangely deserted town? The sole occupant of the town is the white stork that is perched on the rooftop. Like the figures in the foreground, it too seems oblivious to the approaching storm. The stork is a Christian symbol of chastity, purity, and vigilance. Its presence supports the view that the painting does indeed have a hidden message. Why would Giorgione have taken the pains to include the detail if it had no significance?

White cloth

The woman has a white cloth draped over her shoulders. White is the colour of purity, which may be significant, but it serves the technical purpose of leading the eye between the woman and the man, whose shirt is white.

One of the most influential literary interpretations of the picture (which acknowledged that a literary interpretation might not be necessary) suggests that the painting is a pastoral allegory: the storm in the background represents Fortune, which is always unpredictable and uncertain. The "soldier" by the columns represents Fortitude, and the "gypsy" suckling the baby represents Charity. Both have nomadic and uncertain lives, and like the virtues of Fortitude and Charity, they are notably subject to the uncertain whims of Fortune.

Giorgione; *The Tempest*; c.1505; 82 x 73 cm (32 x 28½ in); oil on canvas; Galleria dell' Academia, Venice

Does the picture have a literal meaning, and do the figures need to have an identity? Not necessarily, and we may never know what Giorgione intended. It is quite possibly a picture without a specific meaning, in the way that poetry and music do not need to have a specific meaning. Like these other art forms, painting can just as effectively represent a mood or state of mind.

A Gypsy Woman?

An early description of this painting documented the scene as "a little landscape with a soldier and a gypsy woman". We do not know whether she is a gypsy or, as many experts believe, the Virgin Mary, but her unusually direct gaze is one of the most intriguing aspects of this fine work.

The sentinel

The young man on the left is often referred to as a soldier or a shepherd, although he carries no weapon and there are no sheep. The common duty in the two otherwise very different vocations is sentry duty. Is this man, his strength echoed by the pillars behind him, standing guard over the woman and child?

A pilgrim's staff?

The young man carries what might be a pilgrim's staff, supporting the idea that he is on a journey with his wife and child – perhaps Mary and Joseph at rest on their flight into Egypt?

X-ray photographs reveal that under the image of the man is a nude woman bathing. At some stage Giorgione changed his mind about the composition and painted over it. Does this fact affect our interpretation of the subject? If the figure was the same woman, then her present nakedness can be explained by the fact that Giorgione is showing her after her "toilet".

The Broken Pillars

A broken column is traditionally a symbol of fortitude. Why broken? The reference is to Samson (see p.46), the embodiment of fortitude, who after he was blinded had his revenge on the Philistines when he pulled down the temple around their heads, killing hundreds of them and himself as well.

A snake in the grass

Many complex interpretations hinge on the premise that this is a snake retreating into a hole. Its position below the foot of the woman has led some scholars to conclude that the woman is Eve, whose "seed", God decreed, should bruise the serpent's head beneath his heel (Gen. 3:13). Thus, the child is Eve's first son, Cain. But is the "snake" just a root?

"In his work the world has stopped, leaving a host of queries echoing in the air"

MARY MCCARTHY

SCIENTIFIC EXAMINATION

Scientific developments have produced many techniques for the examination of works of art. The analysis of paint is one example: many pigments were not introduced until the 19th century, so if they appear in a painting that claims to be of an earlier date, there is obviously something to be explained. X-ray photography is a means of looking behind the surface of the picture at the preliminary work below. But although scientific analysis can reveal hidden work, it can never unravel a mysterious meaning. Such judgments are the task of the scholar and connoisseur.

THE SISTINE CHAPEL CEILING

MICHELANGELO'S CEILING for the Sistine Chapel in the Vatican is a prodigious achievement. Panels portraying key stories from Genesis are surrounded by a framework with additional scenes and figures. Stunningly original in concept and execution, the ceiling displays Michelangelo's deep religious faith, expressed through a profound reverence for Classical Antiquity. These were two of the forces that inspired High Renaissance artists to such extraordinary peaks of achievement. Michelangelo painted the ceiling single-handedly in just over four years, developing his style as he proceeded. Illustrated here are three central panels telling the story of Adam and Eve (Gen. 2–6).

MICHELANGELO BUONARROTI (1475–1564)

Sculptor, painter, architect, and poet, Michelangelo was one of the greatest figures of the Renaissance. Born in Florence, the son of a noble-man fallen on hard times, he was the archetypal tormented genius who was rarely satisfied with his enormous talent. In painting and sculpture, his means of expression was limited almost entirely to portraying the male nude, but his massive influence remains undiminished since his death.

Michelangelo Buonarroti

The technique that Michelangelo used is true fresco – the same as that of Giotto's Arena Chapel at Padua, in northern Italy (see p.10) – where the paint is applied to wet plaster.

God creates Eve
According to the Bible, God created Adam and Eve on the sixth day of the Creation, along with the animals. He sent Adam into a deep sleep, and created Eve from Adam's rib. Here, Adam is portrayed sleeping and Eve bows towards God.

The image of God
God the Father seems to be commanding Eve to stand upright. He is literally too big for the space given to Him, and can only fit in by bending His head forward. This figure, which Michelangelo completed before taking a six-month break in 1510–11, seems outdated and stiff compared to the dynamic figures he created after the break.

The She-Devil
Michelangelo shows the serpent coiled around the tree. The serpent has a female head and torso. Like Bosch (see p.24), Michelangelo casts Woman in the role of a temptress – responsible for Man's downfall.

Fall and Expulsion
The Fall of Man is depicted by a new unified design with the temptation of Adam and Eve on the left, and their Expulsion from Eden on the right, one leading to the other. In the centre, the serpent with a human torso hands the apple to Eve. On the right, the Archangel Michael drives the anguished and cowering couple out of Paradise into a distinctly barren landscape.

Crucial *ignudi*
Nude youths sit at the edges of the panels, alert and beautiful, and reacting to the individual scenes. For example, none of them can bear to look at the Fall of Man. On the other hand, one looks back over his shoulder to steal a glance at the Creation of Adam. The exact purpose of these *ignudi* is uncertain, but they are a crucial element in the overall design, and are a superb example of the Renaissance belief in Man as the measure of all things. Michelangelo is clearly fascinated by the form, energy, and spirituality of humankind created in God's image.

Giant medallions
The *ignudi* use ribands to support giant bronze medallions. There are ten medallions in total, each depicting a scene from the Old Testament. The images on the medallions complement the scenes on the main panels.

Symbolic Acorns

The oak leaves and acorns held by one ignudo are a reference to the della Rovere family of Pope Julius II – the oak was taken from their coat of arms. References to oak trees recur throughout the ceiling: the Tree of the Knowledge of Good and Evil in The Fall of Man is an oak tree, and a wrist holding a cornucopia of acorns can be seen just touching Adam's right thigh.

Michelangelo; *The Sistine Chapel Ceiling* (detail); 1508–12; fresco; Sistine Chapel, Vatican

Michelangelo was aged 37 when he completed the Sistine Chapel ceiling. It is said that he had spent so long with his head turned upwards looking at the ceiling, that for a long time afterwards he could only see by keeping his head back in this position.

Sculpted Hands

Although Michelangelo agreed to paint the Sistine Chapel, he considered himself to be first and foremost a sculptor. Most of the figures on the ceiling are conceived as sculpture, and many of their poses are based on famous examples of Greek and Roman sculpture that Michelangelo had studied. These hands are a synthesis of his studies of the human form and are perfect examples of idealized Antique sculpture.

THE REBUILDING OF ST PETER'S

The Sistine Chapel ceiling was commissioned by Pope Julius II who was a member of the della Rovere family. He undertook the rebuilding and redecoration of St Peter's in Rome, commissioning the finest artists of the day. Like Michelangelo, Raphael (see p.32) was one of his "discoveries". Julius was strong willed, and their relationship was a stormy one. The Pope's plans for St Peter's were expensive, and his methods for financing his great project (involving much highly controversial secular activity) were dubious. Julius died in 1513.

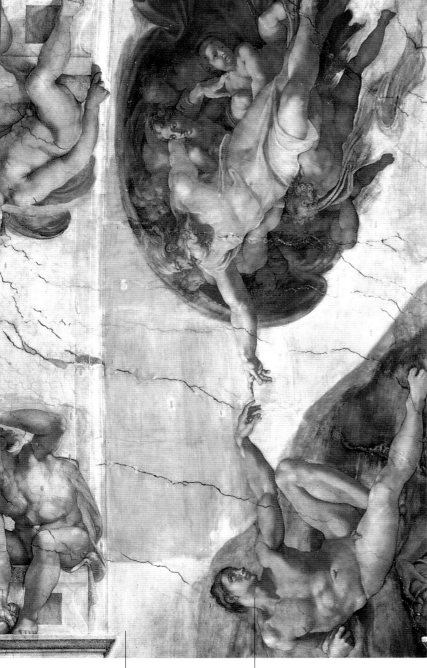

A new directness

Notice the simple background to this dramatic scene. This was probably the first panel that Michelangelo painted after a six-month break in 1510–11. With the scaffolding removed, the artist decided that the details he had been using were not having the effect he intended when seen from the floor. The later panels have a new directness and dynamism.

Michelangelo made around 300 preliminary drawings for the ceiling. These were then enlarged and made into "cartoons" that were the final designs to be transferred to the ceiling.

The Creation of Adam

The image of the Creation of Adam is one of the most famous in Western art – memorable, inspired, and with that rare originality that lifts art onto a new plane and indicates a new direction. God the Father, with a stern grey-bearded face that signals His absolute authority, is surrounded by His angels. He crosses the heavens like a cosmic meteor. Adam, physically perfect in face and limb (but as yet impotent), seems to receive from God's right finger a charge that is beginning to run through his body like electricity, giving him physical and spiritual life. He looks towards God with an expression that embraces many emotions, including wonder and obedience.

THE RESTORATION OF THE CEILING

The restoration of the ceiling, begun in 1980, took a team of renowned art restorers 12 years to complete, three times longer than Michelangelo took to paint it. The restoration has dramatically changed the former, rather dark, appearance, causing it to glow with bright colours. The accumulation of nearly five centuries of grime – which had obscured the surface – has been removed and we can now see the ceiling with all the brilliance that Michelangelo intended. However, the restoration was controversial: some experts claim that the process of removing dirt has also removed Michelangelo's finishing touches from the fresco's surface.

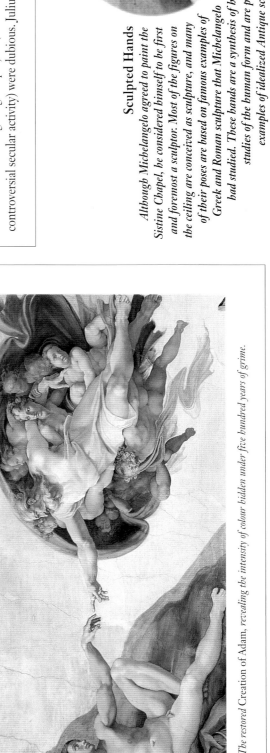

The restored Creation of Adam, revealing the intensity of colour hidden under five hundred years of grime.

THE SCHOOL OF ATHENS

RAPHAEL WAS THE POPE'S inspired and courageous choice of artist to decorate the room called the *Stanza della Segnatura* in the Vatican in Rome. The room was used as a library and the place where the Pope, Julius II (1443–1513), signed the decrees of the ecclesiastical court. There are four themes (one on each wall): philosophy, theology, poetry, and law. This work illustrates philosophy, and it is peopled with images of some of the greatest exponents of that discipline. Raphael was, at the time, a little-known artist, aged 25, with no significant experience of painting on a large scale, or of working in fresco. Next door, another great Papal commission was in progress – Michelangelo was painting the ceiling of the Sistine Chapel (see p.30).

Epicurus
The chubby figure with a crown of vine leaves is Epicurus (341–270BC), the Greek philosopher who taught that happiness lay in the pursuit of pleasures of the mind.

The god of reason
The figure in the niche on the left, holding a lyre, is Apollo, the god of the Sun, who represents harmony and sobriety. He also represents philosophical enlightenment and the civilizing power of reason (see p.50). The image is based on a sculpture by Michelangelo, *The Dying Slave*, which is now in the Louvre Museum, Paris.

Each group of figures is a model of statuesque harmony and continuous graceful movement. Thus the pose adopted by Plato pointing heavenwards could a few seconds later become that of Aristotle pointing downwards. In this way the figures are visually linked in a manner that gives them an extraordinary sense of harmony.

Alexander and Socrates
Alexander the Great (356–323BC), King of Macedonia and a pupil of Aristotle, listens attentively to Socrates (c.470–399BC). The Greek philosopher emphasizes individual points on his fingers. Questioning and analysis are at the heart of Socratic philosophy.

Plato and Aristotle
At the centre of the architectural setting are the two great philosophers of the classical world, Plato and Aristotle. Plato, representing abstract and theoretical philosophy, is pointing upwards. Aristotle is on the right, gesturing towards his immediate surroundings. He represents natural and empirical philosophy.

Raphael; *The School of Athens*; **1509–11; Base 772 cm (304 in); fresco; Stanza della Segnatura, Vatican**

Greek mathematician
Pythagoras (c.580–c.500BC), the renowned Greek mathematician, whose geometrical propositions are still taught in schools, demonstrates one of them to an enthralled group, one of whom holds a slate. Pythagoras also personifies arithmetic and music.

Michelangelo as Heraclitus
The lonely figure on the steps, added as an afterthought, is not included in preliminary drawings. Ostensibly, the figure represents Heraclitus (c.535–c.475BC), a melancholy philospher who regularly wept tears for human folly. The figure, wearing the clothes of a stonemason, is in fact a portrait of Michelangelo. Raphael, astounded by the power of the elder artist's work, included the portrait as a tribute.

Perspective and architecture

The perspectival arrangement allows for the fact that the painting is situated above head height (see the top of the door frame on the lower left). The architectural setting is imaginary, but its scale, magnificence, and harmony represent the ideals of the High Renaissance, which sought to express superhuman rather than human values. When this was painted, Julius II was planning the rebuilding of St Peter's with the architect Bramante. In 1514 Raphael was appointed Papal Architect on the death of Bramante. Raphael's design here, with the use of the sober Doric order, is a handsome acknowledgment of his admiration for Bramante's style and achievements.

> *"Raphael always succeeded in doing what others longed to do"*
> JOHANN WOLFGANG VON GOETHE

RAFFAELLO SANZIO (1483–1520)

Raphael was a child prodigy, born in the provincial city of Urbino in central Italy. In 1504, when he first arrived in Florence, he was only 21 years old, and yet he was quickly regarded as the equal of the other two giants of the High Renaissance: Michelangelo (see p.30), who was 29 years old at that time, and Leonardo (see p.26), who was then 52 years old. He was patronized by Pope Julius II and his successor Leo X, who appointed Raphael as Papal Architect in 1514. Tragically, the artist died of fever on 6 April (which is also the date of his birth) 1520, when he was just 37 years of age.

Raphael (self-portrait)

The goddess of wisdom

The goddess represented in the niche on the right is Minerva, who presides over peace and defensive war. The incarnation of wisdom, she is the traditional patroness of institutions devoted to the pursuit of knowledge and artistic achievement.

Ptolemy

The 2nd-century astronomer and geographer, Ptolemy, who thought the Earth was the centre of the universe, holds a terrestrial globe. Next to him, a figure holds a celestial globe. This is probably the Persian prophet Zoroaster (c.628–c.551BC).

All of Raphael's major works were the result of much detailed planning. Many hundreds of preliminary drawings were made from life to work out poses and expressions. Full-scale designs were then made for transfer to the wall where the fresco was to appear. Little or nothing was left to chance. Raphael was admired in his own day for his ability to include such a variety of poses and expressions in a single work.

Diogenes the dog

The scrawny figure who sprawls across the steps is Diogenes (c.412–c.323BC), a cynic, who hated worldly possessions and lived in a barrel – earning him his nickname "the dog". His stoicism was best illustrated when he ignored an invitation to the coronation of Alexander the Great . The new king paid a visit enquiring if there was anything he could do for the aging philosopher and was told, "You can stop blocking the sunlight".

Euclid

Euclid, a 3rd-century BC Greek mathemetician and a pupil of Socrates, expounds one of his geometric principles. The group around him suggests enthusiastic students who are on the verge of grasping a difficult concept.

Portrait of the artist

Raphael includes a portrait of himself. He is the young man by the side of Ptolemy, and he looks directly out of the picture, as if to capture our attention and be noticed. Many of the other figures are portraits of famous men of Raphael's day: Plato resembles Leonardo da Vinci, and Euclid looks like Bramante. It was a way of connecting the past and present, and of paying a tribute to the great men of his day.

THE ISENHEIM ALTARPIECE

Grunewald's altarpiece was commissioned as the focus of the high altar of the chapel in the Monastery of St Anthony, at Isenheim near Strasbourg. The monastery also contained a hospice where plague victims were cared for by the monks of the Anthonite Order. Plague was the recurrent killer disease of the time. The victims had no hope of recovery, and this image was intended to bring them comfort and to reinforce their faith – the message is that Christ, whose broken body is shown covered in sores like those caused by the plague, understands their condition and suffers with them and for them.

Tortured figure
In many Crucifixion scenes, the crown of thorns is depicted almost as an ornament adorning the head of a serene, unblemished Christ figure. Here, it is unequivocally a cruel instrument of torture, which intensifies the sense of suffering.

Crucifix
The wooden cross strains to bear the weight of Christ, adding to the emotional tension and anguish of the scene.

Stark background
The background of the painting is dark and threatening. Darkness has fallen onto the earth as described in the Gospels (Mark 15:33). Only those features that are essential to the spiritual message of the Crucifixion are included, illuminated by a strange light.

St John the Evangelist
St John was Christ's favourite disciple. He is usually portrayed at Crucifixion scenes, comforting Mary, the Mother of Christ.

Gothic scale
The size of the figures is intended to reflect their importance. Thus Christ is the largest, Mary Magdalene is the smallest. This device was no longer employed by the majority of artists – one of the reasons why this work is called the last great medieval altarpiece.

St Sebastian
The panel on the left depicts St Sebastian, who was invoked as a protector against the plague. Sebastian was a Roman soldier who was converted to Christianity. As punishment he was tied to a pillar and shot at with arrows. Having survived the ordeal, he confronted the Emperor with a renewed avowal of faith, and was put to death. Notice the sculptural style of the Sebastian figure, which is typically Italian. It shows that Grünewald was aware of the achievements of the Italian painters, but consciously chose his own personal and contrasting style for the central panel.

Anguish and grief
The figures on the left, Christ's Mother, Mary, and St John the Evangelist – whom Christ asked to take care of His Mother – display extreme mental anguish as they witness Christ's agony. The plague victims who knelt before this altar would have been able to associate with this vision of earthly and human suffering.

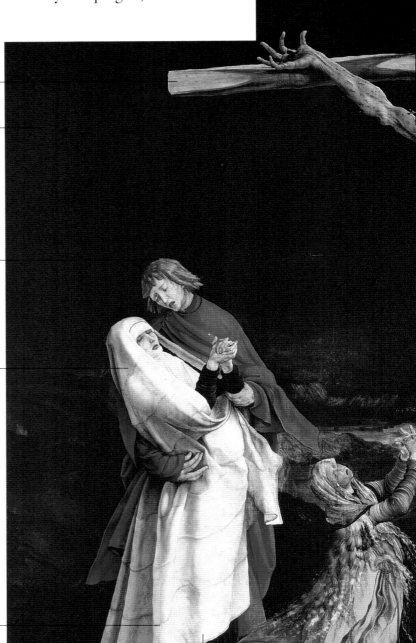

Mother of Christ
Mary, the Mother of Christ, is present in nearly all Crucifixion scenes. She is dressed in white, which is symbolic of innocence.

Mary Magdalene
Mary Magdalene is recognizable from the pot of ointment by her knees. She is the fallen woman who anointed Christ's feet.

MATHIS GOTHARDT (C.1470–1528)

Born Mathis Gothardt, Grünewald was the greatest exponent of the late Gothic tradition. He was successful both as an artist and engineer and was valued for his services at the court of the Archbishop of Mainz, in his native Germany. However, he was dismissed from Mainz because of his Protestant sympathies. He painted little in later life and died of the plague in 1528.

*Mathis Grünewald
(probable portrait)*

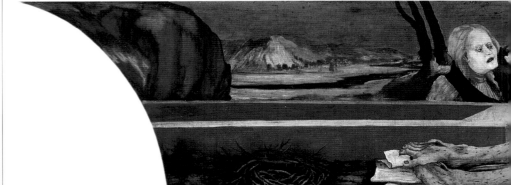

INRI

Iesus Nazarenus Rex Iudaeorum was the Latin inscription placed above the head of Christ. The plaque was meant to identify the crime of the person crucified. It read, "Jesus of Nazareth, King of the Jews", because no legitimate charge was found.

Expressive Hands
Christ's hands express His intense physical pain and spiritual reaching out. Note the expressive hand gestures of all the other figures.

ALTARPIECES

Altarpieces were often elaborate constructions containing many different scenes, which could be shown at the appropriate moment of the Church calendar. At the heart of *The Isenheim Altarpiece* is a carved wooden "shrine" featuring St Anthony. This is enclosed by a series of outer hinged doors, which can be arranged to show the Annunciation, Nativity, and Resurrection. These are very different in colouring and mood to the Crucifixion, which is the image on the outer doors. All altarpieces were created as the principal focus for devotion in places of spiritual worship, and the aesthetic experience of them in a gallery is arguably in direct conflict with this original purpose.

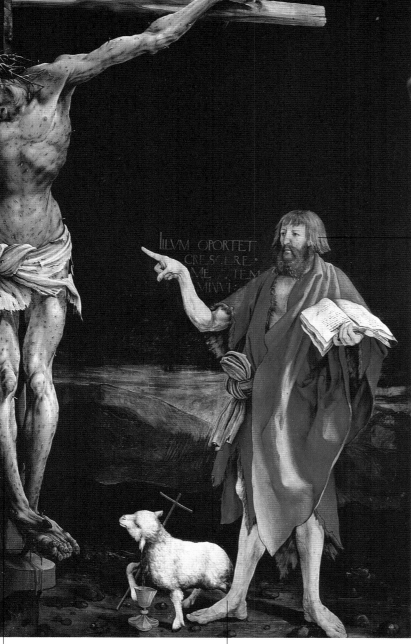

The Black Death
Behind St Anthony, a demon shatters the window and transmits the plague through his poisonous breath. Plague was pandemic in Grünewald's day.

Symbolic presence
The stoic figure of the Baptist dominates the right side of the painting. The Gospels tell us that John was beheaded by Herod long before the Crucifixion. His presence symbolizes the message of mankind's redemption. The words above his arm are "He must increase but I must diminish".

Body of Christ
Christ's agony is depicted by the broken feet, His skin pierced with splinters and His arms stretched as if wrenched from their sockets.

St John the Baptist
The Baptist holds a book that represents the scriptures, which were fulfilled with the sacrifice of Jesus – the "Lamb of God".

Lamb of God
The Lamb of God represents Christ and His sacrifice in shedding His blood for the salvation of mankind.

St Anthony
On the right is St Anthony. He was the patron saint of the religious order that ran the Isenheim hospice.

Predella panel
The panel set in the frame below the main panel of an altarpiece is called a predella panel. It supplements the principal message and adds interest by depicting additional events not referred to in the main panel.

The Lamentation
The scene depicted on this predella panel is the Lamentation. The body of Christ has been taken down from the cross and is being laid to rest in the tomb. The two Maries and St John the Evangelist are recognizable from the main panel. Note also the crown of thorns that has been removed and placed at Christ's feet.

"*And when the sixth hour was come, there was darkness over the whole land until the ninth hour*"
MARK 15:33

Mathis Grünewald; *The Isenheim Altarpiece;* **c.1510–15; 500 x 800 cm (198 x 312 in); oil on panel; Musée d'Unterlinden, Colmar, France**

BACCHUS AND ARIADNE

TITIAN'S PAINTING is one of a series of superb mythologies commissioned by Alfonso d'Este, the duke of Ferrara, in northern Italy. The pictures were commissioned to decorate an alabaster pleasure chamber at the duke's country house. In the painting we are shown the electrifying moment when Ariadne, daughter of King Minos of Crete, meets Bacchus, the god of wine, and they fall in love at first sight. Bacchus took Ariadne's crown and threw it into the sky where it became a constellation (top left). He later married her, and she was eventually granted immortality. Titian was famous for his ability to inject his pictures with moments of crackling psychological energy such as that which pervades this work. He was the Renaissance master of colour, and the rich, glowing brilliance of this painting reflects its passionate subject.

ORDERED CHAOS
Although the scene is crowded, Titian has worked out the composition with great care. Bacchus' right hand is at the centre of the painting where the diagonals intersect. The revellers are all confined to the bottom right. Bacchus and Ariadne occupy the upper left. Bacchus's feet are still with his companions, but his head and heart have joined Ariadne.

Colour links
The pink cloak of Bacchus and the red sash of Ariadne form a link, causing the eye to cross backwards and forwards between them.

Signature
Titian's name appears on an urn in Latin – "TICIANUS F[ecit]", or "Titian made this picture". He was one of the first painters to sign his work and was active in seeking to raise the social and intellectual status of painters.

Ariadne
Ariadne has been abandoned by her lover Theseus, whom she helped to escape from the Minotaur's labyrinth. She wandered alone on the shores of the Greek island of Naxos, where her life was suddenly transformed by love at first sight. The invisible line of tension across the blue sky, between her face and Bacchus, signals this dramatic moment.

Chariot
Bacchus' chariot was traditionally pulled by leopards, signifying his triumphant return from his conquest of India. Titian takes artistic licence by using cheetahs, which exchange glances in a knowing way, echoing the glance of the future lovers.

Cloudy sky
The cloud formation above Bacchus emphasizes his movement and restates the lines of his flowing cloak. Similarly, the clouds that billow above Ariadne echo her movement and swirling robes.

Titian; *Bacchus and Ariadne*; c.1522–23; 175 x 190 cm (69 x 75 in); oil on canvas; National Gallery, London

The God of Wine
Bacchus (Dionysus) is the Greek and Roman god of wine and the giver of ecstasy. He is always young and well fed, and recognizable by the laurel and vine leaves that he wears in his hair. His intense, passionate expression is one of the joys of this painting.

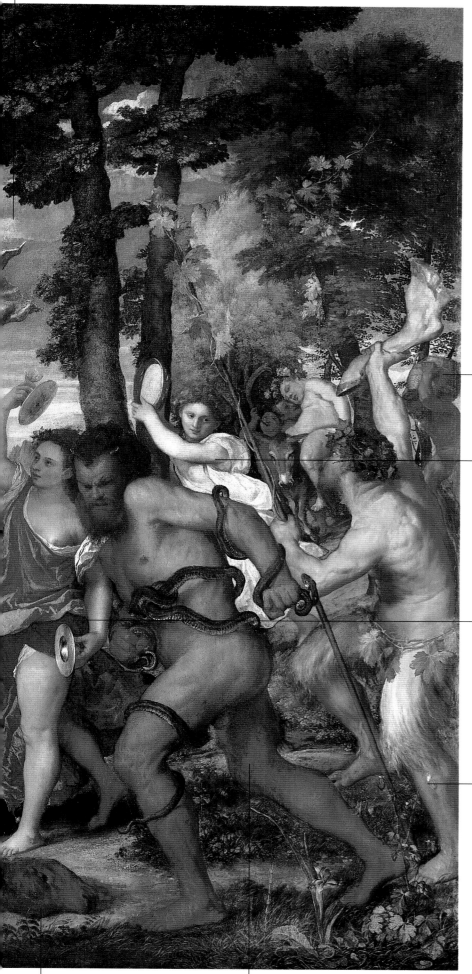

Wine bearer
The character who carries a huge cask of wine on his shoulders is like Atlas who was condemned to carry the world on his back.

Echoes
The longing glance that this maenad exchanges with the satyr contrasts with the intense expressions of the main characters. Like the great English playwright William Shakespeare (1564–1616), Titian often includes subplots for light relief or to reinforce the main theme of the work.

Musical maenads
A female camp follower, a maenad, crashes cymbals together in a pose that mirrors the posture of the astonished Ariadne. Other figures in the riotous procession are also playing instruments: one beats a tambourine, while another blows on a horn. The little dog in the foreground who barks at them is a delightful detail typical of Titian.

Ecstatic satyr
This drunken satyr, crowned and girdled with vine leaves, waves the leg of a calf above his head. In his left hand he carries a staff, entwined with the leaves of the vine.

❝*It is in Venice that the fine things are found… it is Titian who carries the day***❞**
DIEGO VELAZQUEZ

Silenus
The fat old man who rides a donkey is Silenus, chief of the satyrs and foster father to Bacchus. He is often depicted riding drunkenly on an ass.

Calf's head
The dismemberment of a calf, whose raw flesh was devoured by the frenzied revellers, was one of the more gruesome aspects of the Bacchic ritual. The head is pulled along by an infant satyr who looks out to invite our participation. The caper flower between his hooves is traditionally a symbol of love.

Laocoön
The muscular figure shown wrestling with the snakes is based on a celebrated antique Roman statue of the Trojan priest Laocoön (who was killed by sea serpents), which was unearthed in 1506. The statue's rediscovery caused a sensation, and many Renaissance artists, including Raphael (see p.32), incorporated cross-references to it in their work.

TIZIANO VECELLIO (C.1487–1576)

The greatest painter of the Venetian school, Titian was based in Venice for his entire life, inspired by the intense light and colour of the city's waterways. During his lifetime, Venice was one of the most powerful cities in Europe. With such patrons as the kings of France and Spain and the Pope, Titian was one of the most successful painters in history. The remarkably free style of his later years greatly influenced Velázquez (see p.56).

Titian (self-portrait)

THE AMBASSADORS

HOLBEIN SPECIALIZED in portraiture, a skill that could bring honours, wealth, and social status to an artist. The best portraiture was a subtle blend of realism and idealism (or flattery) that, with additional clues from objects and gestures, gave an insight into the personality and status of the sitter. *The Ambassadors* shows a masterly treatment of all these features. The two men are French courtiers, ambassadors from King Francis I (1494–1547) to the Court of King Henry VIII of England (1491–1547). The picture was painted in London where the ambassadors had a difficult mission to protect their country's interests, and to try to prevent the English making a break from the Church of Rome. These were deeply troubled times in Europe, and Holbein reveals far more than is apparent at first sight.

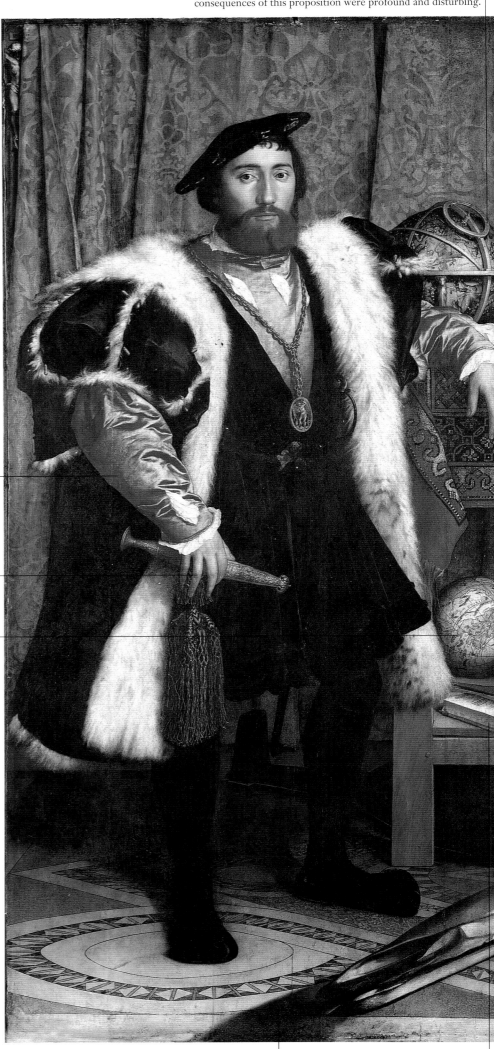

A celestial globe
The celestial globe may hint at Copernicus' revolutionary work establishing that it was the Sun, not the Earth, that was the centre of the solar system. The intellectual and ecclesiastical consequences of this proposition were profound and disturbing.

Jean de Dinteville
The ambassador on the left is Jean de Dinteville, who commissioned this painting of himself with his friend George de Selve, who visited England in 1533. Around his neck Dinteville wears a pendant of the Order of St Michael, one of the most coveted orders of chivalry, founded in France by Louis XI in 1469.

Inscribed dagger
Dinteville rests his right hand on a dagger, which is inscribed AET. SVAE 29, an abbreviated Latin inscription giving the age of the sitter as 29.

Terrestrial globe
The terrestrial globe has been positioned to show the countries that were important to Dinteville. Copied from an actual globe, Holbein has modified his reproduction to include such details as the name of Dinteville's chateau, *Polisy* (near Troyes).

Concealed Crucifix
Behind the green brocade curtain at the top left is a crucifix, suggesting the presence of Christ presiding over the destinies of the ambassadors, their intellectual pursuits, and their national interests. It is also there as a reminder of the inescapable fact of their sinfulness and mortality.

CRISES IN EUROPE

The crises alluded to in this picture were both political and intellectual. The authority of the Catholic Church was being challenged by the Protestants, and old intellectual certainties were undermined by scientific discoveries. Holbein refers to both, and places his ambassadors as leading thinkers in both crises. Easter Week 1533 was the moment England effectively broke away from the Catholic Church, and established the Church of England with their monarch, not the Pope, as its head. The immediate cause was the Pope's reluctance to grant Henry VIII a divorce from his first queen, Catherine of Aragon, so that he could marry Anne Boleyn, who he hoped was pregnant with the son and heir he was so desperate to produce. The ambassadors' specific mission failed, and the developing schism in the Church led to a fragmented Europe and years of conflict whose consequences persist today.

The shadow of death
The skull, which casts the shadow of death across the floor, was Dinteville's personal insignia (he has a silver skull in his cap). It was particularly relevant because Dinteville's health was extremely fragile.

Arithmetic book
The book held open by the set square is a new publication on applied arithmetic. It signals the breadth and modernity of the ambassadors' education and intellect.

Sundial
By Selve's left hand is a sundial showing the date 11 April 1533, a crucial point in the ambassadors' lives.

The Bishop Elect
Georges de Selve, who visited London in April 1533, was the Bishop Elect of Lavau, in France. His right arm rests on a book, on the edge of which is written AETATIS SVAE 25 ("His age is 25").

The Age of Discovery
Dinteville lived at the beginning of the Age of Discovery. The perfection of scientific instruments, such as those on the table-top, made the circumnavigation of the globe and the discovery of new continents possible. In 1492, just over 40 years before this picture was painted, Columbus had discovered America.

HANS HOLBEIN THE YOUNGER (C.1497–1543)

Holbein began his training with his father, Hans Holbein the Elder (c.1465–1524), in the town of Augsburg in his native Germany. By 1515 he had moved to Basel and became the town's leading painter, undertaking major commissions as well as designing for printers until 1526. The crises caused by the Reformation led to Holbein's first visit to England in 1526. He left his family and moved to England permanently in 1532, where he was employed regularly at the English Royal Court.

Hans Holbein (self-portrait)

"He is not a poet, but a historian, for whom the lives of men contain no fairy tales and no secrets**"**
HERMAN GRIMM

Lute with a broken string
The lute, a traditional symbol of harmony, has a broken string suggesting the growing discord between Catholics and Protestants that was to lead to bitter warfare.

Hymns for Unity
By the lute is a book of latin hymns, translated into German by Martin Luther, open at the page showing Come, Holy Ghost *and* The Ten Commandments. *It has been suggested that the choice of hymns, both of which express doctrines acceptable to all Christians, is a plea by Holbein for reform of the Church as demanded by the Protestants, but without a division from the Church of Rome.*

Mosaic pattern
The mosaic pattern of the floor is an accurate copy of the design of the floor of the Sanctuary of Westminster Abbey. It must have made a strong impression on the great German artist during his time in England.

The picture shows Holbein's firm grasp of the principles and philosophies of Italian and Northern European art. From Italian art comes his perfection of perspective, and the confident and lifelike figures. From Northern art comes the attention to detail, the immaculate oil painting technique, and the love of textures such as fur and brocade.

Distorted death's-head
The strange shape at the foot of the table is meaningless if viewed from the front. But if the picture is approached from the side and viewed from about 2 metres (6½ feet) to the right, at eyelevel with the ambassadors, the shape becomes a skull. The artist has used anamorphosis, an extreme form of perspective. It is a technique first described in Leonardo's notebooks.

Hans Holbein the Younger;
The Ambassadors; 1533; 207 x 210 cm **(81½ x 82 in); oil on oak panel; National Gallery, London**

NETHERLANDISH PROVERBS

PROVERBS WERE AN IMPORTANT means of expression in Bruegel's day, and were often expressed visually. There were many prints of similar subjects, which were cheap and easy to circulate. A favourite Bible reading of the day was the Old Testament Book of Ecclesiastes, containing the quotation "the number of fools is infinite". Bruegel set out to entertain and instruct with this painting. He succeeded admirably, and created a window on the world in both a visual and a moral sense. Bruegel's work has lasted through time because each succeeding generation has a sense that he is addressing the issues and realities of their time as well as those of his own day.

> "*To the optimist life is a comedy;
> to the pessimist life is a tragedy*"
> VOLTAIRE

Ever the optimist
By aiming arrows at the "pie in the sky" target, this archer is being over-optimistic. Another eternal optimist is the man (to the right of the archer) who "fiddles in the pillory" – the pillory was a wooden cage where rogues were placed on view to all as a humiliating form of punishment.

Living under the brush
This couple are living together out of wedlock, a state of sin which was commonly referred to as "living under the brush".

Cheating at cards
A rogue sporting a colourful hat with a white bobble is cheating at cards. His attitude to the world is graphically portrayed as he defecates on the globe below the window. Inside the tavern two fools "lead each other by the nose": the ignorant trying to instruct the ignorant.

Armed to the Teeth
"Belling the cat" was the dangerous task undertaken by an intrepid mouse in a Dutch fairy tale. This man is being overcautious; he is literally "armed to the teeth" to protect himself from the wrath of a docile old cat.

Cooking herrings
This fool wastes time by "cooking herrings for the sake of roe". Next to him another old fool literally "falls between two stools", in a vain attempt to sit on both.

Fire and water
The woman carries fire in one hand and water in the other – she cannot form an opinion. Next to her the pig removing the spigot represents overindulgence and greed.

Hypocrite
The pillar represents the Church. The man who both embraces and bites the pillar is a hypocrite. He keeps his vice a secret, "under his hat", which he places on top of the pillar.

House devil
A woman binds a devil to a cushion. She represents a shrewish and nagging wife. Bruegel devoted a picture to this subject known as *Dulle Griet* (Mad Meg). Proverbs of the day stated that such a woman could visit Hell without harm.

Banging his head against a brick wall
Many characters, such as this fool banging his head against a brick wall, are indulging in futile labours. Similar acts of stupidity appear elsewhere. In the river, a fool "fishes behind the net" while another "swims against the tide", and in the bottom right of the painting a man tries to "outyawn a stove".

Shearing the pig
"Much ado and little wool, said the fool, and shore the pig." Behind him two women spread evil gossip.

Too little, too late
Filling in the pond after the calf drowns is taking precautions to prevent a disaster that has already occurred.

Fools
This motley group, led by the man who opens the door with his bottom, does not know whether it is coming or going. One fool goes from bad to worse by falling "from an ox to an ass".

The blind leading the blind
A procession of blind men is doubtlessly completely lost and dangerously close to the edge of a cliff. Stupid people have a tendency to follow others who are equally stupid.

Opportunity knocks
The opportunist warms himself before a burning house, turning disaster to advantage. Another opportunist sits on top of the tower, "hanging his cloak according to the wind".

Pieter Bruegel; *Netherlandish Proverbs*; 1559; 117 x 163 cm (46 x 64 in); oil on panel; Staatliche Museen, Berlin

PIETER BRUEGEL THE ELDER (C.1525–69)

Bruegel was the greatest Netherlandish painter of the 16th century. There is little documentary evidence concerning his career but, far from being the yokel of popular tradition, "Peasant Bruegel" seems to have been a man of some culture. Enjoying a considerable reputation in his lifetime, his influence, through his original work or the prints after them, is incalculable in later Flemish painting.

Pieter Bruegel (self-portrait)

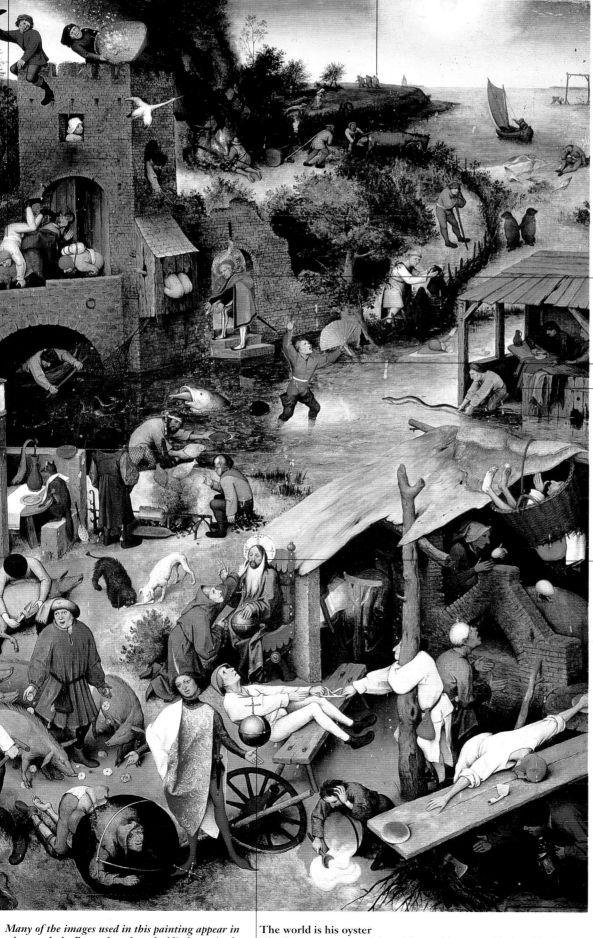

"Minnows and Sharks"
The depiction of the big fish eating the little fish is an image that is universally recognizable: the small and weak are so often victims of the big and strong.

Waste not, want not
This man is throwing his money "down the drain". Other images of waste include the man in the foreground who casts roses before swine. Note his astonishment when they show no appreciation.

A mean spirit
This mean-spirited man resents even the sun shining on the water; he attempts to block the light with a large fan. Above him, a monk "throws his cowl over the fence", rejecting his holy vows. He symbolizes anyone who gives up (the modern equivalent is to "throw in the towel").

Catching an eel
"An eel caught by the tail is only half caught." Like the man "counting his chickens" under the wooden canopy on the left side of the picture, this character would be wise to await the final outcome before celebrating his prize.

The height of folly
Whereas most of the images represent simple human folly, some depict more blatantly sinful acts. This wicked monk mocks Christ by attaching a flaxen beard to his face. Under the portico, in the centre of the painting, one man lights a candle to a devil while another confesses to Satan.

Many of the images used in this painting appear in other works by Bruegel, such as the blind men in the far distance, the big fish swallowing the little fish, and the man in the crystal globe in the foreground.

The world is his oyster
This figure represents wisdom: "the world turns on his thumb"; that is, he has the world "at his feet" or "in the palm of his hand". He gestures sadly towards the man lost in the upturned globe, who represents folly.

The Cloak of Deceit
An adulterous wife places a blue cloak on her husband whom she has deceived. The hood of the cloak restricts his vision, and the wife is pushing it well down over his eyes. Blue is the symbolic colour for deceit.

THE BURIAL OF COUNT ORGAZ

E L GRECO IS AN ENIGMATIC ARTIST about whom we know surprisingly little. This curious masterpiece is a huge picture, painted in 1586 to commemorate the burial of Count Orgaz, who had died 250 years earlier. It is said that as the Count was laid to rest a miracle occurred: two saints descended from Heaven and placed his body in the tomb. The painting was commissioned by the church of Santo Tomé in Toledo, which was then the capital city of Spain and the headquarters of the Spanish Church. It still hangs there today, in a side chapel above the Count's grave. Highly esteemed in his own lifetime, El Greco was subsequently dismissed as technically inept and mentally unstable until "rediscovered" in the 20th century by avant-garde artists such as Picasso (see p.98).

The Soul of Count Orgaz
A golden-haired angel bears the Count's soul, which is shown as the phantom-like figure of a child. The Virgin Mary and St John plead on his behalf to Christ, who sits in Judgment.

King Philip II
Seated among the company of Heaven is King Philip II of Spain. Philip's vision was to create a united Catholic Europe under Spanish leadership. But it was an unrealized ambition. Two years prior to the commission of this painting he had sent his Armada on its disastrous expedition against the Protestant Queen Elizabeth I of England.

St John the Baptist
At Christ's left hand is the near-naked figure of St John who gestures eloquently towards Christ. The Baptist's translucent flesh seems formed of the same stuff as the clouds.

Crucifix
The crucifix connects the events taking place on Earth below with the rapturous scenes above. It reminds us of the Resurrection of Christ, which makes the salvation of the dead Count possible.

Keys of the Kingdom
St Peter holds the keys to the Kingdom of Heaven, whose gates he has opened to receive the soul of the charitable Count Orgaz.

The Virgin Mother
Mary sits at the right hand of a radiant Christ figure. She reaches down to receive the Count's soul.

The contrast between the intense and vibrant motion of the upper, celestial, portion of the painting and the solemn and static lower, earthly, portion is a typical feature of El Greco's work.

Musicians
Divine musicians sit among the opalescent clouds. Notice the strange shapes of El Greco's clouds. They are very typical of the artist's mature style.

Angel
A dynamic angel swirls heavenward on wings that are remarkably realistic and must have been modelled on the actual wings of a bird.

A frieze of faces
One of the most remarkable features of this painting is the array of portraits that divides the earthly scene of the burial from the heavenly scene above. Many of the most illustrious Spaniards of the day appear among them, making the impact of the painting very immediate to the parishioners at Santo Tomé.

Andres Núñez
The priest in the diaphanous surplice is thought to be Andres Núñez, the parish priest of Santo Tomé who commissioned the painting. He won a law suit against the descendants of Count Orgaz who refused to pay money bequeathed to the Church. This work was commissioned as a celebration of his legal victory.

El Greco; *The Burial of Count Orgaz*; 1586; 460 x 360 cm (181 x 142 in); oil on canvas; Church of Santo Tomé, Toledo

El Greco (self-portrait)

DOMENIKOS THEOTOCOPOULOS (1541–1614)

El Greco (the Greek) was born at Phodele in Crete but worked for most of his life mainly in the Spanish town of Toledo and is regarded as a Spanish painter. Principally, he painted religious subjects but also excelled at portraiture. Little is known of his early life, but it is known that he studied in Venice for a period prior to 1570, when he travelled to Rome. In 1577 he moved to Toledo. His style matured, and he spent the rest of his life there, working as a painter, sculptor, and architect. His immediate influence was slight, but interest in his work was revived in the late 19th century.

St Augustine
St Augustine (354–430AD) wears fine robes decorated with images of the saints. He is recognizable by his bishop's mitre; he was a man of religious fervour and the Church's great early theologian.

Resting place
Count Orgaz paid for the rebuilding of the church at Santo Tomé and was buried in one of its chapels upon his death in 1323.

The martyrdom of St Stephen
St Stephen was the first Christian martyr. On his glorious golden robe is a panel showing a detailed image of his martyrdom. He was stoned to death by an angry mob.

" El Greco was as odd in everything as he was in painting "
FRANCESCO PACHECO

THE COUNTER-REFORMATION

Throughout the 16th century, Spain was caught up in the intense missionary zeal of the Counter-Reformation. The Catholic Church sought to reimpose its authority, which had been undermined by the Protestant reformers in the North of Europe. The Spanish Inquisition, controlled by the Spanish monarchy, tortured and burned alive many who were suspected of breaking faith with the Catholic Church. El Greco was an ardent Catholic, although his beliefs were of an intense and personal nature, rather than conforming to the conventional outward show that was approved by the Counter-Reformation.

El Greco
It is suggested that the figure gazing out of the painting is the artist, who includes himself among the bystanders.

Reflecting monk
Notice how the monk on the left mirrors the pose of the priest who is reading from the Bible on the opposite side.

St Stephen
The figure supporting the Count's feet is St Stephen (died 35AD). He is portrayed with the saint's traditional gentle and youthful features and wears the dress of a deacon (he was one of the first deacons appointed by the Apostles).

The artist's son
The child in the foreground is the only other person looking out of the painting apart from the presumed portrait of El Greco himself. He is the artist's son, Jorge. His birth date, 1578, appears on the hand-kerchief that protrudes from his pocket.

The Count's Armour
Toledo was noted for its craftsmanship in arms and armour, and Count Orgaz wears a magnificent suit of armour of the type produced in El Greco's day. The detailed realism of the earthly figures contrasts with the distorted forms and acid colours of the heavenly figures.

THE SUPPER AT EMMAUS

CARAVAGGIO'S STRIKING PICTURE tells a dramatic story. Christ had been crucified but had risen from the dead. Two of his disciples, still shocked by recent events, were walking to the village of Emmaus when they were joined by a stranger. At Emmaus they stopped at an inn and sat down to a meal. Before eating, the stranger blessed the bread. At that moment the disciples realized who the stranger was: it was Christ, and He was blessing the bread as He had done at the Last Supper. This is the dramatic moment that Caravaggio portrays in his picture, which, underneath its realism, is rich in symbolic meaning.

Outside the drama
The innkeeper cannot share in the drama of the moment since he does not know who Christ is and does not know the significance of the blessing of the bread. He can be taken to represent those who do not recognize the Church. His calmness adds to the drama of the moment by contrasting with the agitation of the two disciples. Visually he runs the eye back to the centre of the picture, to draw attention to the face and gesture of Christ.

Blessing the Bread
The bread and wine on the table are the symbols of Christ's body and blood in the Christian Sacrament. It is through the Eucharist that the faithful are united with Christ in body and spirit. This is one of the meanings that underly the picture.

Caravaggio was celebrated for his theatrical use of lighting, and he illuminates the scene as though manipulating a series of spotlights. This creates an overall pattern of bright pools of light and deep, dark shadows. This dramatic organization of light is termed **chiaroscuro** *(from the Italian* **chiaro**, *light, plus* **oscuro**, *dark).*

A brilliant highlight
Caravaggio has intentionally allowed the light-coloured shirt to show through a hole in the disciple's sleeve so that it creates a brilliant highlight that seems to project out of the picture.

Disciple of Jesus
This character is Cleopas, the disciple of Jesus whose name is mentioned in the Bible story (Luke 24:18). He draws back his chair in astonishment at the revelation of the identity of the stranger. His half-hidden face is a brilliantly calculated theatrical touch.

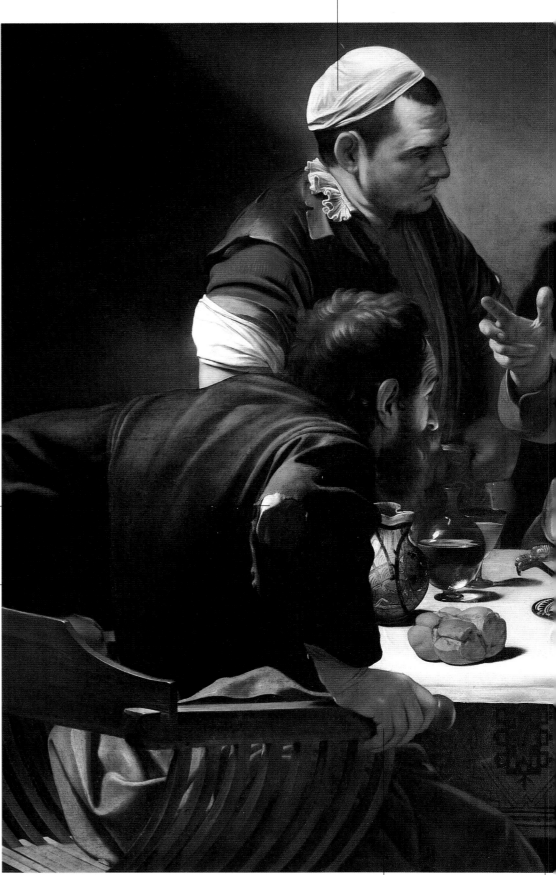

MICHELANGELO MERISI DA CARAVAGGIO (1571–1610)

Caravaggio was named after the town of his birth, near Milan. His style was developing rapidly when he settled in Rome in 1592, but he was forced to flee after a succession of scandals. Inspired by works of the Renaissance masters Leonardo (see p.26) and Michelangelo (see p.30), Caravaggio heralds the dawn of the Baroque, which was the dominant style of the 17th century (see p.46).

Caravaggio

Rough peasant hands
Christ's disciples were fishermen and workmen, and Caravaggio has given them the appropriately strong, rough hands. The artist was frequently criticized for using peasants as models for saints. The strongest criticism came from the peasants themselves, who demanded idealized imagery.

A place at the table
The near side of the table remains open, inviting the spectator to participate in this dramatic event.

CARAVAGGIO'S REALISM

The power of Caravaggio's painting comes from his remarkable ability to combine realism, distortion, and symbolism into a unified image. At first sight he seems to have portrayed events much as they might have occurred in real life. Christ, in His early thirties (the age when He was crucified), is unidealized, and the disciples, who look like real fishermen, react appropriately to what they see. Yet the more one studies the picture, the more the artificiality – the distortions and strategic symbolism – become apparent. Realism alone seldom produces satisfying or convincing art.

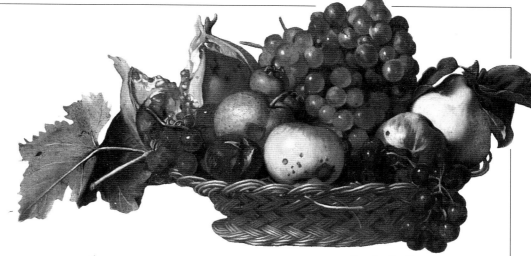

Symbolic Fruit
The blemished apples and cracking figs in the basket of fruit refer to Man's original sin. The pomegranate is symbolic of Christ's triumph over sin through the Resurrection.

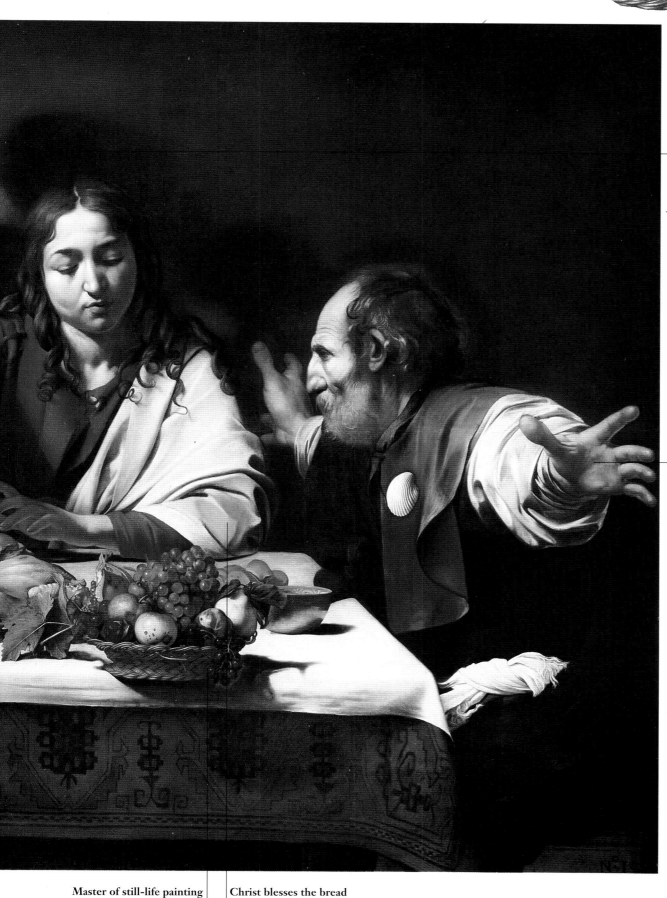

Shadow
The shadow over Christ's head is suggestive of a halo, but not the conventional round gold disc. It also suggests the dark events of Christ's betrayal and crucifixion.

> *"Caravaggio's style is the total destruction of the most noble and skilled art of painting"*
> FRANCESCO ALBANI

This was to be the last time that Caravaggio included a still-life group in his painting. His renegade existence after 1606, when he killed a man in a brawl, necessitated a much more economical style.

Foreshortened arm and hand
Caravaggio was renowned for his mastery of foreshortening, which is the illusion that an object or limb projects straight out of the flat canvas. There are several examples of foreshortening in this painting.

Caravaggio; *The Supper at Emmaus*; 1601; 141 x 196 cm (55½ x 77 in); oil on canvas; National Gallery, London

Cockleshell
The shell on the tunic of the man on the right indicates he is a pilgrim. He is probably St Peter, who was the first disciple to see Christ after his Resurrection.

Master of still-life painting
Caravaggio was a master of still-life painting (see p.52), as can be witnessed by the artist's portrayal of the objects on the table. Placing the basket so precariously on the edge of the table is a bravura example of foreshortening.

Christ blesses the bread
Christ is depicted in the centre of the painting, presiding over the meal. He raises His right hand to bless the bread, a gesture that is re-enacted by the priest in the Christian Communion service. The half-length figure, with a radiant and youthful Semitic face without a beard, was highly novel and was, for many, a shocking and unacceptable portrayal of Christ.

SAMSON AND DELILAH

RUBENS WAS ONLY 31 years old when he painted this magnificent work, which resonates with the enthusiastic and energetic talent that brought him honours and riches. The picture tells the Old Testament story (Judges 16) of the downfall of Samson, the superhuman Israelite warrior who was the scourge of the Philistines. Samson's ruin was caused by his lust for the Philistine Delilah, who beguiled him into revealing the secret source of his strength – his uncut hair. The artist depicts the tense moment when the first lock is cut and the soldiers prepare to gouge out the Israelite's eyes. When his hair grew back, Samson used his returned strength to destroy the Philistines' temple, sacrificing his own life while taking his revenge.

The old woman
Rubens has introduced an old woman, who is not mentioned in the Bible, to act as a counterfoil – her ugliness and treacherous intensity heighten the younger woman's beauty and suggest that she may be youthfully ignorant of the fate she is bringing upon her lover.

Delilah the Philistine
Cheeks flushed with physical pleasure, Delilah reclines languidly. The tilt of her head echoes the statue of Venus above. Her smooth, fresh skin presents a striking contrast to that of the old woman.

Delicate Hands
The intricate and intertwined hands holding the scissors are a brilliant visual metaphor for the deceitful and elaborate plot to cause Samson's downfall. The barber performs his task with the concentration and ingenuity of a surgeon or a skilled diplomat.

THE BAROQUE

The Baroque style dominated the arts in the 17th century. Rubens was one of its finest exponents. The Baroque favoured dramatic and intense subjects, rich textures, and exaggerated lighting. It sought to convince, not through reason, but by illusion, and by overwhelming the senses and emotions. It was the favoured style of the Catholic Church and monarchs such as Louis XIV of France (1638–1715). All of them used art to create an image of divinely authorized, absolute power. Rubens was a devout Catholic, and he believed in "the divine right of kings" – the view that kings are answerable to nobody except God.

Venus
The statue in the niche is of Venus and Cupid. Its presence complements the erotic interpretation of the scene.

Peter Paul Rubens; *Samson and Delilah*; c.1609; 185 x 205 cm (73 x 80½ in); oil on wood; **National Gallery, London**

Hand gesture
Each of the main characters has specific hand gestures that reveal their physical and mental state.

Samson's pose
The sweep of Samson's back leads the eye up to the climax of faces of the leading characters.

Rubens's **chiaroscuro** *treatment of light was strongly influenced by the Italian artist Caravaggio (see p.44).*

" *The fellow mixes blood with his colours* **"**
GUIDO RENI

Philistines
Their faces ominously illuminated from below by a flaming torch, Philistine soldiers enter stealthily through the doorway. They are carrying the sharpened stakes that they will use to put out Samson's eyes.

PETER PAUL RUBENS (1577–1640)

Cultured and charismatic, Rubens was the most influential artist of the Baroque era. A Flemish artist, he lived in Italy from 1600–08. In 1609 he was appointed court painter to the archduke Albert of Austria, who gave him many artistic and diplomatic commissions. In 1629, he was knighted by Charles I of England. More than any other artist, he bridged the gap between Northern and Southern Europe.

Peter Paul Rubens (self-portrait)

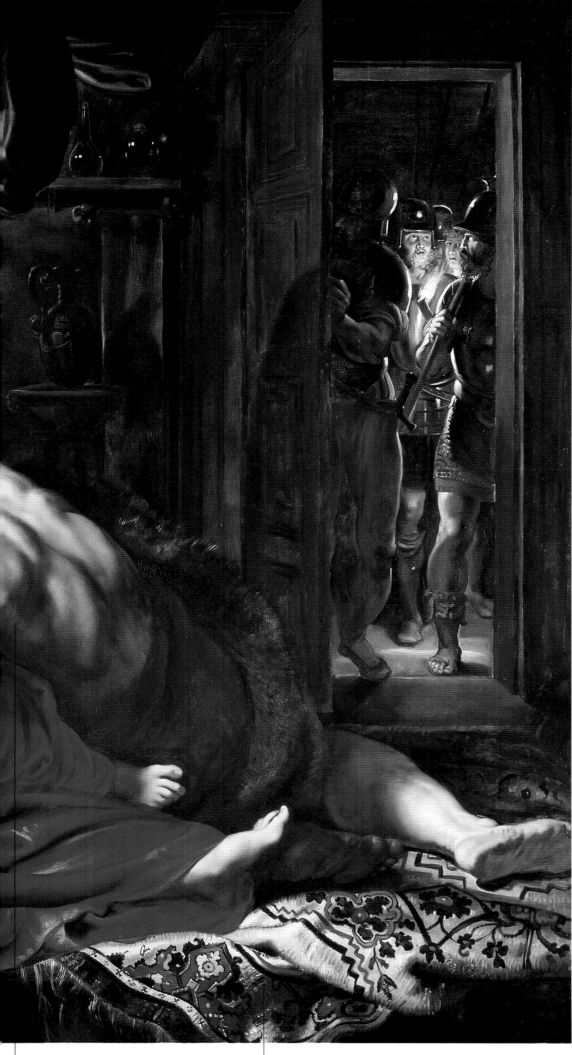

Blood Red
The dominant colour in the lower left section of the painting is a rich and vibrant red, set off against warm browns and gold and Rubens's marvellously translucent flesh tones. Red symbolizes the passion that preceded this scene; as the colour of blood it also suggests the macabre action that will follow.

Michelangelo's influence
Samson's enormous muscular frame was inspired by the work of Michelangelo (see p.30), which Rubens studied in Italy.

Luxuriant textures
The picture is strewn with rich materials and colours – silks, satins, and embroidery in vibrant reds and golds. A technical *tour de force*, they also set the stage for the sensual treatment of the subject.

BELSHAZZAR'S FEAST

REMBRANDT HAS ALWAYS BEEN an elusive, and at times controversial, artist. Although he was initially very successful, his style developed away from the mainstream of Dutch art, and he suffered many personal tragedies. Neither his later work nor his lifestyle met with approval. Today there is controversy over the number of works that are thought genuinely to be by him. This is an early, rather awkward work, which tells the story of Belshazzar, King of Babylon. At the climax of a feast, where the King drank to heathen gods, a mysterious hand inscribed a message on the palace wall, predicting the fate of Belshazzar (Daniel 5).

Chiaroscuro
Rembrandt's work is noted for its dramatic *chiaroscuro*. The King's face theatrically lit against a dark background is typical of the artist.

Elusive Texture
Fascinated by textures, Rembrandt was the supreme master of painting the most elusive texture of all, the skin of the human face, especially that of old people. Particularly difficult to render is the soft area under and around the eyes, which varies in each individual – only Rembrandt has truly succeeded in capturing this quality.

Belshazzar's reaction
Terrified by the visitation, Belshazzar has upturned a chalice of wine. "The King's countenance was changed, and the joints of his loins were loosed, and his knees smote against one another" (Daniel 5:6).

AUTHENTICITY

Like many of the successful old master painters, Rembrandt established an extremely successful workshop, and he had a great many apprentices working for him and imitating his style. Hence the difficulty in deciding which paintings have been completed entirely by the master's hand, which of them are the work of his most talented pupils, and which of them are joint efforts. At the beginning of the 20th century, experts attributed nearly a thousand paintings to Rembrandt. Nowadays, the official view of the Rembrandt Commission is that he painted less than 300.

A fascination with physiognomy
The startled guests recoil in astonishment; their expressions reflect the King's horror. Rembrandt was fascinated by physiognomy – the way the face reveals inner states of mind.

Rembrandt's collection
The gold and silver plate are good examples of contemporary Dutch craftsmanship. Rembrandt owned an extensive collection of works of art and objects – suits of armour, helmets, rich robes, silver cups, and much more – which he frequently employed as props in his paintings.

Two major influences on Rembrandt are detectable from this work. From Caravaggio (see p.44) he has adopted the preoccupation with chiaroscuro and foreshortening. From Rubens, Rembrandt inherits an interest in dramatic biblical subjects and the expressive possibilities of hands. But Rembrandt never succeeded in expressing movement and the fleeting moment convincingly. He is at his best when he develops his own subjective style and when – as in his self-portraits – he expresses stillness and contemplation.

Jehovah's judgment

Rembrandt took great pains to have an authentic inscription, and consulted a Jewish scholar, Samuel Menassah ben Israel, on the subject. The scholar advised that the inscription was probably written vertically and from left to right to confound the Babylonian wise men (Hebrew scripture is usually written horizontally from right to left). The wise men failed to interpret the message despite the King's offer of a "chain of gold".

The Writing on the Wall

The Hebrew script on the wall says Mene, Mene, Tekel, Upharsin. It is interpreted as Mene, "God has numbered the days of your kingdom and brought it to an end"; Tekel, "You have been weighed in the balance and found wanting"; Upharsin, "Your kingdom is to be given to the Medes and Persians." Belshazzar was killed on the night when the writing appeared, and Darius the Mede took over the kingdom.

Although somewhat overambitious, this work still displays most of the key characteristics of this great artist – a rich earthy palette, thick paint, and a fascination with the emotions that are expressed through the human face.

Ring of hands

Note the circular movement described by the hands – including that of God's messenger – around the canvas. The hands emphasize Rembrandt's interest in gestures and conduct the eye on an orbital journey around the main actor, King Belshazzar.

Foreshortening

Rembrandt has attempted a dramatic foreshortening, but the woman seems to be squashed against an invisible windowpane, rather than to project convincingly out of the picture.

Spilled wine

Rembrandt has attempted to capture the split-second moment of the spilled wine, which soaks into the sleeve of the woman, but, like the foreshortening, it is overambitious and not convincing.

Impasto

The paint on the robes is extremely thick and is very similar to the actual textures of the rich material and the jewels. Paint applied thickly like this is called "impasto". The brocade is built up on a layer of umber that is allowed to show through in places.

Rembrandt did not make preliminary drawings but worked directly onto canvases primed with a mid-brown. The paint in the shadows is often quite thin, whereas highlights are built up with the thickest paint.

Rembrandt van Rijn; *Belshazzar's Feast*; **c.1636; 168 x 209 cm (66 x 82 in); oil on canvas; National Gallery, London**

❝*It is said that Rembrandt once painted a picture in which the colours were so heavily loaded that you could lift it from the floor by the nose* ❞
ARNOLD HOUBRAKEN

REMBRANDT VAN RIJN (1606–69)

The greatest artist of the Dutch school, Rembrandt was a master of all genres, though he preferred "history" paintings. He is best remembered for his self-portraits, which present a unique record of the artist's development. He was the first major artist to work for the open market rather than specific patrons. His etchings and drawings fetched high prices throughout Europe. However, his wife's death in 1642 and subsequent poor management brought him financial problems in his later years.

Rembrandt van Rijn (self-portrait)

A DANCE TO THE MUSIC OF TIME

POUSSIN'S SMALL, EXQUISITE PAINTING was commissioned by Cardinal Giulio Rospigliosi (1600–69), who was to become Pope Clement IX. A philosopher and a playwright, he was the type of collector who admired Poussin's work. The painting introduces an intellectual message or puzzle and is a miniature treatise about time and the fate and condition of mankind, appealing to reason rather than the emotions. The four dancers are allegorical figures: Wealth, Pleasure, Industry, and Poverty. We are invited to discuss their significance and meaning against a background of other symbols. Poussin set a standard of academic content and technical skill that many subsequent French painters, such as David (see p.70) and even Cézanne (see p.96), strove to emulate.

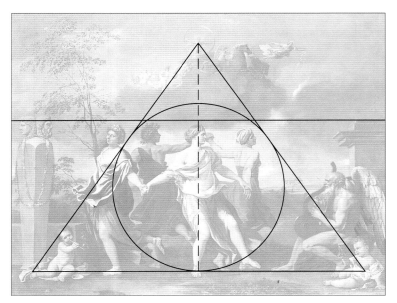

GEOMETRIC COMPOSITION

This painting is a masterpiece of precise and calculated composition and technique. Underlying all Poussin's paintings there is a complex, yet entirely rational and carefully worked-out, geometrical structure. One of the pleasures in looking at his work is discovering this hidden geometry. In this case, the circular motion of the dance is placed within a triangle.

Permanence and transience
The painting is full of contrasting images of the enduring and the ephemeral; for example, the enduring stone bust of Janus is decorated with ephemeral flowers.

❝ *Painting is the lover of beauty, and queen of the arts* **❞**
NICOLAS POUSSIN

The two-faced god
The two-headed figure on the stone pillar is the Roman god Janus, who could look two ways at the same time. The young face looks to the future; the old face looks to the past. The Romans called on Janus to bless the start of any new enterprise, or a new cycle such as a new month. January, the first month of the year, is named after this two-headed god.

NICOLAS POUSSIN (1594–1665)

Nicolas Poussin (self-portrait)

Poussin's intense interest in the classical ideals of clarity and intellectual precision was very much against the spirit of his age, and he had little success in his native France. He built his career in Rome, where he made exact studies of Roman reliefs. A great admirer of the Venetians, Poussin's colourful early works show the influence of this school.

Pleasure
The dancer wearing elegant sandals and a garland of roses in her hair catches our eye as if inviting us to join the dance. This figure represents luxury, hedonism, and idleness.

Homo bulla
The bubbles refer to the concept of *homo bulla*, man the bubble, and so symbolize life's brevity. Like a bubble, human life lasts for just a brief moment and then disappears, leaving no more than a memory.

Industry
The male dancer wears a crown of laurel, which is an evergreen symbol of virtue and victory. He represents industry and fixes his eye on the figure of Wealth.

Apollo's retinue

The maidens who follow the chariot are the Hours, the attendants of the sun god. They are the goddesses of the seasons, and they too dance an eternal round that parallels the dance depicted in the foreground of the painting. Aurora, sister of Apollo, goddess of the dawn, leads the way for his chariot. She opens the gates of morning and rolls back the dark clouds of night. "Rosy fingered", she scatters flowers as she goes.

The Sun God

The circle held by the sun god, Apollo, represents eternity. Apollo represents order and civilized behaviour, whereas Bacchus (see p.36) represents the irrational and emotional side of human nature.

The distant tree

The delicate tree on the right reflects the more prominent one on the left. Both contrast with the bare, stone plinths.

Holding Hands

The relationship between Poverty and Wealth is deliberately tantalizing. We do not know if the two will ever hold each other's hands firmly.

The painting shows Poussin's skill as a draughtsman. His line is confident and precise, and his attention to the smallest detail is meticulous. It also shows Poussin as an exquisite colourist. The picture is an understated harmony of blue and gold, and the accents of blue carry the eye around the painting, complementing the circular movement of the dancers.

Poverty

The dancer on the far right is simply dressed with a plain linen headdress. She represents Poverty, and she is shown attempting to touch the elusive hand of Wealth.

There have been many interpretations of the group of dancers, but the key to their identity and their relationship lies in the way they hold hands. Collectively, they represent the wheel of fortune – the four stages through which Man constantly revolves throughout his mortal life.

Old Father Time

The winged and bearded figure who plays the music for the dancers is Father Time. His presence suggests the inescapable fact that throughout the dance of life, Death is always in attendance. Death is present in all human activities and relationships.

Nicolas Poussin; *A Dance to the Music of Time*; c.1638; 82.5 x 104 cm (32½ x 41 in); oil on canvas; Wallace Collection, London

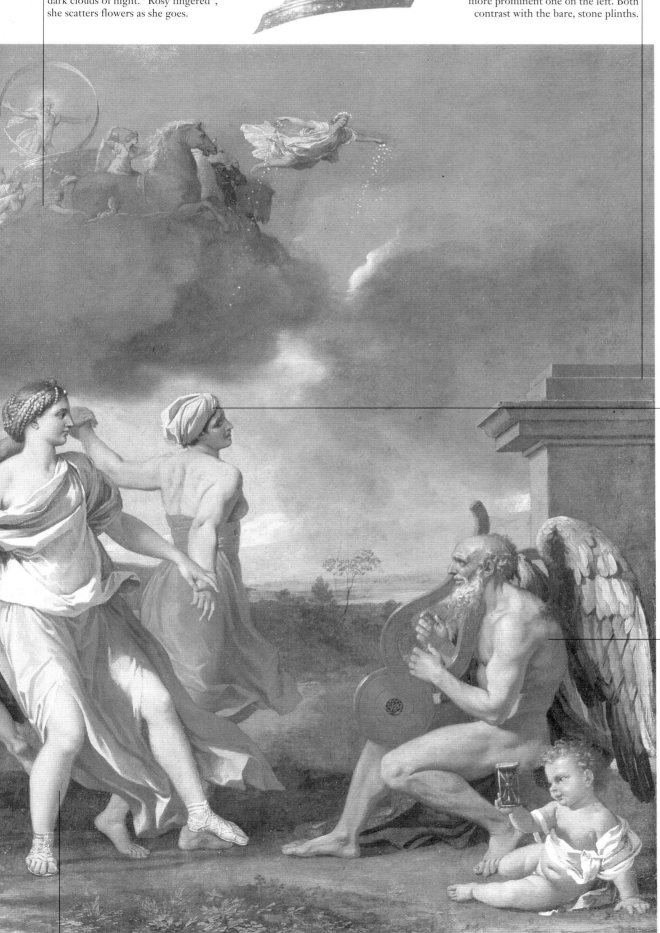

Wealth

This dancer represents Wealth, and she has a garland of pearls in her hair. Pleasure holds her hand firmly, but she herself seems uncertain whether or not to hold the hand of Poverty. Neither Wealth nor Pleasure dance barefooted.

Sands of Time

The infant putto complements the figure of Father Time. His hourglass signifies the passing of time, but there is more sand in the upper half of the hourglass – the dance still has some way to go.

THE VANITIES OF HUMAN LIFE

STEENWYCK'S TANTALIZING PAINTING is a fine example of a still-life picture known as a *Vanitas*. It is full of references to death and the emptiness of life, and the more it is studied the more it emerges as a visual sermon based on the teachings of the Old Testament book of Ecclesiastes. *Vanitas* derives from the word "vanity" in the old-fashioned sense of worthlessness, rather than the modern meaning of conceited. Still-life paintings were much admired and collected in 17th-century Holland, along with genre and landscape paintings (see p.58). A painting such as this effectively encapsulates many aspects of Dutch society in the 17th century. The Dutch were a God-fearing society with high Calvinist moral standards and work ethic; they were in the forefront of scientific developments, with a particular interest in optics and the use of lenses and microscopes for the close observation of the natural world; and they had a passion for collecting works of art and curious objects.

The Dutch loved paintings that were full of hidden meanings and puzzles. A picture such as this would have hung in the house of a rich merchant, and been the object of much discussion. As well as being an acknowledgment of the emptiness of worldly life, it was also an expensive and luxurious material possession – a good example of having one's cake and eating it, too.

A shaft of light
The fall of light has been carefully observed and calculated so that it balances the pile of objects on the right, and highlights the central object in the *Vanitas* – the human skull, the principal reminder of mortality; light is a Christian symbol of the eternal and the divine.

Collector's Item
The shell is a symbol of worldly wealth – it would have been a rare and prized possession in the 17th century. But riches too are a vanity: "As he came forth of his mother's womb, naked shall he return to go… and shall take nothing of his labour" (Eccl. 5:15).

❝*Vanity of vanities, saith the Preacher, all is vanity*❞
ECCLESIASTES 1:2

Empty shell
As well as being a symbol of wealth (see above), the shell, which is clearly empty, is also a more direct reminder of human mortality. To us, such an exotic shell is a fascinating curiosity, but we can no more claim permanent possession of it than the lower life form that once inhabited the shell. "For that which befalleth the sons of men befalleth beasts… as the one dieth so dieth the other" (Eccl. 3:19).

"A Time to Die"
The chronometer was a miniature clock that was not very accurate, but it was still a prized possession. It too is a reminder that our time on Earth is limited: "To every thing there is a season" (Eccl. 3:1).

Harmen Steenwyck;
The Vanities of Human Life;
c.1645; 39 x 51 cm (15½ x 20 in); oil on oak; National Gallery, London

Japanese sword
The sword is a symbol of worldly power and indicates that even the might of arms cannot defeat death. And no matter how mighty a man becomes "He that is higher than the highest regardeth" (Eccl. 5:8).

Phallic symbol
Like the shawm (right), the flute is a phallic symbol, which represents the sensual and erotic pleasures of life that death takes away.

STILL-LIFE PAINTING

Still life has always been the Cinderella of subject matter. Although many major paintings contained exquisite still-life details (for example, see Caravaggio's *The Supper at Emmaus*, p.44, or Rembrandt's *Belshazzar's Feast*, p.48), a painting of inanimate objects was not deemed sufficient to express the aims and ideals of High Art (see p.69). Northern painters, with their meticulous technique, had a love of still-life details (see p.14), and Dutch painters were the first to establish a tradition of still-life painting. This tradition was further developed in the 18th century by Chardin especially (see p.64), and it came fully into its own at the end of the 19th century when artists such as Cézanne (see p.96) overthrew the authority of High Art that the Academies continued to promote.

The Extinguished Lamp
The lamp has just been extinguished – a whiff of smoke can just be seen. Like the chronometer, it is a symbol of the passing of time and the frailty of human existence.

A ghostly emperor
The pitcher on the right has been painted over an image of a bust of a Roman emperor. The emperor's face would have been a reference to the earthly powers and glory that death takes away, but perhaps the artist decided against including the image of any individual that would detract from the presence of the skull as the symbol of "Everyman". The wine flask may be an allusion to the dangers of drunkenness, referred to in Ecclesiastes (Eccl. 10:17).

Dutch society was fascinated by the Old Testament, and Calvinists studied it both in church and at home. They saw analogies between themselves and the Israelites. They were the new chosen people, with a covenant with God stating that if they behaved well they would prosper. Calvinist preachers predicted that the downfall of the Dutch would come through a surfeit of materialism – hence the relevance of the Book of Ecclesiastes, one of the Wisdom Books of the Old Testament, which emphasized the emptiness of worldly possessions.

The shawm, an instrument of love
The musical instruments in the painting directly indicate the vanity of the pursuit of knowledge of that art. But musical instruments are also symbols of love. Music is traditionally part and parcel of courtship and lovemaking. This shawm (a medieval form of oboe), and other pipes traditionally represent the male form, and the swelling form of the lute and other string instruments represents the female body.

The vanity of knowledge
Books symbolize the acquisition of knowledge and learning, which is one of the distinguishing features of human existence. But even here there is a danger of vanity: "For in much wisdom is much grief: and he that increaseth knowledge increaseth sorrow" (Eccl. 1:18).

HARMEN STEENWYCK (1612–after 1655)

Harmen Steenwyck was born in Delft and spent most of his life in that bustling town in the southwest Netherlands. He studied painting under the direction of his uncle, David Bailly (1584–1657). He was joined at his uncle's studio by his brother, Pieter, who also specialized in still-life painting. Little is known of the artist's life and very few of his works survive. He is known to have travelled briefly to the East Indies and was there in 1654. He is last mentioned having returned to his hometown in 1656.

Memento mori
At the centre of the still life (and central to the theme it represents) is a human skull, a memento mori. As in Holbein's *The Ambassadors* (see p.38), its presence is the only unveiled reference to the inevitability of death.

To today's spectator, Steenwyck's painting may seem morbid, but we should remember the closeness of death in all societies prior to the 20th century. High infant mortality, death from illnesses that we would now consider commonplace, and only rudimentary medical treatment to combat disease made the grinning skull an ever-present reality.

THE MARRIAGE OF ISAAC AND REBEKAH

CLAUDE'S LANDSCAPES are a poetic dream, an image of a bounteous world, safe, fertile, and tamed, where man and nature coexist in peaceful harmony. The reality of this relationship in the 17th century was often very different, and this is one reason why he created these idealized images of an earthly paradise. The Old Testament story that gives this work its title is a device to lend the painting artistic and intellectual status at a time when pure landscape was not considered a fit subject for "serious" painting. Isaac, the son of the patriarch Abraham, was happily married to Rebekah, who came from Mesopotamia, and they lived in Canaan (Gen. 24). They are the young couple who are portrayed dancing in the right foreground of the painting.

> *"Claude conducts us to the tranquility of Arcadian scenes and fairy land"*
> SIR JOSHUA REYNOLDS

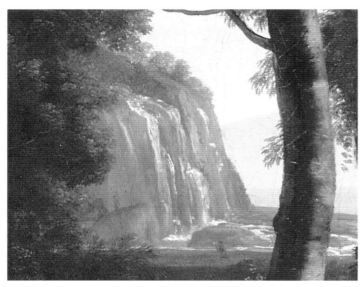

Music in the Landscape
This is a landscape to listen to as well as look at. Claude teases the ear as well as delighting the eye. There are quite definite accents of sound: the sound of the waterfalls, the musicians, the tambourines held by the dancers, the lowing of cattle, the noise of horses' hooves, and the murmur of voices.

As in all of Claude's landscapes, we are invited to enter the painting and walk through it: the eye is led along the paths, through the trees, and over the bridges in one long, continuous, and leisurely stroll.

Proportional representation
In his own day, Claude was praised for the splendour of his landscapes but criticized for the weakness of his figures. Indeed, the proportions of the figures in relation to one another do not bear close scrutiny. However, it can be argued that this "flaw" heightens the poetic charm of the scene.

CLAUDE GELLEE (1600–82)

Claude Lorraine

Originally named Claude Gellée, the artist's surname derives from the Duchy of Lorraine, his native town in France. Like Poussin (see p.50), with whom he was on friendly terms, he spent most of his life in Rome and was passionately attached to Italy. Claude, noted for his skill at capturing the natural effects of light, had a great influence on the 19th-century landscape artist Turner (see p.72), who, in leaving two of his own works to the National Gallery in London, stipulated that they hang beside the painting shown here.

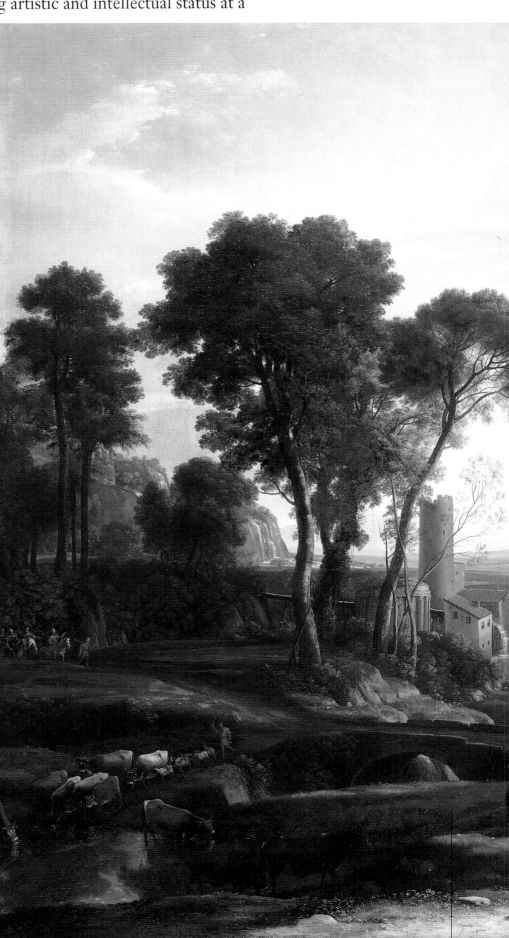

The differing effects of light
Lengthening shadows in the foreground make a subtle contrast with the distance, which is still bathed in a summer haze. Claude has the ability to re-create the delicacy of light in paint. He usually chooses the end of the day, or the early morning, when natural light is at its most elusive. He was the first artist to include images of the sun itself as the light source in some of his paintings.

Summer
*Claude's works often radiate the hot, somewhat
stifling, heat of Italy in mid-summer. However,
he never lets the heat become overwhelming.
Somewhere there is a hint (often so subtle that it
is initially felt rather than seen) of the rustle of
wind in the still air. In the distance of this work,
birds swoop away on a gentle breath of wind.*

ISAAC AND REBEKAH

The title of the picture refers
to an uneventful story from
the Old Testament. But where are
Isaac and Rebekah? Why is it set
in Italy, and not Canaan? Until the
end of the 19th century, landscape
was not deemed to be a serious
subject for painting. There was a
hierarchy of subjects, and history
painting, which included scenes
from the Bible, was the foremost
of these. By introducing notional
subjects from the Bible, Claude
was seen to be a serious painter.

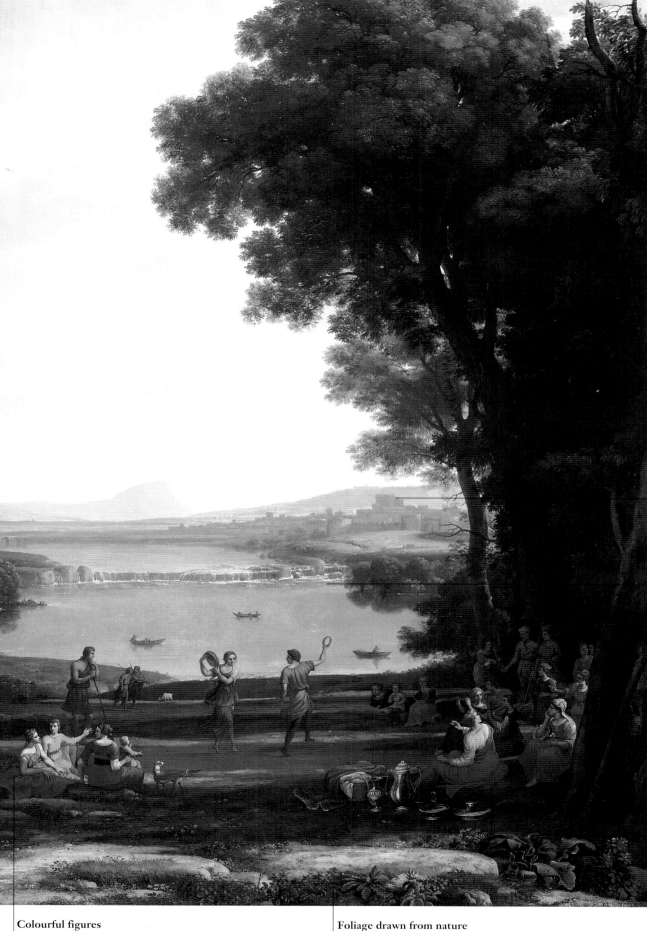

A framing device
The tall, dark trees in the foreground of the
picture effectively frame the landscape and
direct the eye inward towards the light and
silvery middle distance. Claude frequently
employed this framing device in his work.
This is a technique used by many landscape
artists, but it works just as well in a cityscape
by framing a view with tall, dark buildings.

Claude Lorraine; *The Marriage of
Isaac and Rebekah*; 1648; 149 x 197 cm
(58½ x 77½ in); oil on canvas; National
Gallery, London

Atmospheric perspective
Claude increases the illusion of distance
by the use of cool blues that tend to recede.
The browns and the warm accents of red
placed in the foreground appear closer than
cool colours. It is an optical illusion that is
based on a scientific phenomenon whereby
colours in nature lose their intensity with
distance due to the increasing body of air.
The exploitation of this phenomenon in
art is known as atmospheric perspective.

Cooling water
There are three places in the painting
where flowing water creates a welcome
contrast of coolness and freshness in the
sultry atmosphere of the Italian summer:
the fall between the two levels of the lake,
the waterfall in the rocks on the left, and
the wheel of the mill next to the tower.

Delicate Flowers
*There are many finely observed and
charming details, such as the delicacy with
which this girl's hand holds the flowers.*

Colourful figures
The seated group in the centre of the foreground is depicted
in strong primary colours (red, yellow, and blue) making them
stand out from the scenery. Claude uses other carefully placed
figures to lead the eye to further details or back into the distance.

Foliage drawn from nature
Notice the exquisite detail of the foliage at the right of the painting.
Although Claude created this painting in a studio, he often made
trips into the countryside around Rome and made beautiful drawings
directly from nature, which are works of art in their own right.

LAS MENINAS

VELAZQUEZ'S PORTRAITS are a unique and fascinating blend of qualities that are often contradictory: grandeur and realism, intimacy and aloofness. This can be explained in part by his employment as court painter to Philip IV (1621–25) of Spain. As a highly successful courtier, Velázquez would have been required in real life to observe and manipulate exactly these qualities in the intense and artificial environment of a powerful royal court. *Las Meninas* is his most complex and intriguing portrait. In the centre is the King's daughter, the five-year-old Infanta Margarita, flanked by her maids of honour – *las meninas* who give the picture its title. But Velázquez plays an elaborate and artificial game with our perception, and the relationships in the portrait. He portrays himself on the left, painting on a large canvas, but why is he there and what is on the canvas? It cannot be that he is painting a portrait of the Infanta, since he is standing behind her. The answer is in the mirror at the end of the room. It reflects the King and Queen, who must therefore be posing for Velázquez. The little Infanta has come into the room to look at them. Velázquez has reversed all the formal rules and expectations, and in so doing subtly comments on the whole art of portraiture and the role and status of the artist.

Double Portrait
Philip IV and his Queen are reflected in the mirror at the back of the room. They are portrayed standing beneath a curtain of honour. In other words they must be standing where we, the viewers of the painting, are standing.

Large canvas
We are shown the back view of a vast canvas, leaning against an enormous easel, but can only speculate as to what the artist is painting. The size of the canvas has led some experts to suggest that Velázquez is portraying himself in the process of painting *Las Meninas*, and so we are being presented simultaneously with the front and back of the canvas.

Admirer of Rubens
The paintings hanging on the back wall include a version of Rubens's *Pallas and Arachne*. Velázquez's rich, painterly style and love of colour was greatly influenced by the many masterpieces of Rubens and Titian in the Spanish Royal Collection in Madrid. Another key painting was van Eyck's *The Arnolfini Marriage* (see p.14), which was then also in the Royal Collection.

A PAINTING FOR REFLECTION

Velázquez's masterpiece is a painting about painting, designed expressly for the contemplation of the King. Doubtless, as an ambitious courtier, Velázquez was pleased to have an opportunity to encourage the King to reflect favourably upon the status of the court painter within the royal household, and indeed upon the status of painting generally – the question as to whether painting should be considered as a liberal art rather than a manual craft was still much debated at the time. This work's influence cannot be overstated: Goya (see p.74), who fully realized the implications of Velázquez's style, made an etching from this painting, and Picasso (see p.98) painted no less than 44 variations on its theme. Manet (see p.90) was also much influenced by Velázquez.

The illusion of space
An unusually large area of the ceiling is depicted. It helps to create the convincing illusion of space – one of the few qualities linking this mould-breaking painting to the Baroque era (see p.46). The empty candelabra hooks lead the eye into the back of the room; the farthest hook points to the mirror that contains the image of the royal couple.

Perspective aids
The play of light and dark on the side wall augments the painting's illusion of depth.

"*Velázquez is the painter of painters*"
EDOUARD MANET

Light source
Daylight enters through a window in the side wall, but there are other light sources that serve to modulate the shadows. Most significantly, light emanates from the area directly in front of the picture plane, that is, the space where the royal couple, or we the viewers, notionally stand.

Diego Velázquez (self-portrait)

DIEGO VELAZQUEZ (1599–1660)

Before entering the royal service in 1623, Velázquez specialized in genre scenes. The King took a personal liking to the artist and directed his subsequent career, much of which was spent producing royal portraits. Encouraged by Rubens (see p.46), he visited Italy to study the art of antiquity in 1629, and he returned there in 1649–51. He was influenced by the work of Titian (see p.36), some of whose paintings were in the Spanish Royal Collection. A master in the handling of light and shadow, his many innovations were to have enormous influence on 19th-century art.

Infanta

Velázquez achieved a very special sharpness of characterization in his portraiture. We can still see the childlike vulnerability in the Infanta's features despite her knowingness.

Nicolasito

The Court Jester Nicolasito playfully treads on the huge sleepy mastiff. Such a detail helps to develop a feeling of spontaneity in this painting.

Dwarves and clowns provided entertainment at Court, and often feature in the paintings by Velázquez. Another Court favourite, Mari-Bárbola, stands behind the dog. Her grim features and dark dress serve to accentuate the Infanta's delicate beauty.

Brushes

Notice the extremely long brushes that the artist is employing. Velázquez is renowned for his rich harmonious colours and his fluid style with long, visible brushstrokes. He developed a technique whereby the details of the painting come into focus only at a certain distance. The length of the brushes meant the artist could more readily appreciate the effects of his work.

Proud courtier

Richly dressed, presenting himself as a courtier, the artist peers proudly from behind his canvas at the royal couple. Spanish etiquette was excessively rigid; few people would have been permitted such intimate audience with the royal family, yet the artist, deep in concentration, leans back and scrutinizes his subject with an unhurried air. Nor is he distracted by the Infanta and her retinue. Note the sleepy attitude of the dog on the far right, which suggests that they have all been present for a long time.

Diego Velázquez: *Las Meninas;* **1656; 318 x 276 cm (125 x 108½ in); oil on canvas; Museo del Prado, Madrid**

Terracotta jug

The maid of honour on the left proffers a red terracotta jug on a gold plate to the Infanta, which probably would have contained cold perfumed water.

The future Empress

The Infanta Margarita, the future Empress, is the central figure in the painting. She was just five years old when *Las Meninas* was painted.

Chamberlain to the Queen

The man on the steps at the back of the room is José Nieto, Chamberlain to the Queen. He was responsible for the day-to-day management of the royal household. His silhouette next to the mirror image closes the space and, appropriately for a Court official, he points to the reflection in the mirror of the King and Queen who otherwise might go unnoticed.

The Order of St James

Velázquez wears a royal decoration, the cross of the Order of S. Iago (St James), which was not given to him until three years after the date of the picture. In receiving this honour, Velázquez achieved his highest ambitions as a courtier. The image of the cross on the artist's chest was added to the painting in 1640, at the behest of the connoisseur King, who did much to promote painting to the status of the liberal arts.

Maid of honour to the Infanta

A second maid of honour appears on the right of the painting, awaiting the child's orders. Behind her a nun and a priest converse in the shadows. Their presence is a reminder of the power of the Church in what was the most devoutly Catholic nation in Europe.

THE ARTIST'S STUDIO

VERMEER IS ONE OF THE MOST MYSTERIOUS and elusive of artists. Few works are known to be by him for certain, and he was completely forgotten from the end of the 17th century until his "rediscovery" in the mid-19th century. Today he is acknowledged as one of the greatest masters of Dutch genre painting. Typical of Vermeer is this intimate glimpse of the relationship between two people, his meticulous observation of light, and his precise handling of colour. As well as being visually seductive, the work is full of emblems and allusions relating to contemporary life – specifically the achievement and status of the painter and his art in 17th-century Holland.

Hapsburg Eagle
The chandelier, which is rendered with astonishing skill, is decorated with the two-headed eagle of the Hapsburgs. The absence of candles reminds us that the power of the Hapsburgs, the Spanish royal family, is waning. The Northern Dutch provinces gained independence from Spanish rule by the Treaty of Münster (1648).

The Muse of History
The model represents Clio, the Muse of History, whose attributes are the wreath of laurel and a book in which she records all heroic deeds. Note that although Vermeer's work at first appears very sharply focused, a closer look reveals that it has the same quality as a soft-focus photograph, as if the eye is about to sharpen every detail. It may be this effect of clarity about to happen, rather than actually existing, that gives his paintings their remarkable quality of life.

JAN VERMEER (1632–75)

Very little is known about Vermeer's life, and only about 35 surviving works can be attributed to him. He was an officer of the Guild of St Luke, in his home town of Delft, but he was probably apprenticed in Utrecht. In 1653, he married into a wealthy family but died leaving his wife and eleven children with massive debts. A legal dispute is documented in 1677 where Vermeer's family petitioned the courts to prevent the sale of *The Artist's Studio* at auction to pay the artist's debts.

Jan Vermeer

"*Vermeer's most remarkable quality... is the quality of his light*"
THEOPHILE THORE

Roof beams
The roof beams create a strong horizontal pattern continued by the map's roller bars. The underlying structure of horizontals and verticals gives the picture its mood of stability and calm.

The nine Muses were the goddesses of inspiration in the arts and sciences. By showing the artist inspired by the Muse, Vermeer confirms the place of painting as a liberal art.

Crease in the map
The vertical crease marks the frontier between Protestant Holland and Catholic Flanders; the latter was still under the political control and cultural influence of Spain.

Woven curtain
The source of light is hidden behind a heavy woven curtain, which is drawn aside to reveal the artist at work. Notice how Vermeer turns highlights into delicate beads of light, which are not unlike pearls. They are employed with particular effectiveness on the curtain, the magnificent chandelier, and on the studs in the rather uncomfortable-looking chair in the foreground.

This painting changed hands several times, and eventually came into the possession of an Austrian family. It was later confiscated by the Nazi tyrant Adolf Hitler (1889–1945), who hung it in his private rooms at Berchtesgaden. Hitler's first training was in painting.

Symbol of fame

The Muse of History carries a trumpet in her right hand, symbolizing the fame that can be achieved by an artist. Her significance here is not clear; Vermeer may be suggesting that fame need no longer be sought through excellence in traditional history painting – it can be achieved through new subjects such as this, namely, genre painting.

The line of the table-top

The table draws the viewer's eye into the painting towards a vanishing point positioned just below the bulbous finial of the map's roller bar. Notice how the draperies on the near side of the table allow the light to cascade over them like water flowing over a waterfall.

Vermeer loved complex spatial arrangements and creating a precise convincing illusion of objects in a confined space. In several of his works, the artist employed the arrangement of a chair in the foreground, the regular pattern of a slate and marble floor, a table-top, and the interplay of human figures with carefully arranged items of furniture, like variations on a theme. This work is the most successful, and complex, of all such arrangements.

Signature

Vermeer's signature can be found near the bottom of the map, level with the model's collar: "*I Ver-Meer*".

Fine detail

The artist rests his hand on a "mahlstick" – an instrument to support the artist's hand when he is doing detailed work. It has a padded end that rests on the canvas without damaging it. Vermeer's style is distinctive – he portrays himself working on details at a very early stage; the rest of the image is sketched in chalk. It is significant that he is working on the laurel wreath, which "crowns" the triumphant hand of the artist.

Easel

The artist's easel points with confidence towards the new republic of Holland.

The artist's costume

The painter is not dressed in the clothes of his day, but wears a 15th-century costume. It would seem that Vermeer is connecting the art of his own era with art of the time of the great masters van Eyck (see p.14) and van der Weyden (see p.12), perhaps to claim that the standards that they achieved are maintained by Vermeer's generation.

Jan Vermeer; *The Artist's Studio*; c.1665; 120 x 100 cm (47 x 39½ in); oil on canvas; Kunsthistorisches Museum, Vienna

Death Mask?

The face on the table is a plaster mask – a symbol of imitation, representing painting as the art of imitation. Its position suggests it also serves as a death mask and may signify the death of painting in the southern provinces that stayed under Spanish rule, as opposed to the continuing life of painting in Holland.

Following the tiles

See how effectively the eye can follow the tiles on a diagonal to either the left or the right. Alternatively, as is the case in this painting, we may be persuaded to follow a vertical line directly into the painting. Here, we are guided by the "arrows" created by the three foremost marble tiles to follow the line of the white tiles that lead, like stepping stones, directly towards the model. This line is reinforced by the angle of the table-top.

An invitation to view

The prominent position of the chair invites the viewer to take a seat at this carefully staged scene. However, the viewer is not allowed to intrude on the intimacy between the artist and model, who are both absorbed by the task in hand. Neither of them acknowledges the existence of the spectator.

A JOURNEY TO CYTHERA

WATTEAU'S PAINTING, KNOWN AS A "FETE GALANTE", mirrors the elegant open-air parties that were popular in 18th-century court society. Elegant couples acted out polite rituals of behaviour and conversation, where true meanings and desires were discreetly hidden. The couples appear in contemporary dress, but Watteau transports them to a fantasy world – the world that these people strove to achieve in their imagination. He depicts a journey to Cythera, the island sacred to Venus, the goddess of love, who was said to have alighted there after her birth (see p.22). The painting is one of the finest fruits of the Rococo, the style that dominated all the arts in the first half of the 18th century.

Playful Putti
This putto is definitely misbehaving. He attempts to fire an arrow backwards at a loving couple (if he hit them, they would fall out of love), but his plan is thwarted by a more benevolent putto.

Glowing sky
The evening sky seems to suggest a melancholy counterpoint to the playful theme. It appears that Love's day may be ended as the lovers return to the waiting boat that will transport them back to reality.

PAINTING AND MUSIC

Just as music can bring images to mind, so paintings can make you hear music. The trick is to let your eye follow the lines and curves of the composition, picking up the details, and absorbing the textures and colours. Mozart (1756–91) was born 35 years after Watteau died, but there is a parallel between their different arts. Mozart plays with musical textures and colours, and loves the curving phrase. Under the youthful freshness of Mozart's work there is also that feeling of matters more profound than are revealed on the surface of life.

Wolfgang Amadeus Mozart: Idomeneo (1781)

Privileged putti
The putti are the only "gods" of antiquity that Watteau permits to enter the canvas. Tired of turning to the gods of Greece, artists of the Rococo looked to nature as a guide and inspiration, alluding to the gods only in a playful or romantic way.

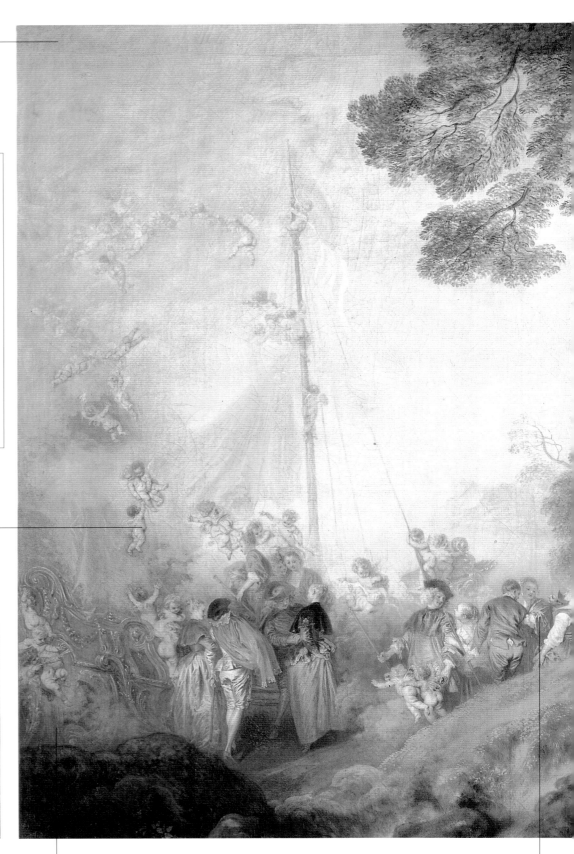

A Moving Image
As well as contributing to the flow of the procession, each group works separately – they can be read like different sequences from a moving film showing the succeeding stages of the motion of a single couple. Porcelain figurines of such couples were very popular in 18th-century Europe.

The Ship of Love
The exotic sailing vessel is being prepared for a journey, but it is never entirely clear if the lovers are now *on* Cythera preparing to return to mundane reality, or if they are going *to* Cythera in the golden distance.

Last glance
The procession of lovers are goaded to the ship by the putti. Note the wistful expression of the girl at the top of the hill as she glances longingly behind her.

The light-hearted theme, the harmony between humans and nature, and the pastel colours are all typical of the Rococo. Watteau uses pale decorative colours, and he applies thin paint in light brushstrokes, which sometimes seem hardly to touch the canvas. In many places he suggests a form or shape rather than drawing a clear outline. This hesitant, ambiguous technique is perfectly suited to the subject, for in love nothing is certain: a half-spoken sentence or snatched glance can mean everything – or nothing – to someone who is in love.

Theatrical foliage
The mood of freedom and lack of inhibition that the putti and the humans display in the picture is echoed in the trees, which are shown to be growing wildly and exuberantly. The sky and foliage act as a theatrical backdrop to a stage set – Watteau was actively involved in the theatre and had many actor friends.

JEAN-ANTOINE WATTEAU (1684–1721)

Watteau was admitted to the French Royal Academy in 1717. His first painting for the Academy, a version of *A Journey to Cythera*, violated all academic canons, and a new category of *fêtes galantes* was introduced to accommodate his radical style. Watteau suffered from tuberculosis and exhibited the symptoms of chronic restlessness throughout his short life.

Jean-Antoine Watteau

Living Statues
Venus is depicted with her son Cupid. A minor god, Cupid is usually armed with a bow and arrows. He shoots his arrows at humans to make them fall in love. The statue seems to be almost alive. This is a common feature in Watteau's paintings – his stone statues appear to be on the point of becoming flesh and blood.

Flowers of Venus
A man gathers roses from the forest as a gift for his lover. Roses are the flowers of love and are sacred to Venus.

Love conquers all
Among the objects placed at the base of the statue are weapons and armour, a lyre, and books, representing warfare, the arts, and learning. A putto pulls up a laurel garland to place around Venus. The message is the triumph of love over all activities: *amor vincit omnia* – love conquers all.

"With a material art he has realized the miracle of representing a domain that it seemed only possible to evoke with music"
CAMILLE MAUCLAIR

Jean-Antoine Watteau; *A Journey to Cythera*; 1717; 129 x 194 cm (51 x 76½ in); oil on canvas; Musée du Louvre, Paris

A moving scene
Watteau leads the eye from right to left along the curving line, which rises and falls like a phrase of music. Note also how he breaks the rhythm at the highest point with the man holding the cane. This breaking of rhythm is a technique also used in music.

The language of fans
The girl plays with her fan – the way fans were held or moved was part of a secret language through which lovers (who were often strictly chaperoned) communicated with each other.

ARRIVAL OF THE FRENCH AMBASSADOR

CANALETTO'S EARLY masterpiece shows one of the most celebrated views in the world. This is the heart of Venice, once a great maritime empire and trading nation, which at the height of its prosperity produced artists such as Giorgione (see p.28) and Titian (see p.36). By the time Canaletto painted this picture in the early 18th century, Venice was past her greatness, and indeed was soon to lose her independence when, in 1797, the last of her rulers, the Doge of Venice, surrendered to Napoleon. Canaletto was a highly successful artist – a view painter or *vedutista* – and his works were eagerly sought after by the Grand Tourists of the period who travelled to Italy for education and pleasure.

Light and water
One of Venice's magical features is the quality of light, and a unique marriage of light and water. Many artists have attempted to capture its fleeting qualities, but few have succeeded. Canaletto was a supreme master.

Customs House
At the entrance to the Grand Canal is the Customs House, which was central to Venice's prosperity as a trading nation. Venice was perfectly situated at the cross-roads of Europe.

Santa Maria della Salute
The Church of Santa Maria della Salute is one of the most important in Venice, and her finest example of Baroque architecture. It was designed by the Venetian architect Longhena. Built to celebrate the end of the great plague of 1630, it was not completed until 1687, only ten years before Canaletto was born.

Venice's power waned after the discovery of an alternative route to China around the Cape of Good Hope in 1498.

CAMERA OBSCURA

The architectural detail in Canaletto's work is so accurate and crisp that it has been suggested that the artist used a *camera obscura* – a device working on the same basic principle as a camera, projecting an image onto a screen that an artist could trace. However, a view such as is shown here could not be recorded by a camera in a single shot since it has many different viewpoints that have been synthesized to form a convincing panoramic illusion. In this painting, the high viewpoint gives the illusion of looking out of a window, but there is no building in the position where the artist would have had to stand to use the "camera".

The Grand Canal
This is the entrance to the Grand Canal, the waterway that runs through the heart of the city like a main street, and along which are many of the finest palaces and major buildings.

The Ambassador's retinue
· The picture ostensibly depicts the arrival of the French Ambassador Jacques-Vincent Languet (1667–1734) in Venice in 1726. However, the subject is an excuse to portray the splendour of the Venetian cityscape and the Venetians' love of pageantry.

Barges and Gondolas
All of the State barges, which were elaborately decorated in gold and silver, were destroyed by Napoleon, but the humble black gondola continues to be one of the most picturesque ways of travelling around Venice – unchanged since Canaletto's day.

One of the hallmarks of Canaletto's style is the patterns that he forms with light and shade. A surprisingly large part of this panorama is in shade, but what the eye remembers are the shafts of sunlight that illuminate the scene. He delights in this never-ending play of light and the razor-sharp edges between light and shade.

Ominous clouds
A large black cloud has settled over the Doge's Palace, as though foretelling the demise of the independence of Venice, which was to occur 30 years after Canaletto's death.

Ceremonial Balcony
Around the balcony are different religious statues surmounted by the winged lion of St Mark. On the skyline, above them all, is the figure of Justice.

The Doge's Palace
On the right is the Doge's Palace, a picturesque mixture of Gothic and Byzantine styles, which was the seat of Venetian government. Venice had a unique aristocratic system of government, which contributed to her power in the 15th and 16th centuries.

" It was the inevitable destiny of Venice to be painted "
HENRY JAMES

Crowded balcony
Another characteristic of this artist's style is the lively anecdotal scenes that he uses to enliven his views. The inquisitive bystanders who throng the balcony of the Doge's palace and hang over the side of the bridge in the bottom left are a typically entertaining feature in this picture.

There is a strongly theatrical flavour about this painting. It is like a stage set with Venice as the backdrop and the arrival of the French ambassador being the play that is acted out in the foreground. Canaletto's early training was with his father who was a stage-set designer.

Canaletto; *Arrival of the French Ambassador*; c.1735; 180 x 259 cm (71 x 102 in); oil on canvas; Hermitage, St Petersburg

The Piazzetta
The square by the Doge's Palace is known as the Piazzetta. On top of the nearest column is a winged lion which is the symbol of St Mark, the patron saint of Venice. On top of the further column is a statue of St Theodore, whose relics are in Venice.

The Library and the Mint
The building on the far side of the Piazzetta is the Library. It was the masterpiece of the Renaissance architect Sansovino, started in 1536. Tucked in behind the Library is one of the most important buildings of the Venetian Empire: the Mint. The Venetian ducat was the main trading currency in the 15th and 16th centuries, and was known for its stability and reliability.

ANTONIO DA CANAL (1697–1768)

Canaletto was immensely popular in his own day, particularly with the English Grand Tourists, for his topographical views of his native Venice. He journeyed to England in 1746 and remained there for ten years, painting views of the River Thames and of country houses. But his work in England never quite reached the same standard set by his Venetian landscapes, and the trip was not a financial success. He returned to Venice in 1756 and declined into obscurity, never having achieved official recognition in Italy.

Canaletto

THE GOVERNESS

CHARDIN'S WORLD was that of the "enlightened" bourgeoisie who were gaining in influence in mid-18th century France, and his paintings are glimpses of their world. He was influenced by the genre scenes and still lifes of the Dutch masters of the 17th century (see p.58), whose paintings were in fashion with French collectors at the time. This picture was exhibited at the Paris Salon, and although modest in size and subject it was greatly admired. Chardin's technique and, in particular, his meticulous craftsmanship and perfect sense of colour are always in harmony with his subject matter. It is this sense of total unity, where nothing is out of place, nothing is overstated, that makes him a great master. Chardin reminds us that looking – at people and objects (including pictures) – can be one of life's greatest pleasures.

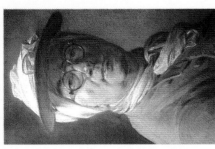

Jean-Baptiste Siméon-Chardin (self-portrait)

JEAN-BAPTISTE-SIMEON CHARDIN (1699–1779)

The finest 18th-century French genre and still-life painter, Chardin was born in Paris, the son of a retired cabinet-maker. He became a member of the Academy in 1728. By the Salon of 1740, Chardin had an exceptionally strong reputation, and the two works entered by him were acquired by the French monarchy. He was elected Treasurer of the Academy in 1752. He died, aged 80, after suffering a long illness.

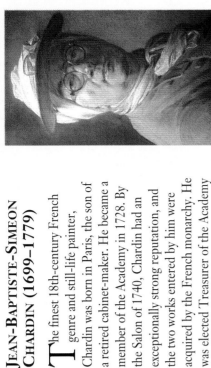

Uncertain Youth
The young man's pose and expression, and the tentative touches of blue on his coat and in the ribbon in his hair, express youthful irresolution and uncertainty.

The open door
The half-open door that leads into an unknown space suggests the child's entry into the adult world and all the unforeseeable trials and pleasures that await him.

School books
Where is the boy going? The books tucked under his arm suggest that he is going to school. The governess was responsible for his early education, but now he must move on to more serious things.

Artist's signature
Chardin's signature and the date of the painting are just visible on the door.

Chardin was widowed early on in life, at the age of 36, and had two small children to bring up. He did not remarry until he was 46. This knowledge brings a special poignancy to his scenes of domestic life such as this, and perhaps accounts for the particular tenderness with which he has recorded this intimate relationship.

Guardian and teacher
The governess's gesture and pose, the expression on her face, and the strong red vertical of the back of her chair express firmness and certainty in keeping with her role as the young man's guardian and teacher.

Prim and proper
Although traditionally identified as a governess, the woman is so finely dressed that she could easily represent the boy's mother.

The tricorn hat

The governess brushes the boy's tricorn hat (an object that Chardin included in many of his pictures and which he clearly liked to paint). It is a symbolic gesture, repeated today in many different ways, as parents make that final adjustment before sending their children off on their journey. One of the main attractions of this pictures is the timelessness of its subject matter.

Jean-Baptiste-Siméon Chardin: *The Governess*; 1739; 46.5 x 37.5 cm (18 x 15 in); oil on canvas; National Gallery of Canada, Ottawa

An open drawer

The card table is minutely observed. Chardin's father was a cabinet-maker – so the artist was raised in a tradition of craftsmanship, and had a good knowledge of the art of furniture making. The half-open drawer suggests the boy's carelessness. The cards on the floor were taken from the drawer that he has forgotten to close.

Although the painting is mute and the conversation can never be heard, part of the charm is that it is easy to sense what is being said. The painting recalls those moments of admonition or instruction familiar to most families.

Forgotten games

The young man is leaving behind his toys and games, which lie abandoned on the floor by his feet. These instruments of idleness – the cards, the racquet, and the shuttlecock – are positioned in the foreground and are given the same prominence as the work basket on the opposite side of the painting, which represents the more fruitful instruments of industry.

" Chardin always makes us admire the simple and true which rule his works and which attract everyone because his perfect imitation of nature strikes every eye "
THE ABBÉ-DESFONTAINES

SENSE AND SENSIBILITY

One of the central themes in 18th-century art and literature is the balance between sense and sensibility. Should we be governed by our hearts and emotions (sensibility), or by our heads (sense)? In France, the philosopher Voltaire (1694–1778) argued for sense, while Rousseau (1712–1778) preferred sensibility. Wright's *The Experiment with an Air Pump* (see p.68) also addresses this theme, but with a less homely subject than Chardin's. Chardin was clearly on the side of reason, and many of his genre paintings are gentle sermons in praise of industry, and of experience instructing youth.

Work Basket

Chardin was a master of still-life painting (see p.53), and many of his works concentrate solely on such humble objects as this work basket. Cézanne (see p.96) was a great admirer of Chardin's paintings.

Symbolic Cards

The cards, which at first sight seem to have fallen randomly on the floor, are carefully chosen and arranged by the artist. They point towards the half-open door, and the two leading cards are the King of Hearts, representing love, and the Ace of Spades, which represents death. They indicate the ordeals and experiences of the boy's future.

MR AND MRS ANDREWS

GAINSBOROUGH'S SMALL DOUBLE PORTRAIT is one of the gems of the National Gallery in London, and earns its place there for a number of reasons. It is a quintessentially English picture – the landscape, the pose and the faces, and the practical and slightly awkward character of the picture mean it could not be anything else. Nearly all the European countries have produced schools of painting with distinct features that reflect strongly on that country's character, and on the cultural and social traditions. There was no native English school until the 18th century. Gainsborough helped to establish the strong and distinctive style of English portraiture, and this painting is an early stepping stone on the way to building that tradition.

Unfinished Portrait
Although painted in careful and exquisite detail, one area of the portrait remains unfinished – the hands of Mrs Andrews. It has been suggested that she was originally to have been portrayed holding a pheasant that Mr Andrews had shot. It is not known why the portrait remained unfinished.

The happy couple
Robert Andrews and Frances Carter were married at Sudbury, Suffolk in November 1748. Mr Andrews was aged 22 and his wife was 16. This double portrait was presumably commissioned to celebrate the marriage, and the landscape is recognizably their estate at Aubries, near Sudbury.

English attitude
The "no-nonsense" appearance and attitude of the sitters, which contrasts with the escapist quality of Watteau's painting (see p.60), is a comment on the difference between English and French society in the 18th century.

Mr Andrews
Mr Andrews's eagerness to be portrayed casually dressed as a country gentleman, with a dog and a gun, indicates the deeply rooted aspiration of English society to channel its creative energies into its country houses and estates.

The painting is composed of two separate pictures: a double portrait on the left and a landscape on the right. Although he made his reputation as a highly successful portrait painter of the high society of his day, Gainsborough's first love was landscape painting, which was not considered a serious form of art. Here Gainsborough has succeeded in balancing the figures and landscape.

Thomas Gainsborough; *Mr and Mrs Andrews*; c.1748–49; 70 x 119 cm (27½ x 47 in); oil on canvas; National Gallery, London

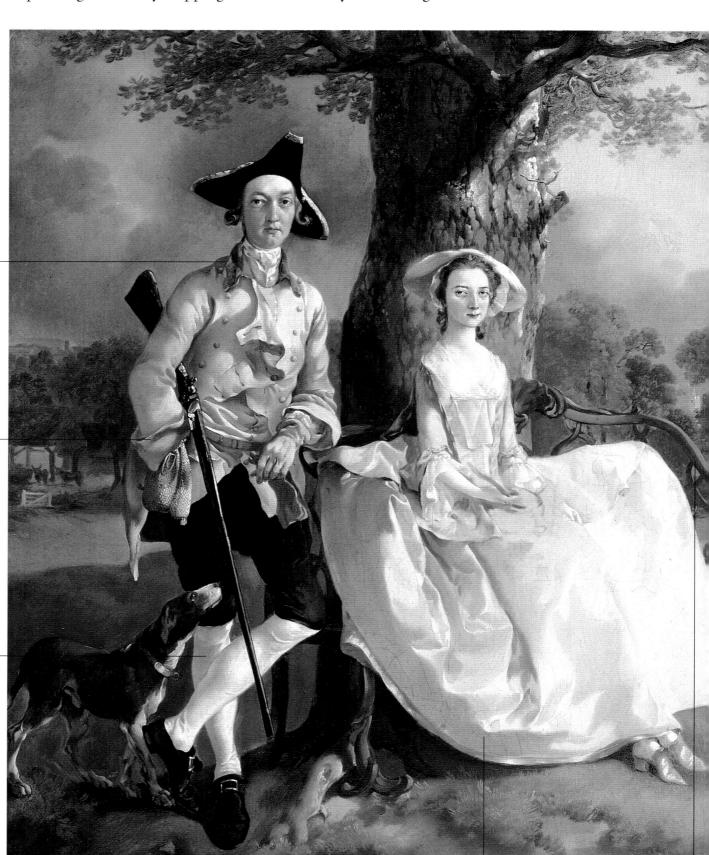

The influence of the Rococo
Mrs Andrews is wearing her best satin dress, which is exquisitely modelled with sumptuous highlights. It shows the Rococo influence of Watteau (see p.60) whom Gainsborough admired. French fashions were much in vogue with the English gentry and aristocracy.

Elaborate bench
The elaborate wrought-iron bench with its crossed feet echoes the poses of Mr and Mrs Andrews. It is probably painted from the artist's imagination.

THOMAS GAINSBOROUGH (1727–88)

Born at Sudbury, England, Gainsborough was a painter of both portraits and landscapes, influenced in his early years by the 17th-century Dutch school of painting. In 1740 he moved to London to study, and he moved back to Sudbury in 1746. He established himself as a portrait painter and worked in Ipswich and Bath, before returning to London in 1774. Here he further developed his personal style, and gained favour from the Royal Family. Despite his success as a portrait artist, landscape painting was his passion.

Thomas Gainsborough (self-portrait)

Modern Farming

The landscape, which is well cared for and very similar in appearance to the English countryside as we see it today, would have struck many people in the mid-18th century as unusual. The corn has been planted in straight rows, implying the use of a seed drill, as opposed to scattering corn by hand, which was the traditional method used prior to the invention of the mechanical seed drill. The portrait shows landowners who are proud of their up-to-date agricultural expertise.

> **"** *I'm sick of portraits, and wish very much to take my viol da gamba and walk off to some sweet village where I can paint landskips and enjoy the fag end of life in quietness and ease...* **"**
> THOMAS GAINSBOROUGH

Trees
The three trees on the right balance the oak in the foreground; they help lead the eye into the distance where the high, billowing clouds form a suitably harmonious backdrop.

Enclosure farming
In the middle distance a flock of sheep is shown in a neatly enclosed field, and the cattle are separately enclosed in a field with a wooden shelter on the the far left of the painting. This is further evidence of the Andrews's modern approach to farming. Enclosure farming was an innovation of the 18th century that led to more intensive cultivation. Previously, sheep and other livestock were allowed to wander freely over the same common land, a system that proved to be detrimental to the health of the livestock as well as damaging to crops.

Fashionable Footwear
Like her husband, Mrs Andrews has her legs crossed. This was typical in 18th-century portraiture. Her feet are fashionably small in the painting.

A real landscape
An asymmetrical, off-centre composition is a typical feature of the Rococo style. However, Gainsborough adds his own innovative and quirky touch by including a real landscape, not the conventional Arcadian fiction.

Sheaves of corn
The sheaves of stooked corn in the foreground and middle distance are traditional symbols of fertility, which support the theory that the painting is a wedding portrait. Technically, their placement helps to create the painting's illusion of depth.

THE EXPERIMENT WITH AN AIR PUMP

WRIGHT'S PICTURE IS A BRILLIANT summary of interests and attitudes characteristic of the mid-18th century – the Age of Reason. A group of friends have gathered in a private house to watch a dramatic scientific experiment demonstrating the power that man can have over life and death. The artist spells out a wide range of reactions to what the friends witness. Thus the picture succeeds in embodying the hopes and fears of the age – and offers food for thought for our own as we face changes resulting from developments in science. Wright was a minor master, but he has here produced an undoubted masterpiece of the highest quality: technically accomplished, visually satisfying, and morally and intellectually challenging.

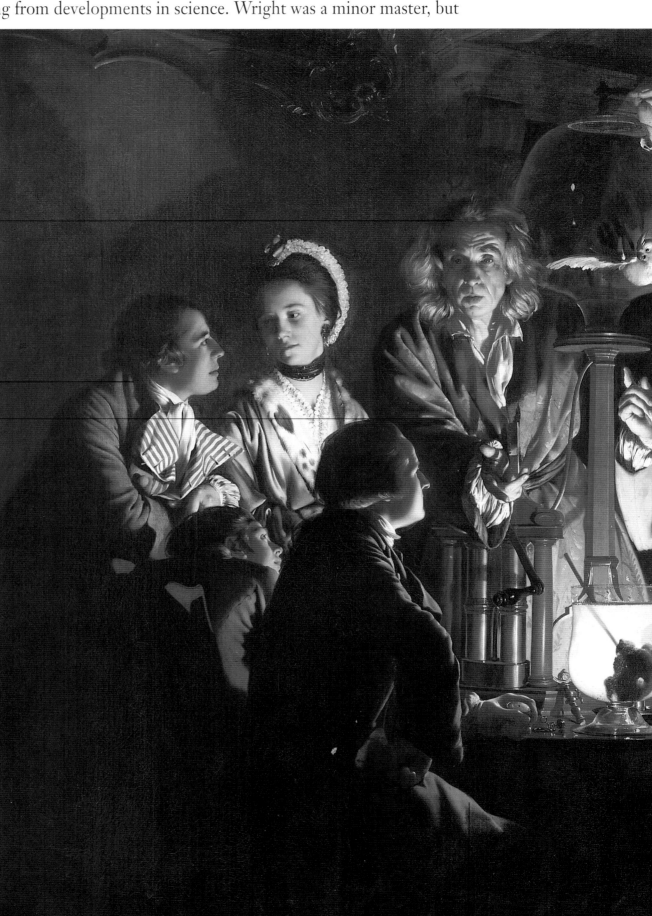

A modern magician
The visiting scientist has flowing locks and a long robe, which makes him look rather like a wizard. It was common practice at the time for a scientist to travel to a private residence to provide an evening's entertainment and instruction to a wealthy family.

Love is blind
As a contrast to the general enthralment at the progress of the experiment, the artist includes a pair of elegantly dressed lovers who are enraptured only by each other, and who remain oblivious both to the experiment and the scientific and moral questions raised.

Questioning gesture
The scientist has his raised hand on the valve, and his other hand gestures towards us – his audience. He makes direct eye contact, as if to ask the question, "Shall I open the valve and let air in so that the bird will live? Or do I let the bird die? You decide."

Light and Symbolism
The principal source of light in the painting is a candle, which is hidden behind the glass bowl. Its distorted image is just observable down the right side of the bowl. In the bowl is a pickled skull. As well as being a brilliant technical rendering of light, which was much admired by Wright's contemporaries, the candle and skull also have symbolic meanings as reminders of the inevitability of death and the transience of life.

Joseph Wright; *The Experiment with an Air Pump*; **1768; 183 x 244 cm (72 x 96 in); oil on canvas; National Gallery, London**

Fascinated observer
This gentleman, who times the experiment, represents those who are excited by scientific discoveries. Beside him, a boy – who is also totally involved – strains to get a better view.

Room to view
An empty place at the table allows Wright to open up the scene, and invites the viewer to participate.

The Experiment

In the glass bowl is a bird. (Wright has painted a white cockatoo for dramatic effect. In practice it would have been a more commonplace bird, like a sparrow, or a small animal like a mouse.) There is a valve on top of the glass bowl. When the valve is sealed and the air pumped out, the bird or animal collapses from lack of oxygen. This reaction may seem obvious to us, but it was new knowledge to many people in the mid-18th century, who wanted scientific proof. Oxygen was not properly identified until the 1770s.

Birdcage

This boy is lowering the birdcage. He seems uncertain: if the bird lives it will go back in the cage; if it dies the cage will not be needed.

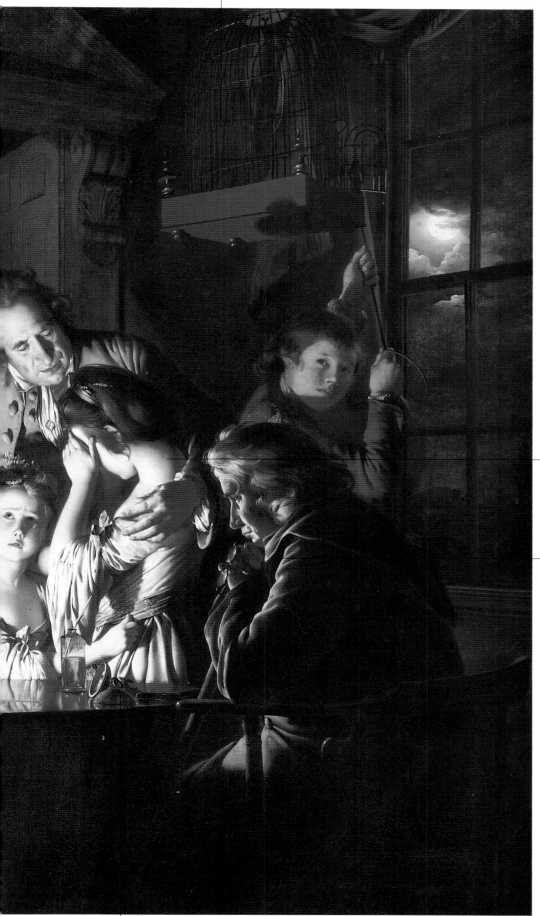

Scientific equipment

On the table, scientific equipment is arranged like a still life (see p.44). They include a pair of Magdeburg Spheres, which demonstrate the strength of a vacuum. When they are placed together and the air pumped out between them, they become inseparable.

> **"***The scientist discovers... the artist creates...***"**
> EUGENE DELACROIX

The way everyone is illuminated by a single source of light at the centre of the experiment suggests that all of them, and us, are capable of being enlightened by the power of science.

Moonlight and the Enlightenment

The moon is probably a reference to the Lunar Society. Based in the English Midlands, the birthplace of the Industrial Revolution, it met each month to discuss recent scientific developments and conduct experiments. Many of Wright's friends and patrons were members of the Society. It epitomizes, like Wright's painting, the spirit and exchange of ideas that are the essence of the Enlightenment (the Age of Reason). The Society met during the full moon so that its members would have the convenience of riding home by the light of the moon – hence the Society's name.

Two sisters

The two sisters are torn between curiosity and distress. The man, probably their father, reassures the sister who is in tears. He tries to explain to the girls what is happening in the experiment.

The philosopher

The posture adopted by the old man is a time-honoured one that represents the thinker. He seems troubled, perhaps pondering the consequences of this new-found knowledge and power? He is there as another reminder that science can be used for both good and evil.

JOSEPH WRIGHT (1734–97)

Joseph Wright

Known as Joseph Wright of Derby, after his native English town, it was here that he completed most of his paintings. In 1773 he spent time in Italy where he was less interested in recording scenes of antiquity than in the effects of fireworks on the Roman skyline. He also recorded one of the greatest natural firework displays – the eruption of Vesuvius – which he described as being the "most wonderful sight in nature". After an unsuccessful venture in the south of England on his return in 1775, he moved back to Derby permanently.

THE OATH OF THE HORATII

DAVID'S PAINTING IS A DELIBERATE celebration of the art, life, and morality of ancient Rome. The Roman Republic is at war, and the dispute is to be settled by mortal combat between three Roman brothers (the Horatii) and three enemy brothers (the Curatii). David shows the dramatic moment when the Horatii swear before their father their allegiance to the State, and a readiness to die on its behalf. But the story presents a difficult moral dilemma, for one of the Horatii brothers is married to one of the sisters of the Curatii, and a Horatii sister is betrothed to one of the Curatii brothers. They will choose self-sacrifice and loyalty to the Republic over family ties and personal emotion.

"Those marks of heroism and civic virtue presented to the eyes of the people will electrify the soul, and sow the seeds of glory and loyalty to the fatherland"
JACQUES-LOUIS DAVID
(REVOLUTIONARY CONVENTION, 1793)

Red for passion
The dominant colour in the male grouping is a vivid red, the colour of passion, which was to become the traditional colour of Revolution.

David was only 37 when he painted his masterpiece. A technical tour de force, *it was acclaimed by critics and public alike.*

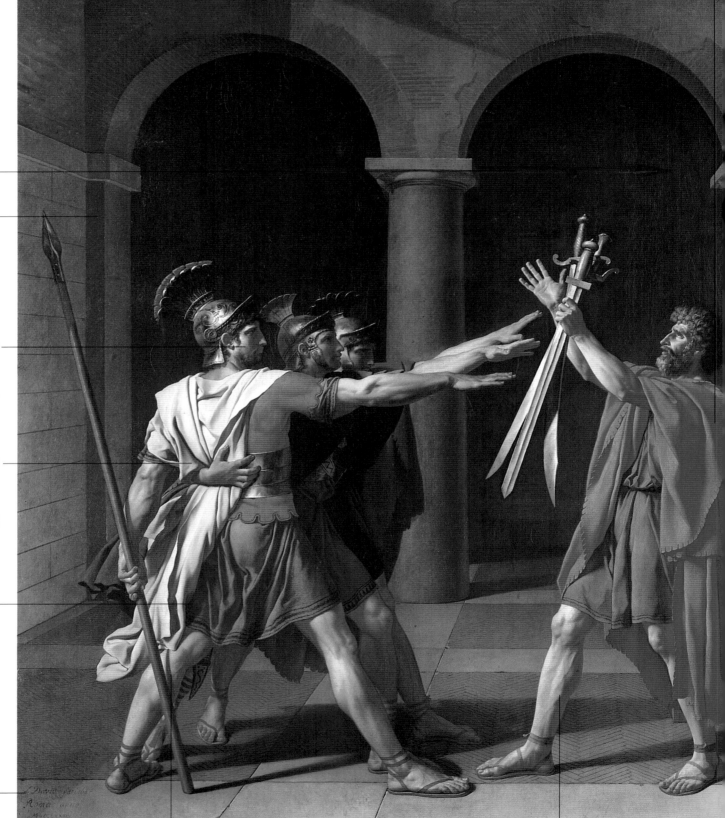

Lance
The lance, barely visible in the shadowy recesses, is the only "ornament" in the stark, box-like recess, devoid of any suggestion of domestic luxury. Style and subject matter are inextricably linked in this extraordinary painting.

Roman architecture
The architectural setting is recognizably Roman, and uses a style of column known as the Doric Order. The austere Doric column, characterized by the absence of a base, was considered to have a masculine and military character.

Stony profiles
The heads of the Horatii have been placed in a way that suggests the shallow carved reliefs (called bas-reliefs) that are found in ancient Roman sculpture and architecture.

Precise outlines
The clarity of David's style reflects the certainty of his moral message. The figures are larger than life; all outlines are crisp and definite; the colours are bright and clear. Even the shadows seem to be disciplined and unambiguous.

Authentic dress
The togas are faithfully copied from known Roman examples, as are the helmets and the swords. David ensures that every detail is as accurate as possible – even the men's noses are the shape known as "Roman noses".

Classic touch
Even the signature, written in Latin, is Neoclassical; it means: "Created in Rome by David in 1784" ("L. David faciebat Romae Anno MDCCLXXXIV").

Jacques-Louis David; *The Oath of the Horatii;* **1784; 330 x 425 cm (129 x 169 in); oil on canvas;** Musée du Louvre, Paris

Model soldiers
The heroic warriors are presented as models for the ideal soldier. Designed to excite and inspire, with grim, determined faces, their body language is unambiguous. The political and moral message is clear: duty and discipline are the supreme virtues, and if necessary the soldiers will die for them.

Father's sacrifice
The father's heroic pose stresses the nobility of his sacrifice. The angle of his body is balanced by the lance held by his foremost son.

Although it is a huge painting, The Oath of the Horatii has been painted with the fine and polished technique usually found in a small Dutch still life such as Steenwyck's The Vanities of Human Life (see p.52).

ART AND POLITICS

David intended this painting to be a propaganda picture, but even he could not have predicted how successfully it would fulfil this purpose. When it was painted, the *ancien régime* of the French monarchy, based on the divine right of kings, had only four years left. In 1789 the French Revolution, which David supported, replaced it with a new political order: the republican Nation State with its ideals of liberty, fraternity, and equality. Heroic, authoritative, and impeccably composed, his painting embodies the new political dream and epitomizes the Neoclassical style. Ironically, the picture was commissioned by Louis XVI, who was guillotined in 1792.

The shadow of death
The male group casts a shadow that falls on the children who huddle together under the sheltering cloak of the mother of the Horatii. Note how the older child, though obviously frightened by the turn of events, pulls away his grandmother's hand to gaze at the swords. The shadow indicates that even innocent children must be willing to pay the price that loyalty to the State demands.

Three arches
The three Doric arches of the building correspond with the grouping of the figures. Each group or individual – the father, the brothers, and the women and children – is framed by one of the arches, suggesting their isolation and the links that tie them together. Throughout the picture, the artist repeats the theme of the group of three.

The Swearing of the Oath
Every gesture confirms total commitment to the solemn oath. The hands and the glittering swords of the male figures converge dramatically and are isolated by bright sunlight. The father looks heavenwards, towards the gods. Legs are planted firmly and confidently on the ground. The nearest soldier is held by his brother in a vice-like grip around the waist.

Two Women
The woman in white is Sabina, the sister to the Curatii and wife of one of the Horatii. She leans against her sister-in-law Camilla, who is betrothed to a Curatii brother. Camilla is destined to be murdered by her own brother for lamenting the death of her lover. The two women are the personification of grief and tragedy.

Hands
The women's hands are inert and passive compared with those of the men.

Gentle curves
In direct and striking contrast to the strong, straight lines that describe the male group, the women and children are drawn with soft curves. This makes the eye interpret the emotion and uncertainty of the situation.

JACQUES-LOUIS DAVID (1748–1825)

One of the central figures of Neoclassicism, David won the Prix de Rome in 1776 and travelled from his native France to Italy, where he was able to indulge his passion for the antique and came into contact with the initiators of the new Classical revival. In 1780 he returned to Paris, where he established himself as the embodiment of the social and moral reaction to the frivolity of the Rococo (see p.58). David was renowned for his active support of the French Revolution, and he became court painter to Napoleon Bonaparte in 1804.

Jacques-Louis David (self-portrait)

HANNIBAL CROSSING THE ALPS

TURNER'S PAINTING WAS FIRST exhibited in 1812, a year that proved to be a turning point in modern European history. Napoleon's armies had reached the gates of Moscow, and it seemed that France would conquer all of Europe. But the tide turned, and the French armies were forced to retreat, not defeated by force of arms, but by the cruel Russian winter. Turner shows the armies of the great Carthaginian leader, Hannibal, who, like Napoleon, invaded Italy by marching through the Alps. But Turner does not directly glorify Hannibal's daring military success. The might of nature is the real subject of the painting: Hannibal's forces are battered by a raging snowstorm. But suddenly the clouds lift to reveal the prize – the brightly lit, fertile plains of Italy. Despite his initial successes, Hannibal was eventually defeated by the Romans. Many people saw Turner's painting as a prediction of the eventual defeat of Napoleon, the modern Hannibal.

Hannibal's Elephants
Hannibal's notorious war-elephants are barely discernible in the distance. Turner portrays these formidable creatures, the largest land mammals, as being small and insignificant when compared with the stormy forces of nature.

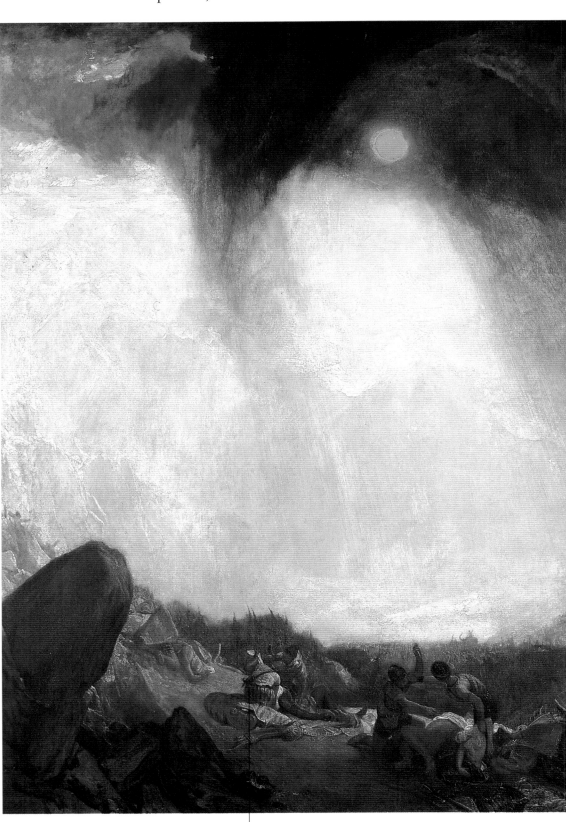

ROMANTICISM

Turner lived in a period that was prodigiously creative in all the arts. His era was shared by Mozart, Beethoven, Mendelssohn, Schumann, Schubert, Byron, Keats, the Brontës, Victor Hugo, Goethe, David, Géricault, Delacroix, and Goya. In politics, major figures included Napoleon, Nelson, Wellington, and Washington. We call this period the Romantic movement. It was a revolutionary moment in history when many new ideas and hopes were born. The Romantics believed passionately in the freedom of the individual, they loved new experiences and enjoyed taking risks. They lived life to the full, and were larger than life. They were not interested in compromise – better to be a heroic success or a total failure: anything in between was of no interest. It is this spirit that infuses all their work and ensures its enduring popularity.

Figures in the Landscape
The rearguard of Hannibal's army was plagued by the local Salassi tribesmen shown here. Painting figures was the weakest aspect of Turner's work, a weakness shared by the French landscape artist, Claude (see p.54), whom Turner admired.

The Salassians
This pair of Salassian warriors is shown in the foreground robbing their victims. One appears to be blowing on a horn, while the other strips the clothing off a corpse.

In 1810, Turner was staying in Yorkshire and went for a walk with a young companion. They saw a storm sweep across the hills in the distance. Entranced, Turner took a piece of paper and rapidly sketched what he saw, remarking: "In two years you will see this again and call it Hannibal Crossing the Alps".

Capturing the Sun

Turner was interested both in the visual power of the Sun and its symbolic force, and was one of the few painters who have succeeded in painting the Sun itself as opposed to the effect of sunlight. Here he shows the Sun attempting to burst though storm clouds, which represents hope breaking through the dark clouds of fear and despair.

"*The Sun is God*"
TURNER'S DYING WORDS

A swirling vortex
Turner has composed his picture in the shape of a huge oval vortex of wind and rain and storm. The vortex swirls around the human action and seems ready to engulf and destroy it.

JOSEPH MALLORD WILLIAM TURNER (1775–1851)

Turner was an extremely precocious artist, and was accepted into the Royal Academy Schools in 1789, when he was just 14 years old. He exhibited his first painting at the Academy a year later. He was strongly influenced by the work of Claude whose work he emulated in his youth. It was soon recognized, however, that Turner was developing a revolutionary approach to landscape painting. His subject matter was increasingly Romantic, with a highly dramatic sense of movement. Much of his later work has an abstraction that anticipates 20th-century art.

J. M. W. Turner (self-portrait)

A sombre palette
Turner instinctively understood the emotional impact of colours, and later in his life made a study of them. Here his palette of dark browns, blues, and greens encapsulates the underlying sombre mood that gives way to the warm bright glow of sunlight in the centre.

Turner went to great trouble to ensure that the painting was hung at the correct height. He wanted it to be hung low down so that the spectator would be drawn visually and emotionally into the centre of the picture.

Avalanche
The extreme right of the painting is dominated by a blaze of white – an avalanche of snow cascades upon the Carthaginian army, their captives, and their enemy alike.

Mountains
The mountains seem as much a force of the storm as the blizzard, the clouds, and the huge cones of light that echo their form. Turner was fascinated by mountains and made regular journeys to France, Germany, and Switzerland to make sketches of the Alps and the river valleys. His first visit to France and Switzerland was in July–October 1802. He first visited Italy in 1819.

Rear procession
Turner has used white paint to pick out highlights on the shields and banners of the Carthaginian troops. He has also highlighted the army's bristling pike-staffs, the long lances that played such a vital role in the Carthaginian battle strategy – they presented an impenetrable front to occupy the Roman army while the Carthaginian cavalry, supported by the terrifying war-elephants, attacked the enemy flanks and rear line.

Heaving boulders
A group of Salassi tribesmen strain to lever a boulder to send an avalanche of rocks onto the heads of the soldiers below.

An emotional focus
We can barely discern the figure waiting in ambush behind this boulder. Turner suppresses detail in favour of a general dramatic effect. His focus is emotional, not anecdotal, and his appeal is to the emotions and the imagination.

Gesture of despair
This shadowy figure raises his arms in despair as the avalanche descends. Turner allows this sole figure to "speak" for all in the lower right corner who are victims of nature's "wrath".

J. M. W. Turner; *Hannibal Crossing the Alps;* 1812; 146 x 237 cm (57½ x 93 in); oil on canvas; Tate Gallery, London

THE THIRD OF MAY 1808

G OYA'S STARTLING PAINTING stands as one of the most memorable images of man's inhumanity to man. Napoleon's armies occupied Spain, but on the second of May 1808 the citizens of Madrid rose up against the French. The following day the French army took a terrible revenge by executing hundreds of the rebels and many more who were innocent bystanders. Goya was not able to record the events until half a decade later when King Ferdinand VII was restored to the Spanish throne. The painting transcends its specific historical setting and displays two principal features of Goya's art: his ability to produce images that are strikingly direct, and his questioning but ultimately detached morality.

A modern crucifixion?
The central victim has his hands raised in the symbolic pose of Christ crucified – notice the indentation in the right palm – and many parallels have been drawn between this scene and the Crucifixion of Christ. Yet Goya was critical of the superstitions of Spanish Catholicism, and greatly admired the French Enlightenment.

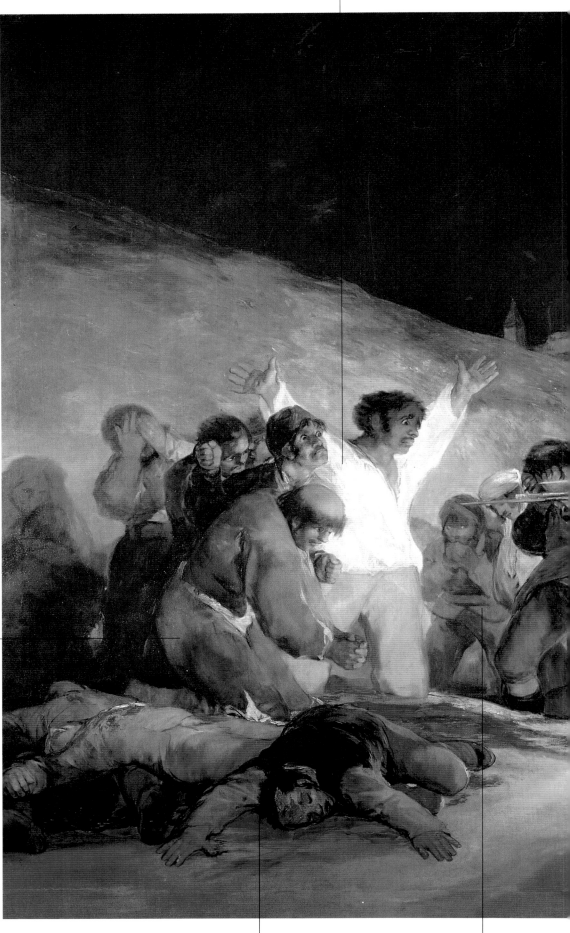

Francisco de Goya; *The Third of May 1808*; 1814; 266 x 345 cm (105 x 136 in); oil on canvas; Museo del Prado, Madrid

A Silent Scream
A severe illness in 1792 left the artist completely deaf. However, Goya's disability gave him a heightened awareness of the significance of gestures. The pose of the central victim, his arms thrown wide, is a heart-rending cry for humanity against tyranny and barbarity, which is all the more poignant for its futility.

Franciscan friar
The man's grey robes and shaven head suggest he is a friar in the order of St Francis. His hands are clasped in a gesture of supplication. He is unlikely to have been involved in the previous day's insurrection, so his presence reminds us of the random and arbitrary nature of the French revenge killings – many innocent people were rounded up and shot along with those who attacked the French soldiers.

HEROES AND ANTI-HEROES

A esthetically and historically, Goya's painting is the reverse of David's *The Oath of the Horatii* (see p.70). The latter sets up a familiar image of the hero, willing to die for a cause. Goya gives us the anti-hero: not the warrior, but the victim whose death becomes, almost by chance, a rallying point for those struggling against oppression. Goya's style also contrasts with David's, with few clear outlines, and loose succulent paint full of ambiguities and subtleties. Note that the pose of Goya's soldiers echo, in reverse, those of David's *Horatii*.

Merciless massacre
The corpse in the foreground, lying face down in a pool of blood, echoes the gesture of the "crucified" victim. Goya leaves us in no doubt as to his inevitable fate.

Expression of terror
This figure is especially haunting. The whites of his eyes glisten with fear, and he gnaws his fingers in a childlike expression of terror.

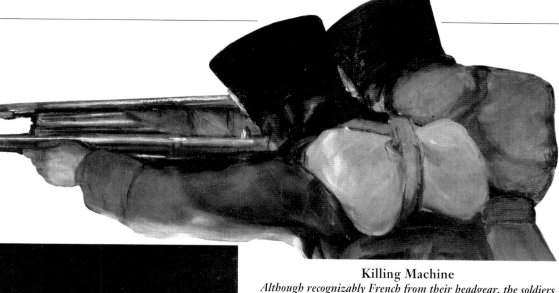

Relentless night
The massacre took place at night and on into the early hours of the morning. The black, unrelenting sky, which dominates the top third of the picture, helps create the grim mood for this painting.

The fixed bayonets add an extra dimension of horror. The blades were used on the victims if the bullet wounds were not immediately fatal.

Killing Machine
Although recognizably French from their headgear, the soldiers are depicted as anonymous and timeless automatons – the mindless functionaries who carry out the orders of political and military superiors. Significantly, Goya does not show their faces.

❝ *The sleep of reason produces monsters* **❞**
FRANCISCO DE GOYA

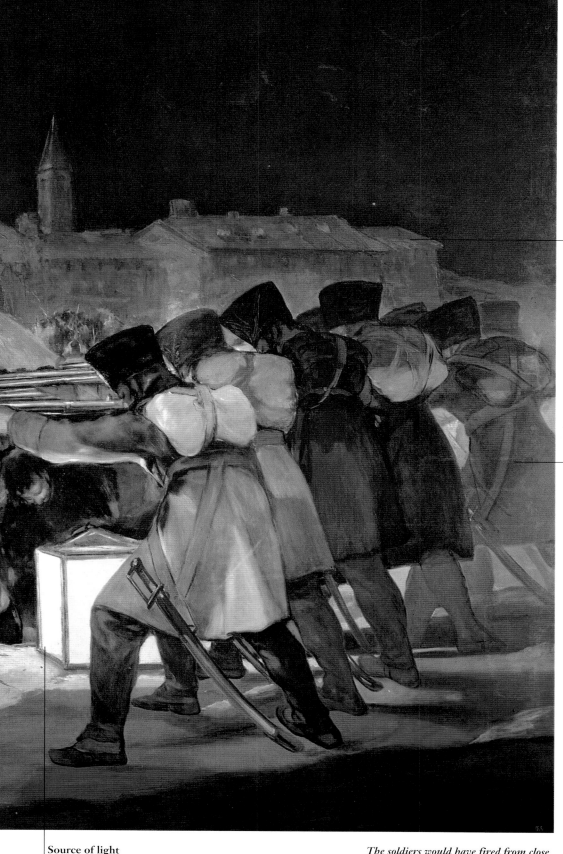

Scene of slaughter
The buildings are not meant to represent any real site that may have existed at the time. The executions actually took place close to the Royal Palace in Madrid, at the Montaña del Príncipe Pío.

Uniform
The soldiers' greatcoats were made of undyed wool, which accounts for the difference in shades of colour. Their backpacks suggest that they are infantrymen, although uniformed men rarely carried out executions in reality. The distinctive headgear (*shakos*), the square-handled sabres, and the trousers were introduced during the Napoleonic wars.

The Tower
The official-looking buildings in the background suggest the authority of the political institutions that create the events in the foreground.

FRANCISCO DE GOYA (1746–1828)

Goya's development as an artist was slow and laborious; he was 43 years old when he became a royal painter. Goya's foremost influence was the work of Velázquez (see p.56), whose free brushwork he studied and emulated. His own brushwork in his mature style became so free that it anticipated the Impressionists (see p.84). His illness in 1792 made him sympathetic to the suffering of others, and his work has a depth of humanity rarely encountered.

Francisco de Goya (self-portrait)

Source of light
Nominally the light comes from the huge lantern, but in effect it radiates symbolically from the white shirt of the victim. The eerie shadows intensify the terrified faces.

The soldiers would have fired from close range because of the poor light, but Goya has shortened the distance to point-blank range to increase the dramatic effect.

The Raft of the Medusa

Géricault's painting broke new ground by taking art into the controversial realm of political protest. It portrays on a heroic scale the moment when the survivors of a wrecked ship see the sail of the vessel that will save them. They had been abandoned by their captain, and their story scandalized the French nation. The incident was seen as a metaphor for corruption in France after the fall of Napoleon. Artistically, the picture makes an interesting comparison with David's *The Oath of the Horatii* (see p.70), which is similar in size, and beside which this work is displayed in the Louvre Museum. David's art encourages service to the State; here art castigates the State for abandoning those who serve it.

A work of this size and power required a great deal of forethought and planning. Géricault made dozens of drawings and small painted sketches to clarify his ideas.

Dramatic outline
A silhouetted figure against a dramatic sky features in many of Géricault's works. This figure draws the eye up from the bottom of the picture to a dramatic focus near the top.

❝*Neither poetry nor painting can ever do justice to the horror and anguish of the men on the raft* **❞**
Theodore Gericault

Billowing sail
The sail echoes the shape of the large wave behind it, and so gives it greater power and force. The billowing sail and the violence of the sea emphasize Nature's destructive force. In order to study the sea's motion, the artist made a trip to the coast of Normandy.

Rays of hope
The storm clouds are broken by light, a symbol of hope. The lowering cumulus cloud on the left reiterates the shape of the tumultuous wave beneath it.

Damaged areas
Unfortunately, Géricault's masterpiece is badly damaged, and many areas such as this have lost a great deal of the original detail. Géricault applied a tar-like pigment called bitumen to produce rich, dark colours. However, it soon bubbles and turns black and, tragically, there is no way of repairing the damage.

Beyond despair
Even the prospect of rescue is scant consolation for this man who is grieving over his son's death.

Reality or art
The painting is a fascinating marriage of artifice and reality. The occupants of the raft are not the emaciated souls who survived in reality, and they owe much to Géricault's study of the vigorous, muscular nudes of Michelangelo (see p.30). He establishes a poetic rather than "photographic" truth.

The Face of Death
In pursuit of authenticity Géricault visited the local hospital, l'Hôpital Beaujon, *to make detailed studies of the sick and dying. He even took a severed head and an assortment of limbs from the morgue back to his studio in the* Faubourg du Roule.

Théodore Géricault; *The Raft of the Medusa*; 1819;
491 x 716 cm (193 x 282 in); oil on canvas;
Musée du Louvre, Paris

A realistic raft
Géricault had a full-size reconstruction built in his studio, and wax models of figures to place and rearrange on it.

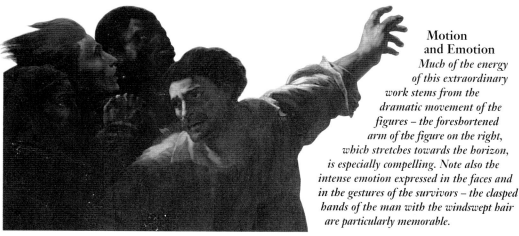

Motion and Emotion
Much of the energy of this extraordinary work stems from the dramatic movement of the figures – the foreshortened arm of the figure on the right, which stretches towards the horizon, is especially compelling. Note also the intense emotion expressed in the faces and in the gestures of the survivors – the clasped hands of the man with the windswept hair are particularly memorable.

THE STORY BEHIND THE PICTURE

In the summer of 1816 a French frigate, the *Medusa*, was wrecked off the coast of Africa while carrying soldiers and settlers to the colony of Senegal. The incompetent captain was a nobleman who gained his position through political influence. When the ship was wrecked, he was on one of the few lifeboats, leaving the people he saw as his social inferiors to fend for themselves. The 149 men (and one woman) built a makeshift raft and were adrift for 13 days. Only 15 survived the horrendous circumstances, and instances of cannibalism and insanity were reported. Five more died on reaching land.

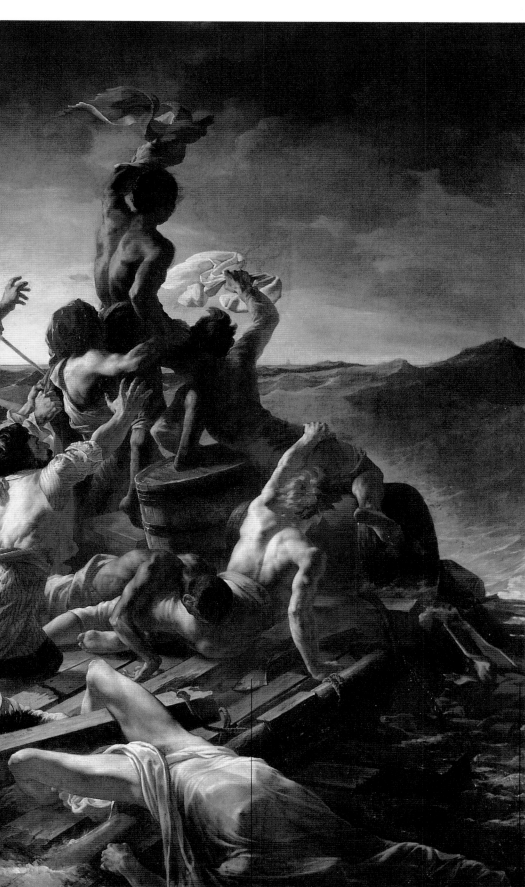

THE PYRAMID OF HOPE

Géricault organizes the composition to form two pyramids. The first is outlined by the guy ropes supporting the sail. The second is often described as a "pyramid of hope": the lowest figures are dead, and the pyramid rises through the sick and dying to the topmost figure who finds fresh energy at the prospect of rescue. It is a progression from the depths of despair to an apex of hope.

The Argus
Like the survivors, you need to search hard to find the ship that eventually saved them. The Argus was the sister ship of the Medusa, and Géricault shows it as a tiny speck on the horizon of his huge canvas. The minute size of the ship serves to heighten the dramatic moment captured by the painting. It is still conceivable that the ship will turn away (as had occurred once before in reality) and all hope of rescue would be dashed.

THÉODORE GÉRICAULT (1791–1824)

With a private income, Géricault was a new type of artist. He did not need commissions, and so was able to choose the subjects that appealed to him personally. He studied in Italy from 1816–18, and was greatly influenced by the work of Michelangelo

Théodore Géricault

(see p.30). He returned to France to paint his masterpiece, *The Raft of the Medusa*. His own influence is visible in the work of his contemporary Eugène Delacroix (1798–1863).

Bloodstained axe
A discarded, bloodstained axe is the only reference to the horrific cannibalism described by survivors.

Abandoned uniform
A French soldier's uniform lies abandoned, a metaphor for the political and military collapse of France.

THE HAY WAIN

CONSTABLE'S PICTURE has become so popular that it adorns thousands of tea towels, chocolate boxes, plates, postcards, and all kinds of tourist souvenirs. Constable's country in East Anglia, England, is a famous beauty spot that now attracts visitors from all over the world, and the cottage and stretch of river shown here are maintained and preserved by the National Trust. To many people Constable's picture represents a nostalgic image of the English countryside, with mankind working the land in perfect harmony with bounteous nature, a golden age before the industrial problems of modern times. Although it is perfectly legitimate to read the picture in this way, Constable was in fact trying to create a new subject matter for painting, but few of his fellow artists or collectors could accept it as serious art.

"I should paint my own places best – painting is but another word for feeling"
JOHN CONSTABLE

John Constable; *The Hay Wain*; 1821; 130 x 185 cm (51 x 73 in); oil on canvas; National Gallery, London

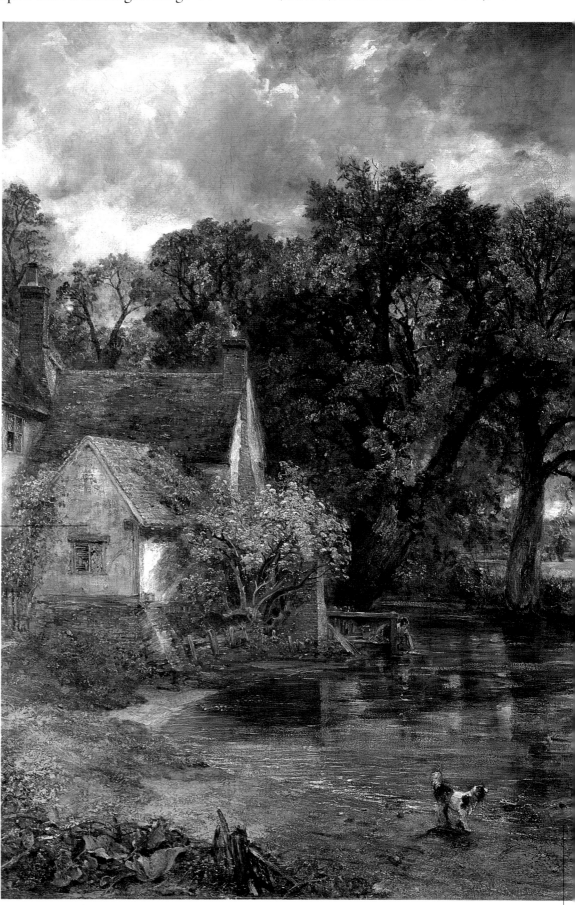

English Washerwoman
Outside Willy Lot's cottage a woman is either collecting water or washing clothes in the estuary. The detail shows Constable's traditional palette of earth colours, and his highlights of thick white paint.

Willy Lot's cottage
The cottage on the left is known, even today, as Willy Lot's cottage. Willy Lot was a deaf and eccentric tenant farmer who was born in the cottage and lived there for over 80 years; he would have been the inhabitant at the date of this picture. Even though the scene is set in midsummer, Constable shows smoke rising from the chimney, indicating Willy Lot's unseen presence.

Constable's scene of harmonious nature is derived from his boyhood memories of life before the Napoleonic wars. The son of a wealthy miller, he was familiar with the details of country life and played in the places he shows in his work. But in the 1820s, when The Hay Wain *was painted, there were many agricultural problems. There was economic depression and much social unrest, with soldiers coming back from the wars unable to find work. There were riots and farms were burned. None of this is apparent from Constable's serene landscapes.*

The Dog's Lead
The dog is an essential part of the composition, leading our eye towards the focus of interest, which is the hay cart. It was added quite late in the development of the picture.

Shadowy figure
A shadowy figure riding a horse is just visible here. At some stage Constable changed it to a barrel, and then painted both out. With the passing of time oil paint becomes more transparent, and the figures are now beginning to reappear through the paint surface.

Constable was a slow worker, and behind this work lie many small sketches made in the open air over several years. The artist then made a full-sized sketch in which he planned the composition and general appearance of the final work. The finished picture was made in his studio in London as stated in his signature, which can be seen along the bottom edge of the painting.

The formation of clouds
The high, billowing clouds are a special feature of this part of the world, caused by water vapour drawn up from the Stour Estuary close by. Constable avoids treating clouds merely as a backdrop and makes them an integral part of the picture, giving them proper perspective so that they appear to curve over the far horizon.

JOHN CONSTABLE (1776–1837)

John Constable

Constable is ranked alongside Turner (see p.72) as one of the finest British landscape painters. His deep love of the English countryside is expressed in his work and by the fact that he never left his native country. He became a member of the British Royal Academy in 1829, but he was never really appreciated by his compatriots. Although he had many imitators, Constable had no real successor in England. He was, however, much admired in France.

As a young artist Constable was much influenced by Gainsborough (his wealthy uncle David owned an early landscape by Gainsborough), who also came from East Anglia in England. At one stage Constable said "I fancy I see Gainsborough in every hedge and hollow tree".

Constable failed to sell the picture at the Royal Academy. He turned down an offer of £70 (without the frame) as too low. He exhibited the painting at the Paris Salon of 1824, where it was such a success that it won a Gold Medal. His work was a major influence on the French Barbizon School of painting, and through them influenced the Impressionists (see p.84).

A pattern of light
Constable was particularly concerned with integrating the sky and the landscape, so that the play of light and shadow over the land would be consistent with the pattern of light and clouds in the sky.

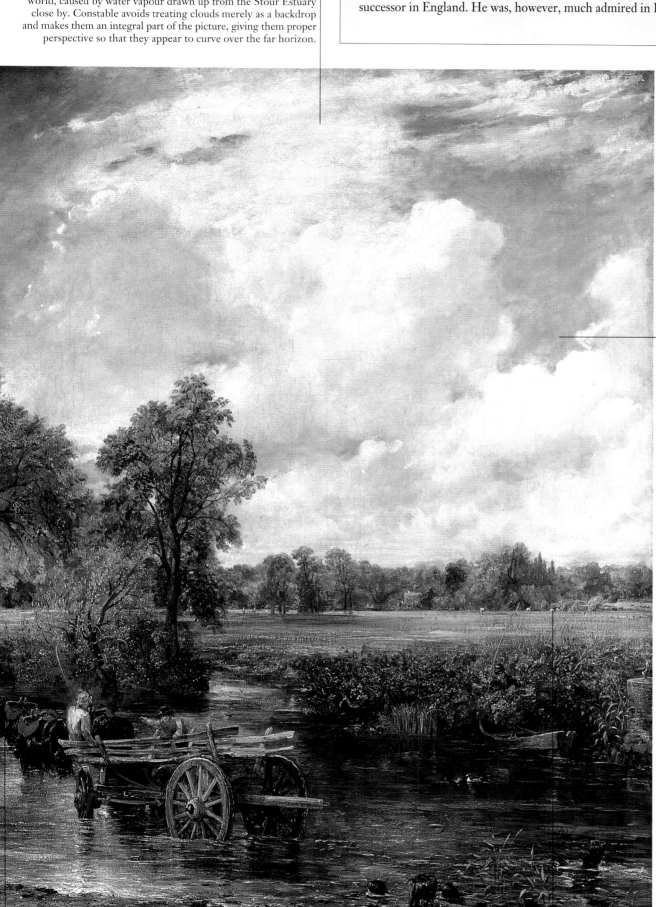

A Splash of Red
If you look carefully you can see that all areas of green are an interweaving of many different shades of green, and there are touches of red, such as in the figure of the man fishing. Red is the complementary colour to green, and so intensifies its effect.

CONSTABLE'S CRITICS

Why was Constable rejected? He wanted to make landscape as important as history painting, and he believed that "God Almighty's Daylight" was as full of moral and spiritual values as a scene from ancient history. He also wanted people to stand in front of his work and feel the splendour and freshness of nature. This laudable aim was too revolutionary a proposition in his day. Fifty years ahead of his time, Constable was hurt and depressed by his constant rejection.

Cooling the horses
The hay wain is being directed to the ford that leads to the reapers in the distance. The water cools the legs of the horses and soaks the wheels of the wagon. In hot, dry weather the wood shrinks, causing the metal band around the rim to loosen. By wetting the wheels the shrinkage is reduced and the metal band kept in place.

Making hay
In the far distance it is possible to see the haymakers in the fields carrying their scythes, and loading hay onto a cart. It will take its load away, and be replaced by the empty cart that is passing though the river.

THE AWAKENING CONSCIENCE

HUNT IS A MINOR MASTER of the English school of painting, but this work is a fine example of a type of picture that became very popular in Victorian Britain. It is a storytelling picture, and the theme, which was explored in 19th-century literature, as well as in art, is the fate of the fallen woman. It is a genre scene – a contemporary domestic interior that comments on the society of the day. It contains many details that are intended to be read symbolically. The moral message of the picture, however, is very different from the Dutch genre scenes (see p.58), which often treated the theme of sexual licence and prostitution with tolerance and humour. In true Victorian fashion, the moral message here is stern and strongly disapproving. Pictures such as this, meticulously painted with heavily moralizing or sentimental themes, were produced by artists all over Europe, and were enormously popular both with the public and collectors.

> **❝** *The corn and vine are left unguarded by the slumbering Cupid watchers, and the fruit is left to be preyed on by the thievish birds* **❞**
> WILLIAM HOLMAN HUNT

THE PRE-RAPHAELITES

In 1848, several young English artists formed a group to challenge what they regarded as the emptiness of the current state of "High Art" (see p.69), and the precedence given to the works of Raphael (see p.32). They sought to bring a fresh moral seriousness to painting, and to take the precise observation of nature as their standard, rather than the styles of the Old Masters. Hunt was one of the founders of the movement.

The Light of the World
The girl stares out of the window at the sunlit garden reflected in the mirror. The light represents Jesus Christ as The Light of the World, which was the title of this work's companion painting. It represents her salvation. Note the white roses in the garden, which are traditional symbols of purity.

Changing expression
The first owner of the picture asked Hunt to repaint the girl's face because her original expression was too painful for him to live with. The girl's face is illuminated by the light of a window, which appears in the mirror.

A Victorian gentleman
The young man is well-to-do and well dressed. He is visiting his mistress whom he lodges in a comfortable and modern house, and visits when it pleases him. She is in a state of undress – the lace-hemmed garment that she wears is her petticoat.

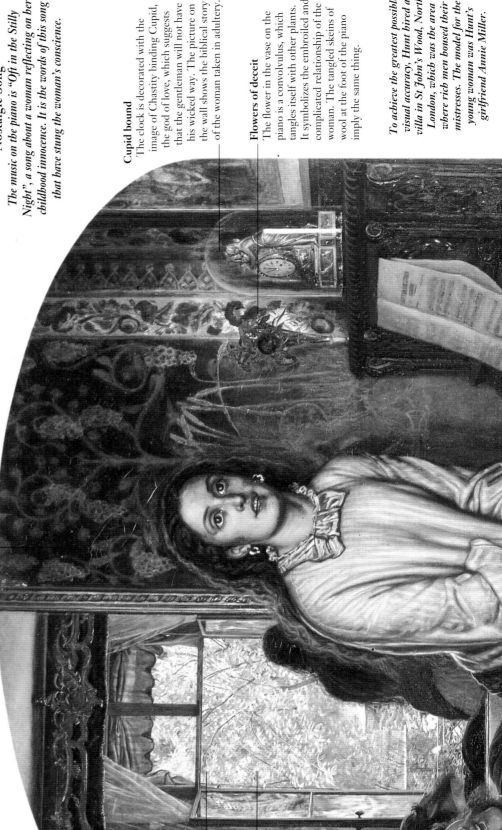

Sleeping Cupid
Even the design of the wallpaper is laden with symbolism. The corn and the vine are left unguarded by the sleeping Cupid, so the birds are able to come and steal the fruit. Hunt is implying that a farmer guards his crops.

Nostalgic Song
The music on the piano is "Off in the Stilly Night", a song about a woman reflecting on her childhood innocence. It is the words of this song that have stung the woman's conscience.

Cupid bound
The clock is decorated with the image of Chastity binding Cupid, the god of love, which suggests that the gentleman will not have his wicked way. The picture on the wall shows the biblical story of the woman taken in adultery.

Flowers of deceit
The flower in the vase on the piano is a convolvulus, which tangles itself with other plants. It symbolizes the embroiled and complicated relationship of the woman. The tangled skeins of wool at the foot of the piano imply the same thing.

To achieve the greatest possible visual accuracy, Hunt hired a villa in St John's Wood, North London, which was the area where rich men housed their mistresses. The model for the young woman was Hunt's girlfriend Annie Miller.

Rings on her fingers

The young woman shows her hands. There is a ring on every finger except that which should bear a wedding ring. She is a kept woman, entirely dependent on the support and whim of the young man. Should he reject her, then it is likely that she would resort to prostitution.

Posture

The woman's posture indicates that she is on the point of rising from the lap of her lover. This is the precise moment when her conscience is awakened. Her lover continues singing and playing the piano. He is entirely oblivious to the transformation that has taken place.

Discarded Glove

The soiled discarded white glove on the floor symbolizes the girl's fate if she stays with her lover.

William Holman Hunt;
The Awakening Conscience;
1853; 76 x 55 cm (30 x 22 in);
oil on canvas; Tate Gallery,
London

William Holman Hunt

WILLIAM HOLMAN HUNT (1827–1910)

Hunt was the co-founder of the Pre-Raphaelite Brotherhood with his friend John Everett Millais (1829–96) whom he met when they were in the Royal Academy schools in 1844. Although the group broke up after five years, Hunt remained faithful to their ideals throughout his life. From 1854 Hunt made several journeys to Egypt and the Holy Land to paint biblical scenes, which he produced with typical Pre-Raphaelite attention to accuracy of local detail. In 1905 he published his memoirs, *Pre-Raphaelitism and the Pre-Raphaelite Movement*.

ART AND NEW TECHNOLOGY

Rapid technological advances in the 19th century presented artists with a number of challenges. Photography, which spread as a practical tool from the 1840s onwards, challenged the artists' previously exclusive ability to make a visual record. At the same time, bright new synthetic colours, which had been produced for the cloth industry, became available to artists. Hunt here meets both challenges: using the new colours extensively, and competing with the detailed accuracy of black-and-white photography.

Hat and book

The hat on the table signals that the young man is a visitor and not a permanent resident in the house. The black bound book relates to Hunt's plans to educate his barely literate girlfriend, Annie Miller.

Hunt exhibited the picture with an elaborately decorated frame, which he designed himself. It contained appropriate emblems, such as marigolds symbolizing sorrow, and bells representing danger. He also included the biblical quotation: "As he that taketh away a garment in cold weather, so is he that singeth songs to an heavy heart", which be cited as his inspiration.

The artist's initials

Hunt has initialled and dated his work in the bottom left corner. In the opposite corner, the shaft of light, falling on the foot of the piano, is symbolic of the girl's salvation, and the strands of wool becoming unravelled from the tapestry is a symbol of her current state, which could well have been her undoing.

"Tears Idle Tears"

The music on the floor is "Tears Idle Tears." It was Edward Lear's musical adaptation of a poem by Tennyson, which contrasted past innocence with present wretchedness. Like the music on the piano, it indicates the sorrow of the woman's present predicament.

Cat and Bird

The cat under the table plays with a bird. There is, perhaps, a double meaning here. Although the cat doubtlessly symbolizes the man toying with his mistress, the bird, which represents the girl, seems to have escaped, suggesting that salvation is possible for her.

THE PAINTER'S STUDIO

COURBET WAS A POWERFUL FIGURE in every sense. A physically large man, he painted big pictures about big subjects: life, death, nature, and human existence. He was always the centre of controversy – artistic, political, and social. He challenged the practices of the conventional art establishment in France during the second half of the nineteenth century. This picture, although painted early in his career, is his masterpiece. It is like a manifesto in which he sets out his central beliefs and opinions. It shows his studio in Paris. There are three groups: himself in the centre; to his right are his friends; and to his left are those whom he said "thrived on death", not just his enemies and the things he fought against, but also the poor and the destitute and the losers in life. We know a great deal about the picture because he wrote about it while he was painting it.

Ghostly pictures
In the background are the ghostly images of two of Courbet's own paintings, both of which had infuriated the art critics when displayed: one showed peasants, the other a fat female bather. Courbet always puzzled the critics and the art establishment. They recognized his considerable technical skill, but his offensive (in their opinion) subject matter, and his resolute refusal to produce conventional "High Art", baffled them.

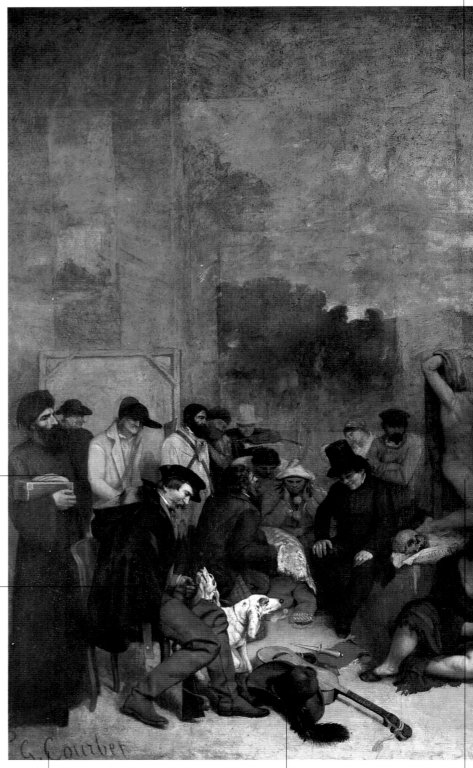

Death to the Critics
On a table to the immediate left of the artist there is a skull, which is the archetypal symbol of death (see p.52). The skull is resting on top of a newspaper. This is Courbet's unambivalent comment on the critics who were extremely powerful in shaping popular and artistic opinion in the 19th century.

❝ *The sea's voice is tremendous, but not loud enough to drown the voice of Fame crying my name to the entire world* **❞**
GUSTAVE COURBET

The gathering of the exploited
Among the people gathered together on the left are a Chinaman, a Jew, a veteran of the French Revolution, a labourer, an Irishwoman, and a poacher. They are not Courbet's enemies; they are the losers and the exploited – those on whom his enemies feed and thrive. They may also have allegorical roles as well, but if so Courbet did not spell them out exactly, preferring to maintain a certain private ambiguity and mystery.

Napoleon III, a disguised tyrant
The figure in the foreground wearing huntsman's dress is Napoleon III, the effective dictator of the French Second Empire. He created a harsh, repressive, and financially greedy regime, which ended in disaster and a popular uprising. Courbet was a committed and active political opponent.

GUSTAVE COURBET (1819–77)

Courbet was born at Ornans, close to the Swiss border of France. He went to Paris in 1839, and exhibited paintings regularly at the Salon. In 1853 a wealthy art collector, Alfred Bruyas, whose self-esteem almost equalled Courbet's, sat for the first of many portraits and brought the artist financial security. Courbet's strong political views were to prove his downfall. He was forced to flee France after the political turmoil of the Paris Commune, which he actively supported. He developed dropsy, and died in exile in Switzerland.

Gustave Courbet

Cloak and dagger
Abandoned on the floor is a large floppy hat with a feather, a cloak and dagger, and a guitar. These are the typical gear of the Romantic artist. Because Romantics live in the world of dreams and emotion rather than the world of realities, Courbet rejects them as well.

Signed in blood
Appropriately for one who had such a large ego, Courbet has one of the largest and most prominent signatures of any artist. He sometimes signed his name in red, the symbolic colour of blood and revolution.

Crucified figure
In the shadows behind the easel there is a figure in the pose of the Crucifixion. This is a "lay figure" – a lifesize jointed wooden doll that a conventional artist would copy. Here it symbolizes academic art, which Courbet rejected. It is also overshadowed by the new type of art on the easel in the centre of the painting – a realistic landscape.

The Artist's Friends
On the right side of the painting Courbet produced portraits of individuals whom he admired. The men above (from left to right) are the art collector Alfred Bruyas, the socialist Pierre-Joseph Proudhon, Urbain Cuenot, and Max Buchon.

Plaster medallion
The plaster medallion of a woman's profile is one of the very few props depicted in the bare studio. It is an example of Courbet's experiments in bas-relief sculpture at that period.

The painting is enormous, and the figures are life size. Even now it makes a powerful impact, and the dark colours are his conscious choice. It was begun and completed within 10 months – a prodigious feat of artistic virtuosity.

The light of life
Light is shown entering through a window on the right side – the side of life. The studio was also lit by a large skylight.

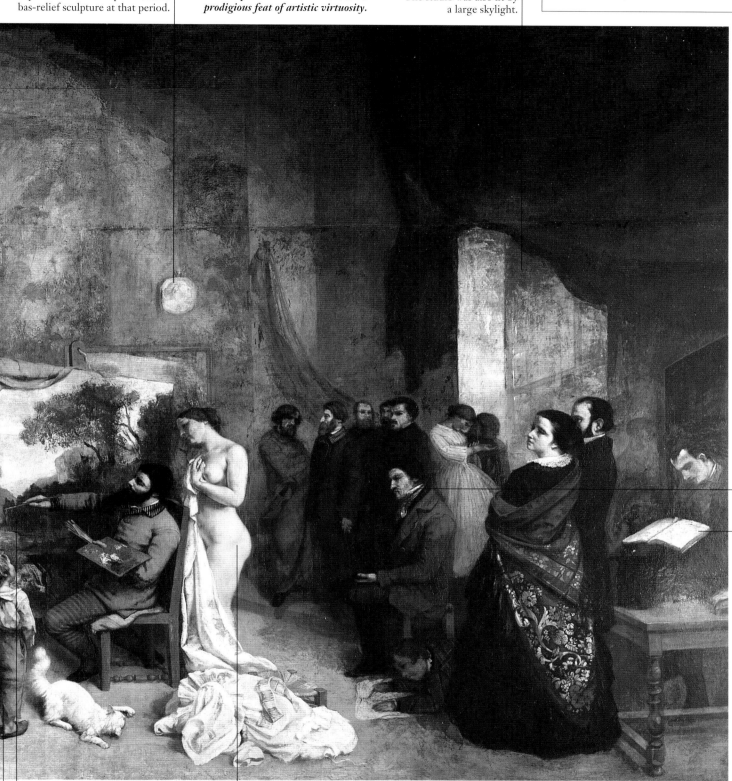

Most of the figures on the right side of the painting had a positive bearing on Courbet's development as an artist and human being. The only ones not specifically identifiable are the lovers in the window, and the husband and wife in the foreground who are rich art collectors. In spite of his independent views, Courbet still needed patrons.

Champfleury
The central figure among Courbet's friends is the writer Champfleury, who was the founder of the Realist movement in literature. He introduced Courbet to the theories of Realism, but he and his writings were soon overshadowed by the power of Courbet's personality and paintings. Champfleury did not like this picture, and his friendship with Courbet did not last. He disapproved of Courbet's involvement in politics and attempts to scandalize the public.

Baudelaire
The figure seated on a table at the far right reading a book is the great French poet Charles Baudelaire (1821–67); behind him and next to the dark mirror is the ghostly figure of the poet's mistress Jeanne Duval. Courbet had painted over this figure, but it is reappearing as the paint thins in this area.

Gustave Courbet; *The Painter's Studio*; 1855; 361 x 598 cm (142 x 235½ in); oil on canvas; Musée d'Orsay, Paris

Landscape
On the easel is a large landscape, depicting the artist's homeland. The art establishment still did not consider landscape a fit subject for a serious painter. Courbet is effectively declaring war on the establishment, refusing to bow to their ways.

The eyes of innocence
The young boy by the canvas is naive and uneducated. Courbet prefers the open-minded and honest directness of the entranced child's view to the false values of so-called educated opinion. The child's presence is also an excuse for the artist to turn away momentarily from his work and show off his famous "Assyrian" profile of which he was very proud. Despite his vanity, the artist refused to wear the fine clothes of the art establishment, preferring to dress and behave like a provincial.

The naked truth
The woman standing behind Courbet represents naked truth guiding his brush; that is, he is seeking to paint pictures that are true to life and up to date. The tilt of her head balances the tilt of the artist's head in the opposite direction.

Child Artist
The boy kneeling on the floor is making a crude sketch on a large piece of paper. Like the young boy placed in front of the easel, he has not been shackled by the rigidity of formal education. He simply records as best he can what he sees, and this was one of the central principles of Realism. Courbet includes him as a symbol of the freedom and spontaneity on which the future of art depends.

AUTUMN EFFECT AT ARGENTEUIL

MONET WAS THE LEADING IMPRESSIONIST painter, and this work is the quintessential Impressionist painting – a modern landscape painted in a modern style on a small scale, with no story to tell and no moral instruction to communicate. It is a faithful rendition in paint of the impressions and sensations experienced by the eye. The location is Argenteuil, one of the small towns close to Paris on the River Seine that were being opened up to industry and commuters by the railways. Monet lived at Argenteuil between 1871 and 1878.

Nature's Textures
Monet was fascinated by textures – not just the textures of his own painting, but also the textures visible in nature. Clouds are painted with a soft, rounded stroke to imitate their woolly textures, and the river is painted with short, horizontal strokes to suggest its smooth but gently rippled surface.

The quality of sunlight
Seen from a distance, the picture gives an instant and brilliant impression of the quality of sunlight and the colours that are so characteristic of autumn. Close up, this effect is lost but the eye is captivated by the rich textures, the brushstrokes, and the quality of the paint surface – all woven together to sensuous effect.

Rainbow palette
Monet has used warm golds to suggest the autumn leaves. On the left, pinks and yellows are counterpointed by touches of green. This is one of the first works where Monet fully embraced the rainbow palette that was to become a hallmark of the Impressionist artists.

The style of painting created by the Impressionists was facilitated by the artists' materials that had recently become available. Whereas the Old Masters had to mix their own colours, the Impressionists could buy paint ready mixed in easily portable metal tubes – familiar today, but an innovation then.

Framing device
The expanse of blue water leads the eye into the picture. The paler blue of the distance and the frame of the two masses of the trees help to pull the eye into depth, and is in essence the same sort of device that was used by Claude (see p.54) to create the effect of recession.

Bold brushstrokes
The brushstrokes along the bottom edge of the picture are relatively large and bold. Monet grades them so that they become smaller as the eye is led into the distance.

Monet has employed the newly available scientific knowledge about colour theory. For example, he has used the optical contrasts between complementary colours that give the maximum optical vibration to the retina of the eye.

Chimney or church spire?
In the distance is a chimney from one of the new factories that appeared at Argenteuil. Although Monet was stimulated by the rapid social changes happening around him, he often "edited out" ugly buildings if they spoiled his intended effect. Here, the chimney could quite easily be mistaken for a church spire, and it does not intrude on the tranquil atmosphere.

THE IMPRESSIONISTS

The "Impressionists" was the collective name for a group of highly talented young artists who exhibited together, including Monet, Renoir (see p.88), and Cézanne (see p.96), united by their dislike of the current standards of academic art (which they deemed false) they also disliked the emotionalism and sentimentality of Romantic art. Like Courbet (see p.82), whom they admired, they wanted detached and objective art, but they were not attracted to his social Realism. Landscape and still life provided subjects through which they could experiment with the objective recording of their "impressions". It was Monet who remained the most dedicated and consistent exponent of this type of Realism.

Rippling Wind
The trees on the right of the painting clearly show where Monet has scratched into the surface of the paint with the sharp end of his brush, lightening the density of the paint and creating the elusive impression of the wind rippling through the autumn foliage.

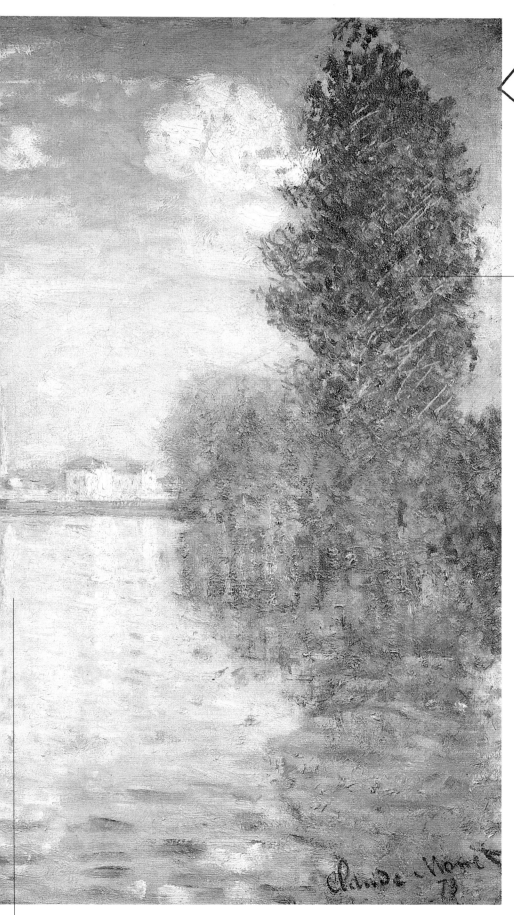

Luton Sixth Form College Learning Resources Centre

❝ *Monet is only an eye but, my God, what an eye!* **❞**
PAUL CEZANNE

Throughout his life Monet was fascinated by light effects and the challenge of capturing their appearance in paint. This work prefigures the famous "water lilies" series painted in his garden at Giverny, not far from Argenteuil. He built his famous lily pond so that he would have a permanent expanse of water reflecting the sky, and light that he could observe at all times of day.

Warm reds and cool blues
Monet uses contrasts of colour temperature in close proximity, for example warm reds and oranges next to cool blues to create the sensation of warmth combined with freshness – one of the special qualities of a sunlit autumn day.

The term plein-air *painting refers to work that is begun and mainly completed out in the open air and/or conveys the sensation of being in the open air. True Impressionist paintings have both these qualities. A reason for their small scale is that the canvases needed to be portable so that it was possible to paint on the spot in front of the chosen subject, and largely complete the picture in that place.*

A Band of Blue
The narrow band of blue between the River Seine and the town creates a strong visual focus, and acts as a sort of bridge tying the two groups of trees together. The detail shows how Monet worked and reworked the surface, weaving different textures and colours together to give the effect of objects dissolving in an envelope of light.

CLAUDE MONET (1840–1926)

Monet spent his youth in Le Havre, in northern France. It was here that he developed his predilection for outdoor painting, inspired by his mentor Eugène Boudin (1824–98). In 1862, he entered the studio of Charles Gleyre (1808–74) in Paris, where he met Renoir, the other figure central to the Impressionist group. Monet pleaded poverty for much of his life but by 1890 his reputation was established. In his later years he was troubled by failing eyesight.

Claude Monet

Reflected images
Typical of Monet is the equally balanced composition where the shapes above the horizon are mirrored by the shapes below the horizon – the reflections in the water.

Claude Monet; *Autumn Effect at Argenteuil;* **1873; 55 x 74.5 cm (21½ x 29 in); oil on canvas; Courtauld Institute Galleries, London**

THE DANCE CLASS

DEGAS WAS FASCINATED by the ballet, and over half of his works (both paintings and sculptures) are devoted to this theme. Although he made paintings of dancers on stage, Degas much preferred the more informal scenes of dancers rehearsing and relaxing. There are parallels between the activity of classical ballet and Degas' style and method of painting that help to explain his interest. Classical ballet is an art form of great precision and balance, and perfection is only achieved by constant repetition and practice. Degas' art is also one of the finest precision. Although he exhibited with the Impressionists, he achieved a sense of immediacy through his subject matter and composition rather than through the spontaneous brushstrokes typical of "true" Impressionists.

Compositional Changes

X-rays show that Degas made many changes to this picture. For example, there were two dancers in the foreground who originally faced the viewer. One can still be seen between the two dancers that are now there, painted over the original idea. The instructor originally stood facing the back wall.

Dancers and their Mothers

At the back of the room is a group of gossiping dancers accompanied by their mothers. In Paris at this time, ballet was not a respectable activity, and many dancers fell into prostitution. It was never clear whether the mothers were there to protect their daughter's morality, or to ensure that they received the best offer available.

Casual poses

The group of young ladies at the back of the room adopts a variety of casual poses and appears to pay no attention to the master. Particularly delightful is the girl seated on the platform adopting a rather unflattering pose, with her arms folded, pointing her feet. Above her, a girl stands, arms akimbo, echoing the pose of the dancer nearest to us, creating a subtle diagonal line that follows the line of the floorboards.

Japanese influence

Like many artists of the time, Degas was influenced by the Japanese wood-block prints that were in fashion. Their influence appears in the effect of the steeply rising floor and the asymmetrical and unbalanced composition.

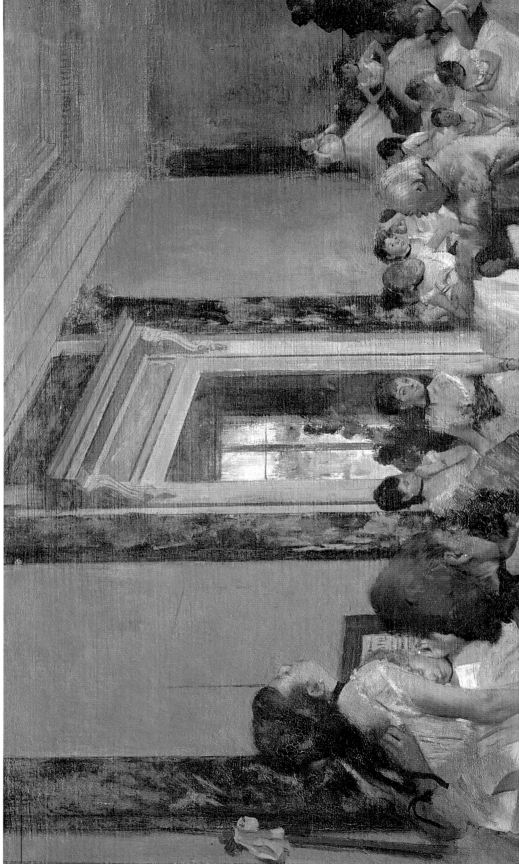

Strong verticals

The marblework that is part of the room's architecture creates strong verticals, which lead the eye to the back of the room where a girl, standing on a low platform, is adjusting her choker.

Skilled draughtsman

Degas was the finest draughtsman of his generation, and his interest and skill in drawing has often been compared with that of his great compatriot Watteau (see p.60). The accuracy with which the artist has observed the girl sitting on the piano scratching her back, and the confidence and precision of the line that defines her form and movement, are astonishing. This accuracy of observation and draughtsmanship is repeated throughout the painting.

Bright sashes
Degas' palette is a traditional one of earth colours. He "modernized" his colour scheme with accents of bright colour, which he introduces notably through the sashes.

Degas spent countless hours backstage at the Paris Opera making sketches, sometimes using photography, so that he built up a large repertoire of poses and images. He was then able to select from these when he worked out his set-piece compositions which he created in his studio.

Watering can
Degas has signed his name with typical precision on the green watering can. The can was used to dampen the floorboards, which became very dusty.

Dancing master
In the centre of the picture is Jules Perrot, a famous ballet dancer who, with his partner Maria Taglioni, had once been the star of the Paris ballet. He seems to be talking to, or commenting on, the dancer who is framed by the doorway. He is the central axis of all the activity in the room, even if he does not succeed in holding everyone's attention.

Empty space
The contrast between the empty space in the bottom right, and the crowded groups of figures, which cut into the space, is a device that was much explored by Degas.

Edgar Degas;
The Dance Class;
c.1873–75; 85 x 75 cm (33½ x 29½ in); oil on canvas; Museé d'Orsay, Paris

Diagonal boards
Typical of Degas is the strong diagonal composition (made all the more evident here by the clear lines of the floor boards) that pulls the eye into depth.

A cool reception
Although we feel that we are standing with Degas in the corner of this room, the nearest dancers have their backs turned, and no-one catches our eye or acknowledges our presence. This sense of being present and yet ignored is a quality that adds tension and *frisson* to Degas' work. Degas was a lonely, reclusive man, and the mood in his work reveals one who observes with the greatest accuracy and interest what others are doing, but who is never part of the action himself.

The painting was shown in London in 1876 when it was sold to Captain Henry Hill of Brighton. It was then sold at auction at Christie's in 1889, being bought by van Gogh's brother Theo who was working for the Parisian art dealers Goupil. It was bequeathed to French state collections by Count Isaac de Camondo in 1911.

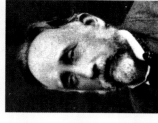

Edgar Degas

Edgar Degas (1834–1917)

Degas abandoned his law studies when he was 18 years old in order to concentrate on his career as an artist. Like his compatriot Manet, with whom he shared the same upper-middle-class background and whom he befriended in 1862, Degas was inspired by modern life in his native Paris. He was closely involved in the organization of the first exhibition of Impressionist painting in 1874, although he did not consider himself to be an Impressionist painter. Indeed, his style was very different from that of the Impressionists – he worked slowly in a studio rather than outside in the open. Degas was a shy man with an acid wit who was obsessive about his privacy. Due to failing eyesight during the 1880s, he worked more often with sculpture and became increasingly anti-social.

❝*A painting requires as much fraudulence, trickery, and deception as the perpetration of a crime***❞**
Edgar Degas

Using Photographs

The "photographic" quality of Degas work is often remarked on. The very rapid perspective recession, in which the two nearest dancers seem to be pulled forward and the distant group pushed back, is an effect created by certain types of camera lenses, and is not a function of ordinary human perception. The way that figures are cut off by the edge of the picture is also typical of photography. This was a technique that Degas often employed, creating a sense of casualness that belies the artist's meticulous and considered skill at composition.

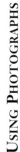

Sniffing Dog
The terrier sniffing at the dancer's legs is a delightful detail. Like the watering can, it is a necessary accent in the precise composition (take it away with your finger and something is lost – the eye needs such a detail to hold it at this point). It is also a good example of Degas' "calculated spontaneity".

THE LUNCHEON OF THE BOATING PARTY

RENOIR WAS ONE OF THE EARLY adherents of Impressionism, and this is his last major work in that style before he returned to techniques more akin to the Old Masters. He was conscious that he had undertaken an ambitious work, and he pushed himself to his limits during a whole summer living "on site" at Chatou. The picture has no story line or symbolism, and in many respects its theme of youthful pleasure-seeking and love is simply a more modern version of Watteau's *A Journey to Cythera* (see p.60). The setting is a famous restaurant on the Seine, near to a bathing place, *La Grenouillère*, which was popular with young people.

Friend of the Impressionists
Baron Raoul Barbier, a former cavalry officer and a close friend of Renoir's, sits with his back towards us. He helped Renoir organize his friends to sit for the painting. He is shown chatting to the proprietor's daughter Alphonsine, who leans on the railing of the balcony.

Enjoying the River
Boating activity can just be glimpsed in the space between the awning and the bushes. Along with swimming, it was one of the principal leisure attractions of the river.

The Restaurant Fournaise
M. Fournaise (in the straw hat) was the proprietor of this popular restaurant. Famed for its food and lively atmosphere, it was a popular meeting place for oarsmen.

The guests at the luncheon party are Renoir's friends. The identities of most have been established from a photograph with their names written on the back.

❝I have a predilection for painting that lends joyousness to a wall**❞**
PIERRE AUGUSTE RENOIR

Impressionist Brilliance
Renoir paints in a true Impressionist style, using a palette of rainbow colours and with short, broken brushstrokes. Shadows are often bright blue rather than black.

Pierre Auguste Renoir; *The Luncheon of the Boating Party*; 1881; 129.5 x 173 cm (51 x 68 in); oil on canvas; Phillips Collection, Washington, D.C.

Wife and model
Aline Charigot, Renoir's girlfriend, coos at her little dog. Renoir married her the year after this painting was completed. She was a devoted wife, and it was a very happy marriage.

Master of still life
Renoir was an accomplished still-life painter, and the debris of this meal is a sparkling achievement. The spontaneity is deceptive, since he constantly reworked the painting.

The location of the restaurant Fournaise is the Isle of Chatou, just west of Paris, on the River Seine. In the 1880s, it was an open-air place where Parisian city dwellers could go, travelling by train, to escape the dirt and noise of the city for a day of relaxation and fresh air.

Awning and even light
The awning stretched above the scene creates a more even light than that which usually appears in Renoir's work. Renoir was fascinated by the effects of dappled sunlight, which is exquisitely evoked in many of his paintings.

Innocent flirtation
The trio in the top right hand corner includes Lestringuez (in the bowler hat), a friend of Renoir's who was interested in hypnotism and the occult. Paul Lhote, wearing pince-nez glasses, flirts with the actress Jeanne Samary. He had a reputation as a ladies' man.

Late Addition
The man in the background wearing a top hat is Charles Ephrussi, who was a banker. He was added later, and it is possible to see different paint layers and marks under the surface in this area of the picture, indicating the changes that have been made.

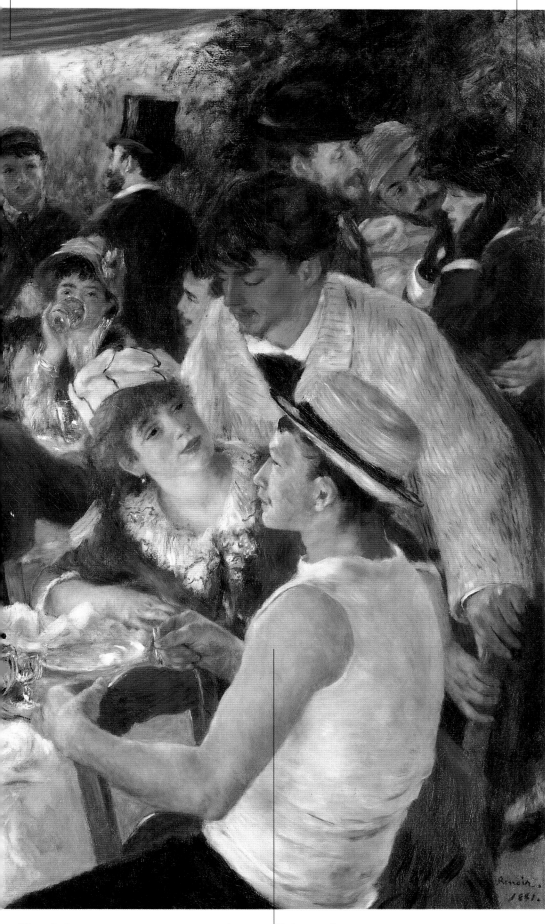

UNDERLYING STRUCTURE

This busy picture has a simple underlying structure. One diagonal (AB) places the table and the two groups who form trios on one side, and the single figures on the other. The other diagonal (CD) places M. Fournaise and Mlle Charigot on one side, and everyone else on the other. The figure groups and still life fall neatly into the four resulting triangles.

PIERRE AUGUSTE RENOIR (1841–1919)

Born in Limoges in France, Renoir was to become one of the key figures of the Impressionist movement. At the age of 13, Renoir worked as a painter in a porcelain factory in Paris. When he was 19 years old, he embarked on his career as an artist. Renoir formed a lasting friendship with Monet (see p.84). After 1883, he developed a more classical style. Although crippled by arthritis, Renoir continued painting into old age.

Pierre Auguste Renoir

The painting seems as spontaneous as a snapshot. Renoir's favourite model, Angèle, in the centre of the picture, has been "caught" with a glass raised to her lips. Behind her, the proprietor's son casually smokes a cigar and converses with Charles Ephrussi.

Painter and patron
This trio is deep in conversation. The man in the straw hat is Gustave Caillebotte, a talented artist but better known as a patron. The girl is the actress Ellen André, who regularly posed for Renoir. The journalist Maggiolo stands behind her.

A BAR AT THE FOLIES-BERGERE

MANET'S FAMOUS PICTURE is set in the Folies-Bergère, one of the celebrated café-concert venues of late 19th-century Paris, much loved by artists. They were places in which to meet people from all social classes, to eat and drink, to entertain, and to see and be seen. The arrangement and composition of the picture is typical of Manet at his best: a simple and memorable structure within which the eye and the imagination are kept constantly alert. At the centre stands the barmaid Suzon, lost in thought. At our left is a busy crowded scene, and at our right is what seems to be a reflection of Suzon talking to a customer. But is it? The more the picture is studied the more intriguing it becomes – like the daydream of Suzon herself.

Friends in the Crowd
The woman looking though her opera glasses is unidentified, but she symbolizes this society where to see and be seen was all important. The woman in white on the far left of the balcony is a friend of Manet, May Laurent, and the woman behind her in beige is another friend, Jeanne Demarsy.

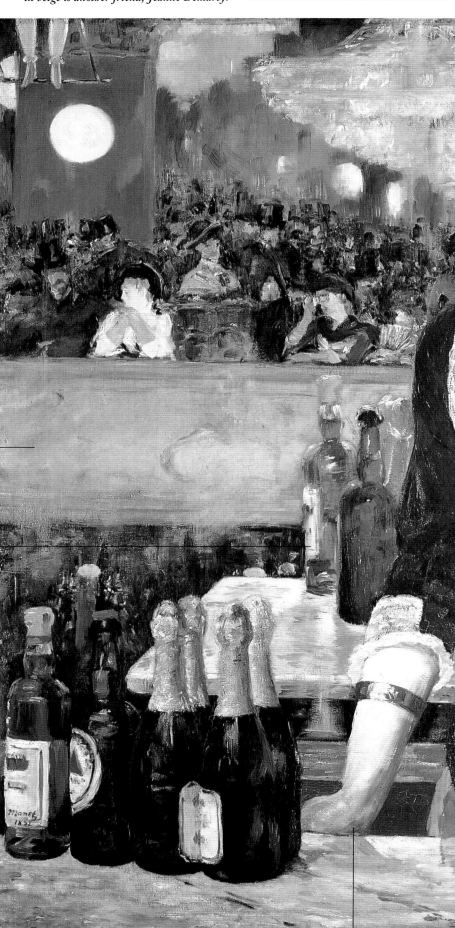

Acrobat
In the top left corner are the pink-stockinged legs and bright green shoes of an acrobat who is providing the entertainment at the café-concert. But nobody, least of all Suzon, seems interested, and the acrobat's presence serves only to heighten the barmaid's air of sorrow.

Dissecting balcony
The balcony reflected in the mirror provides a horizontal band that dissects the composition. Other strong horizontals define the top of the bar and the reflection of the bar. Suzon and the bottles tie these bands together.

A spatial arrangement
Manet loved playing with space. Note how he uses the mirror and bottles here to push space back, and uses them on the other side to do the exact opposite; that is, to pull space forward. The reflection of the bottles does not correspond with their arrangement on the top of the bar.

A cocktail of classes
Although Manet usually avoids any conscious or overt symbolism in his pictures, preferring instead to show modern life in a factual way, the bottles do contain nuances of meaning. Champagne, the drink of high society and the well-to-do, stands next to a bottle of English Bass beer, identifiable from the red triangle on its label, which is more often associated with the lower classes. The society of the café-concert was similarly mixed: dandies (like Manet himself), workers, and prostitutes of the *demi-monde* rubbed shoulders with each other, and enjoyed each other's company.

> **❝***I love this life, I love the salons, the noise, the lights, the parties...***❞**
> EDOUARD MANET

Vintage Manet
The artist's signature and the date, 1882, appear on the label of the bottle in the far left corner of the painting.

Manet is painting a place that he knew intimately. It was a place where he felt at home, preferring the bustle and sharp edges of city life in the metropolitan capital to the more relaxed and slower pace of the country or provincial cities.

A barmaid at the Folies-Bergère
Manet chose as his model a girl called Suzon, who was in fact one of the barmaids who worked at the Folies-Bergère. The majority of Manet's paintings were of women, and he formed lasting relationships with many of his models.

Electric lighting
Manet captures the brilliance of electric lighting, which was becoming popular in more exclusive venues. The brushwork defining the chandelier reflected behind Suzon complements the delicate lace in the sleeves and collar of Suzon's bodice.

Lost in thought
Suzon is lost in her own thoughts, and we must search for clues to unlock her inner thoughts, and share the intimacy of this moment.

EDOUARD MANET (1832–83)

Manet was born into a comfortable upper-middle-class family and so was not obliged to sell paintings to make a living. An urbane and amiable character, he was the centre of the Impressionist circle (see p.84), counting Monet and Renoir among his close friends. Throughout his career, Manet's paintings caused shockwaves in the conservative Academy, by whom he was accepted only in the last years of his life.

Edouard Manet

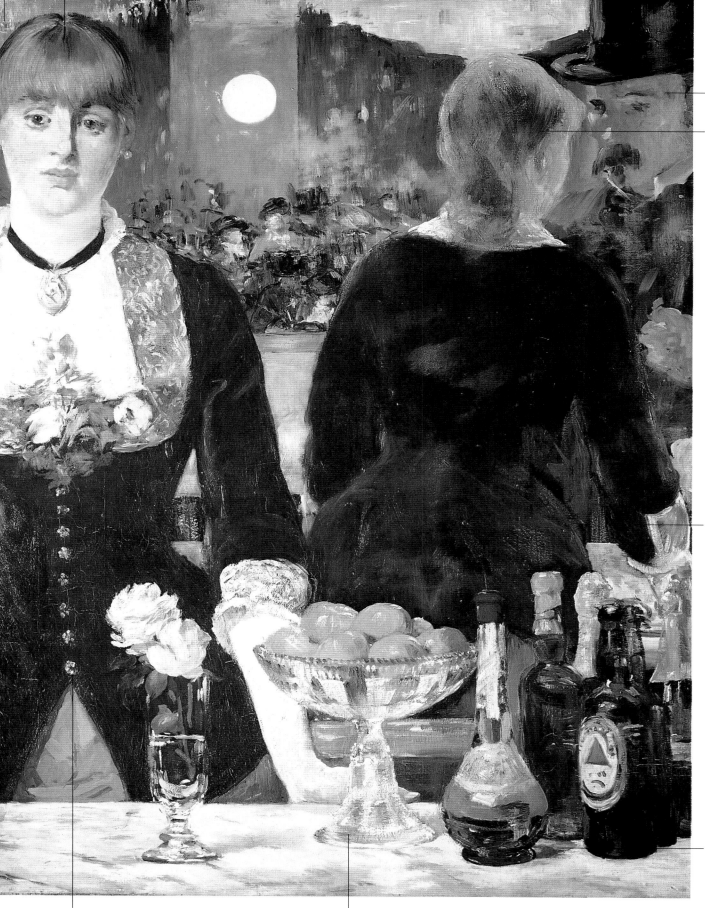

Gaston Latouche
Manet asked a fellow artist called Gaston Latouche to pose for the man who talks to the barmaid. But, compared with the face of Suzon, the man's face is not individualized.

Reflections of a barmaid
Logically, Suzon's reflection would not appear in this position, and her pose is different to that of the girl who gazes out of the canvas. The reflected Suzon is in conversation with a man whose presence we must imagine in our own viewing space in front of the picture. The images make sense only when they are looked at on a poetic level. Perhaps this is the conversation that Suzon had a few minutes earlier, and on which she is now reflecting? Perhaps this is the conversation she hopes she will have, meeting the man who will fall in love with her and take her away from the drudgery of her barmaid's existence?

Although he was invited to join the Impressionists when they held their own exhibition in 1874, Manet declined the invitation. Despite his loyal support for the Impressionist movement, he saw his own work as being more traditional and continued to pursue success in the Salons. In 1881, he finally received the coveted Légion d'Honneur.

Painting in black
Manet is renowned for his love of large flattish areas of rich, sensual colour. In particular, he loved black (in direct contrast to the Impressionists who did not use black in their palette), which is one of the most difficult "colours" to handle successfully and bring to life. He was a great admirer of Velázquez (see p.56) whose works were being rediscovered by avant-garde artists of the day.

The world shown by Manet in this picture is one that is also recalled in novels of Emile Zola such as Nana. *Zola was a good friend of Manet's and was a pall-bearer at the artist's funeral. The great Impressionist artist Claude Monet (see p.84) was also a pall-bearer.*

Rare shadows
Although there are many reflections, there are only a few shadows. This is typical of Manet's work.

Edouard Manet; *A Bar at the Folies-Bergère*; 1882; 96 x 130 cm (37½ x 51½ in); oil on canvas; Courtauld Institute Galleries, London

Strong vertical
A strong vertical runs down Suzon's face and dress so that each side of her is like a reflection of the other.

Succulent fruit
The still-life details of the flowers in the glass and the fruit in the bowl are painted with exceptional richness of colour and succulence of paint. Manet made many such still lifes, painted directly from the object. The pair of roses offset the flowers pinned to Suzon's bodice.

LA GRANDE JATTE

SEURAT TOOK TWO YEARS to complete this monumental painting, and it is a work of astonishing maturity for a young man not yet 30 years old. Shown at the last Impressionist Exhibition in 1886 it created an immediate sensation, both for the novelty of its modern subject matter, and the innovative techniques with which it was painted. In this painting, showing Parisians enjoying a Sunday by the Seine, the artist reconciles a number of potentially conflicting values, combining the innovations of the new scientific age with the enduring qualities of the timeless masterpieces of ancient art.

"Divisionism"
The picture demonstrates the theory of "Divisionism". Colours were broken down into their component parts, so that rather than being mixed as pigments and applied to the canvas, they would, when seen at the right distance, be mixed in the eye.

Boating on the Seine
The picture notionally shows the island of the Grand Jatte on the River Seine near Neuilly, where well-to-do Parisians went for recreation on Sundays. Boating activities were all the fashion. However, Seurat is not trying to give us a convincing or real picture of the Grand Jatte and its visitors. They are a vehicle for his explorations of subject matter and colour theory, and the static and academic quality of the painting says more about Seurat's own personality and highly theoretical approach to art than it does about Parisians in the 1880s.

Women fishing
The women fishing on the banks of the Seine have been identified as prostitutes, using the sport as a front for their real objective. The soldiers in the distance represent their potential "catches".

Egyptian influence
Many figures are shown in profile, reflecting the influence of Ancient Egyptian art, which Seurat was studying at this period. He made many sketches from Ancient Egyptian reliefs on his visits to the Louvre in Paris.

Divisionism in practice
In direct sunlight, local colour is interwoven with dots of yellow and orange pigment. In the shadows blue is interwoven, and there are more extensive and subtle colour inter-weavings and reactions. A few dots of orange and yellow represent the stray particles of sunlight that filter in. There are also reds and purples to show light that has been partly absorbed and reflected back to the eye.

ART IN THE 1880S

The 1880s was a flourishing period for the arts. Wealthy collectors were spending large sums of money on contemporary art in the traditional and academic styles, unaware that the Neo-Impressonists, like Seurat, were pioneering ideas that would change the face of art. Young artists were excited by the prospect of a new century and, embracing modern scientific colour theories, actively sought to create a modern style of art that would be expressive of this new epoch.

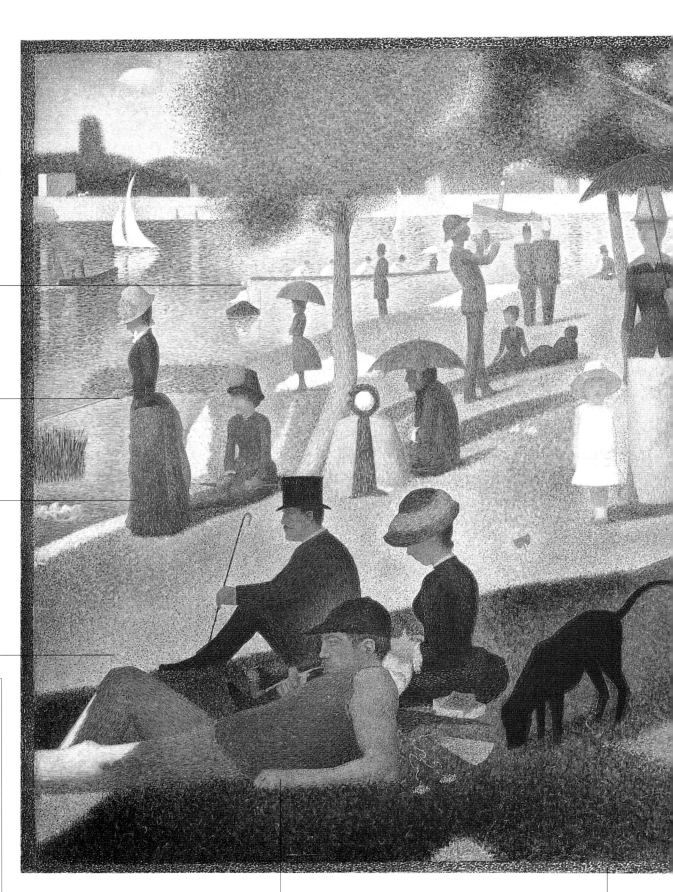

Mixed classes
Like Manet (see p.90), Seurat shows a mixture of classes and types enjoying themselves together, innocently or otherwise. Here, a rough-looking oarsman sits near to a middle-class lady (her dainty fan striking a particularly incongruous note behind the lounging bulk of the boatsman. A "toff" in a top hat sits close by.

Painted frame
In order to produce exactly the right optical effect in the eye of the spectator, Seurat has dispensed with the conventional gold frame and painted his own border, or "frame", around the picture. This painted frame has been designed so that in any one section it contains the complementaries of the colours that are next to it in the painting.

GEORGES SEURAT (1859–91)

Seurat was born into a comfortable bourgeois family in Paris, and trained at the Ecole des Beaux Arts, which he entered in 1878. He made meticulous studies from such masters as Raphael (see p.32) and Poussin (see p.50). In 1879, military service interrupted his studies. In 1884 he began work on his masterpiece *La Grande Jatte*, which was hailed by critics as offering the way forward from Impressionism (see p.84). Tragically, he died, at just 31 years of age, from meningitis. He left a one-year-old son and common-law wife (Madeleine Knobloch, his former model).

Georges Seurat

Static Atmosphere
In seeking to achieve the timeless and monumental quality that characterizes Piero (see p.18) or Poussin (see p.50), Seurat created a similar static mood. It is as if all the humans have been ordered to hold their breath and not move, and even the oarsmen and sailing boats seem frozen in time. But there are a few subtle accents of motion, which it takes time to discover: the girl running, the small dog in the foreground, and the six butterflies.

❝I painted like that because I wanted to get through to something new – a kind of painting that was my own ❞
GEORGES SEURAT

Geometric landscape
Many of Seurat's sketches concentrated on the layout and geometric composition of the landscape and contained no figures, illustrating the painter's meticulous and studious approach to his art.

Seurat made many visits to the Grand Jatte and made 38 oil sketches and 23 preparatory drawings for this painting. They were working material for the creation of this masterwork in his studio. So obsessive was he that there are anecdotes of him asking friends to cut the grass by the river when it had grown too long. Even if such stories are not true, they indicate the nature of Seurat's personality and the sort of reputation that gathered around him.

Fashionable dress
Although the static quality and geometric composition of the picture gives it a timeless quality, the men and women are dressed in the height of fashion particular to the 1880s. The ladies have the nipped-in corsetted waists and bustles then fashionable. Seurat used fashion plates from magazines as models for the figures.

One of the interesting features of the picture is that it is innovative on two levels: it explores a new monumental subject matter which appealed greatly to those artists who believed in the importance of poetic and symbolic subjects; and it explores new painting techniques, appealing to those interested in perception and light.

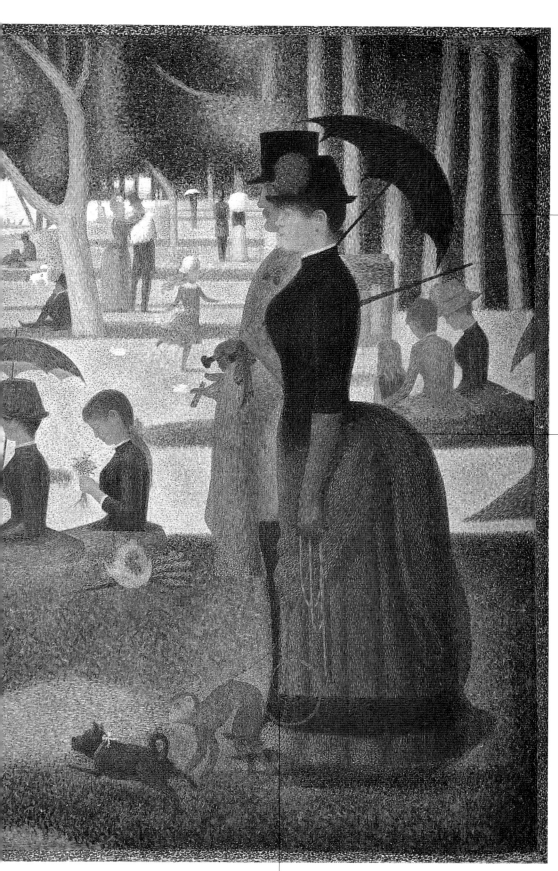

Perspective scheme
Why do this couple and the woman with the monkey seem so disproportionately large? The perspective scheme of the picture is worked out so that it ought to be viewed at an oblique angle from the right, and not straight on. From this angle the apparent distortions disappear. (Hold the page so that the right-hand edge of the picture is close to you and the left-hand page points away at a 45° angle.)

Georges Seurat; *La Grande Jatte*; 1884–86; 205 x 304 cm (81 x 120 in); oil on canvas; **The Art Institute of Chicago**

Monkey Business
Capuchin monkeys were fashionable pets in Seurat's day. It has been suggested that the monkey represents licentiousness. The monkey on a leash indicates that the woman, a prostitute, successfully feigns respectability. Seurat was perhaps including a coded message about the hypocrisy that was a feature of French society at the time.

THE BEDROOM AT ARLES

VAN GOGH'S PAINTINGS are among today's best-known images. Reproductions sell in their millions, and the paintings have sold for tens of millions of pounds. The contrast between his own failure and rejection, and his posthumous success, is notorious. Van Gogh painted three versions of this picture. The first was painted in October 1888, when he was waiting for his fellow artist Paul Gauguin (1848–1903) to join him at Arles in southern France. This is the third version, which he painted for his mother in 1889 while recovering from a mental breakdown in a lunatic asylum at St Remy. All three versions differ slightly in their colouring and detail. Ten months after this picture was painted, van Gogh committed suicide.

Windows ajar
The windows are ajar and open inwards, implying access to the outside world, but significantly there is no clear view – they might just as well be shutters. This makes the room appear self-contained and womb-like. The open space in front of the bed helps prevent the picture from becoming too claustrophobic.

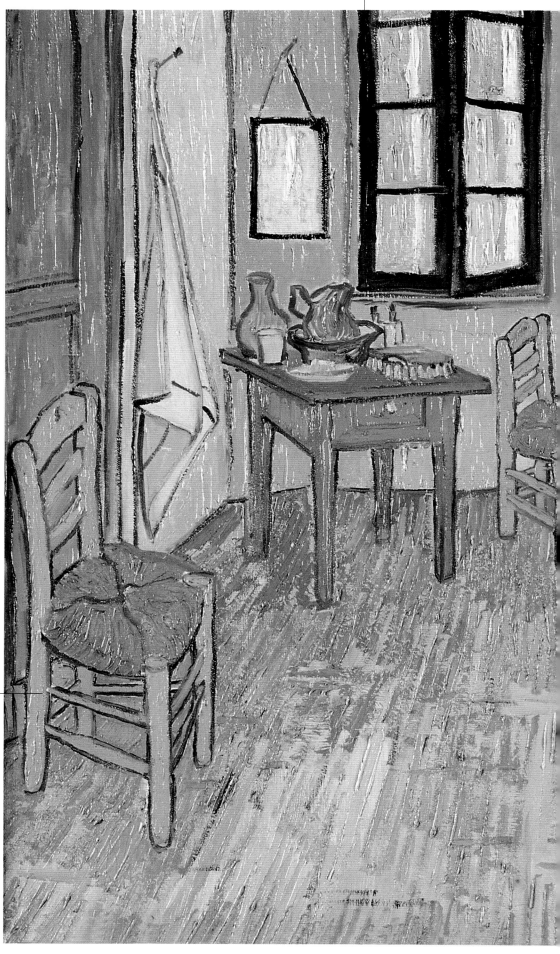

Two of Everything
Many of the objects in the room are paired – two chairs, two pillows, two waterjugs, and two bottles. The first version of this scene was painted in anticipation of Gauguin's arrival, and the pairing can be seen as van Gogh's never-fulfilled wish of partnership and friendship.

❝*When I saw my canvases again after my illness, the one that seemed the best was* **The Bedroom ❞**
VINCENT VAN GOGH

The seat of happiness
The actual chair in van Gogh's bedroom was made of plain white wood. He has painted it yellow for symbolic reasons – yellow being the colour of sunlight, warmth, and happiness. Although he believed in painting directly from nature, van Gogh constantly transposed or intensified colours.

Thick Impasto Brushstrokes
Paint is applied very thickly and individual brushstrokes are clearly visible. Van Gogh used paints straight from the tube and painted rapidly, often completing a picture in a single day. His consumption of paint – notably yellow – was large, hence his constant pleas to his brother Theo to send more materials from Paris.

Vincent van Gogh; *The Bedroom at Arles;* **1889; 57.5 x 74 cm (22½ x 29 in); oil on canvas; Musée d'Orsay, Paris**

Van Gogh wrote constantly to his brother, Theo, who was an art dealer in Paris, describing his paintings. The letters provide a remarkable insight into an artist's mind. Of this picture he wrote, "This time it's just simply my bedroom, only here colour is to do everything, and giving by its simplification a grander style to things, is to be suggestive here of rest or of sleep in general. In a word, looking at the picture ought to rest the brain, or rather the imagination."

Portraits
The pictures above the bed differ in all three versions. Here they are clearly identifiable: on the left is a self-portrait (the last self-portrait that he painted); on the right is his portrait of his sister Wil.

Japanese Prints
Van Gogh was among the first artists to be influenced by the Japanese wood-block prints that had become available in the West. He admired their simplified designs, flat areas of colour, steep perspectives, and the suppression of shadows. All of these features are visible in his work, and the influence of the wood-block prints is an important reason for the popularity of his work in Japan today.

Violet walls
Van Gogh has transposed the white walls of the room to blues/violets, creating colour harmonies with the greens such as can be seen in the windows, and making colour contrasts with the yellows of the bed and chairs.

A peasant's bed
The bed was purchased by van Gogh with money lent to him by Theo. He deliberately chose a rustic peasant bed rather than a metal bed, which was more fashionable at the time. Vincent planned to decorate the bed with a painting of a nude or a child in a cradle, but he never fulfilled his intentions. He took the bed with him when he moved to Auvers, and it was there, on this bed, that he died.

Expressive colour
Van Gogh was well aware of the emotional impact of colour: "Instead of trying to reproduce exactly what I see before my eyes, I use colour more arbitrarily so as to express myself more forcibly". The bright red of the counterpane on the bed animates and lifts the mood of the picture (cover it with your hand and see how the picture changes).

VINCENT VAN GOGH (1853–90)

It was not until he was 27 years old, after a nomadic existence of venturing unsuccessfully into many diverse careers, that van Gogh wrote to his brother telling of his decision to become a painter. In 1888, he left Paris for the south of France, where he found some happiness and stability in Arles. In October 1888 Paul Gauguin joined him for what was hoped to be a fruitful artistic collaboration. However, both artists were highly volatile and in December van Gogh suffered his first severe mental attack. He spent the following year in and out of a mental hospital. In July, 1890, he died from a self-inflicted gunshot wound.

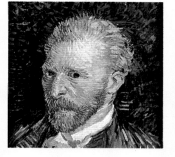

Vincent van Gogh (self-portrait)

The changing colours of the floor
The room had a red brick floor, and in the first version of the painting it is dusky pink. Here the mushroom-coloured floor gives the picture a more sombre feel, expressive of the artist's changing mood. His dream of establishing a happy artist's colony in the sun has faded.

Strong outlines
A particular feature of van Gogh's style is the dark outlines that he places around objects, filling in the outline with thickly painted areas of flat colour.

STILL LIFE WITH PLASTER CAST

CÉZANNE'S WORK WAS VIRTUALLY UNKNOWN for most of his lifetime, except to a few other artists and dedicated collectors. But shortly after his death he began to be recognized as one of the true giants, whose work was so influential as to play a key role in changing the face and direction of art. He is to modern art what Giotto was to the Renaissance. Cézanne, through his work, showed that there was a new way of seeing and a new way of recording our perception of the world, outside the conventions that had been established by the Renaissance. His subject matter is, in fact, very traditional: landscapes, nudes, portraits, or a still life set up in the corner of the studio. But rather than apply the polished techniques, that were taught in the art schools (and which Cézanne was never able to master), he disciplined himself to record only what he actually saw. This famous still-life painting, which was painted towards the end of this great artist's life, can be seen as a remarkable demonstration of this activity. But it also shows that his was not just a cold, objective eye. His humble still-life objects are observed with devoted passion, and he strives to make his painting into an object of great beauty (albeit unconventional).

❝*Cézanne is the mother of us all*❞
PABLO PICASSO

❝*Cézanne is the father of us all*❞
HENRI MATISSE

Blue Drapery
Why does the blue cloth rise up into the air? How does it support two pieces of fruit? Leaning against the studio wall is another still life in which the same cloth covers a table with fruit resting on it. Cézanne presents us with a picture within a picture, and he confuses the boundary where one ends and the other begins, hinting that all art is illusion.

Images of apples
The left side of the picture is dominated by Cézanne's *Still Life with Peppermint Bottle*. Two apples and a glass placed on a blue cloth can be distinguished in the section of the painting that is included here. The long, reddish-brown stripe disappearing behind the Cupid's head is part of the wall. Its presence helps create the distortion of perspective that gives this painting its peculiar abstract quality.

Search for truth
Cézanne shows the corner of his studio, including paintings propped against the wall. Conventional still-life paintings always kept the existence of the studio well hidden.

Enormous apple
What is the round object at the end of the studio? If it is an apple, it seems enormous. Although we know that distant objects are smaller according to perspective, do we actually perceive them as smaller and think of them as smaller? Aren't all apples in reality more or less the same size? So isn't it just as "correct" to show a distant apple the same size as one that is close up?

Cézanne spent so long working on a painting that the fruit often rotted in the bowl before he had finished. Towards the end of his life he dispensed with real fruit, and used plaster imitation fruit that would not rot.

Another point of view
Why does the floor of the studio appear to tilt upwards in such a curious way? Cézanne has rejected the perspective system of the Renaissance and all subsequent art. To the left of the plaster Cupid he is looking across (not down) towards the wall of the studio. These changes of position and viewpoint can give his works a disjointed appearance, but this is so only if we presuppose that a picture will have a fixed and logical perspective system.

Twisted Cupid
The plaster Cupid seems to be twisted around on its base. This is because Cézanne has looked at it on many different occasions and from different points of view, moving around it. By painting what he sees each time, and building up the figure little by little, he shows us more than could be seen from one position.

Paul Cézanne; *Still Life with Plaster Cast*; c.1894; 70 x 57 cm (27½ x 22⅜ in); oil on paper on board; Courtauld Institute Galleries, London

Cézanne's painstaking process of recording his exact perception could never be finished, because every time he returned to his still life there was something new to see. By moving his head to the left or the right he would perceive a different relationship between the objects, so he could never apply the last brushstroke. Very few of his paintings are signed – a signature implied finality.

Shadows
The shadows thrown by the objects fall in different directions, which are inconsistent if one presupposes a single and fixed source of light. But Cézanne painted over a long period of time, and the shadows were different at different times of day.

Outlines
The fruit on the table has many different outline marks, each one precise and each different. They show the care with which Cézanne recorded his perception, and bear witness to the fact that he never removed a mark once he had made it.

PAUL CÉZANNE (1839–1906)

Born in Aix-en-Provence in southern France, Cézanne was the son of a wealthy banker who opposed his son's artistic aspirations. Despite his father's strong disapproval, Cézanne abandoned his law studies and went to Paris, where he exhibited his paintings in the first Impressionist exhibition in 1874. Under the influence of his friend, the great French writer Emile Zola – who advised the Impressionists to work on large, structured subjects – Cézanne stated his intention to "make of Impressionism something more solid and durable". He ushered in a new artistic era, and has been hailed as the father of modern art.

Paul Cézanne (self-portrait)

Precise Brushstrokes
Cézanne's palette is quite restricted, and is a harmonious blend of earthy greens and reds and blues. He used short and precise brushstrokes, and changed their direction according to what he was painting. This gives the surface of his paintings a sense of life and activity. There is also a grid-like structure underlying the composition – not rigidly enforced, but firm enough to hold the composition together and define the different areas.

Forms of fruit
What sort of fruit and vegetables are on the dish and on the table? Apples? Pears? Peaches? Parsnips? Onions? And which is which? Cézanne is not interested in painting an illusion of fruit. He paints what he sees, and what he sees is form, shape, colour, and the relationship between objects.

CÉZANNE'S INFLUENCE

Cézanne has touched nearly every 20th-century painter of any significance. The Cubists (see p.98) were impressed by Cézanne's ability to break up space and forms into different components and reassemble them like pieces of a jigsaw puzzle. Many artists, however, notably Henri Matisse (1869–1954), were inspired by the expressive possibilities inherent in Cézanne's work. By abandoning the obligation to copy the forms and colours of nature with illusionistic precision, it was possible to express emotion with a new directness and freshness.

Guernica
The event that was the immediate catalyst for the painting was the destruction of the Basque capital of Guernica, on its market day, 26 April 1937. In broad daylight, Nazi planes, under the orders of General Franco, attacked the defenceless town. Of its 7,000 inhabitants, 1,654 were killed, and 889 were injured.

GUERNICA

PICASSO'S *GUERNICA* WAS FIRST EXHIBITED at the International Exhibition in Paris in 1937. It was conceived and executed at great speed in his Paris studio, and he intended the painting to be a rallying cry against the murderous events that were destroying Spain through the terrible Civil War (1936–39), and against man's continuing inhumanity. High expectations were placed on the painting. Picasso was recognized as the leading avant-garde painter. He was politically and morally committed to the Republican, anti-fascist, cause in the Spanish Civil War. Thus it was inevitable that the painting would cause deep controversy, artistically and politically, and if it was to have any effect it was perhaps necessary that it should do so. Half a century later it is now possible to assess *Guernica* with some objectivity, and it has taken its place as one of the significant achievements by the major genius of 20th-century art.

The picture is organized so that effectively it is a triptych with a principal central feature and two side panels. It is a secular, not a religious, painting, but given its subject matter and public display, it might well be seen as the 20th-century equivalent of Grünewald's **Isenheim Altarpiece** *(see p.34).*

The bull
Picasso was always fascinated by Spain's ancient, spectacular, and brutal national sport, bullfighting, and imagery from the bullring recurs frequently in his work. In spite of Picasso's statement that the bull in *Guernica* represents brutality, it is an ambiguous image. It does not look savage as it stands swishing its tail. Perhaps Picasso has in mind that moment of the bullfight when, having made an attack successfully, the bull stands back to survey what it has done and contemplates its next move.

Absence of colour
The stark monochrome suits the subject of the picture. Even today, the theme of the mural is politically contentious in Spain. The vast work, which is exhibited in the Prado in a room of its own, is protected behind an equally vast sheet of bulletproof glass.

Mother and child
A dead child hangs limply in its mother's arms. Among the complex Cubist images in *Guernica* this is one that can be interpreted instantly. The mother's scream is represented by her tongue, which suggests a dagger or a shard of glass. Similar shards appear through-out the painting.

CUBISM

Between 1900 and 1914 many of the ideas and innovations that have shaped and defined the 20th century were either born or first given practical application. Among them were manned flight, motor vehicles, radio broadcasts, plastics, and jet propulsion. New concepts such as Relativity and Freudian analysis offered new ways of interpreting our world, to run alongside traditional concepts. In the visual arts it was Cubism, born in 1907, that created a new, alternative language.

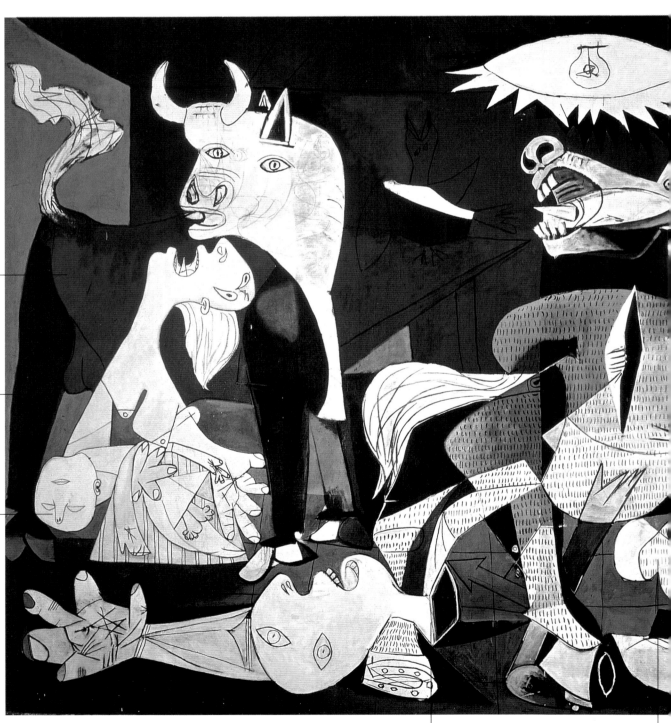

“*Art is a lie that makes us realize the truth*”
PABLO PICASSO

The severed head
In the foreground is a fragmented figure with a severed head on the left, and a severed arm in the centre holding a broken sword. Is it possible that Picasso was thinking back to Uccello's *Battle of San Romano* (see p.20)? Uccello's interpretation of warfare as a ceremonial tournament contrasts with Picasso's powerful image of mass murder.

Anguished horse
Picasso, who rarely gave interpretations of his work, said that the horse stood for the people. Like the mother on the left, agony is suggested by its dagger-like tongue. Above the horse's head is an electric light, which suggests the all-seeing eye of God. Even the light seems to shriek with horror.

PABLO PICASSO (1881–1973)

A precocious artistic talent as a child, Picasso first visited Paris in 1900 and later became the leader of the Parisian avant-garde. The period from 1901–04 became known as his Blue period, when he painted melancholic subjects in blue tones. His mood lightened after 1905, and he painted in pink hues during what came to be known as his Rose period, 1905–07. In his Negro period, 1907–09, Picasso studied African art and the work of Paul Cézanne (see p.96). It was this period that led to the development of Cubism. Picasso had many relationships with women that profoundly effected his development as an artist. His remarkable versatility and endless flow of ideas meant that he had a hand in almost every artistic movement of the 20th century.

Pablo Picasso

Cubist Faces
All the faces are drawn in the Cubist style, which abolishes the distinctions between profile and full face and allows the artists to reassemble the features in a free and expressive manner. The anguish in the face of the woman holding the dead child is especially penetrating, perhaps heightened by the contrast in the style of her face with the more conventional representation of the infant.

A reference to Goya
The figure on the right has his or her arms raised upwards as if to ward off the bombs falling from the sky. But it is also the pose of the central figure in Goya's *Third of May 1808* (see p.74). There is a similarity between the events that lead to both paintings – both were acts of savage brutality against innocent people. Picasso would have been aware of how closely he was following in Goya's footsteps.

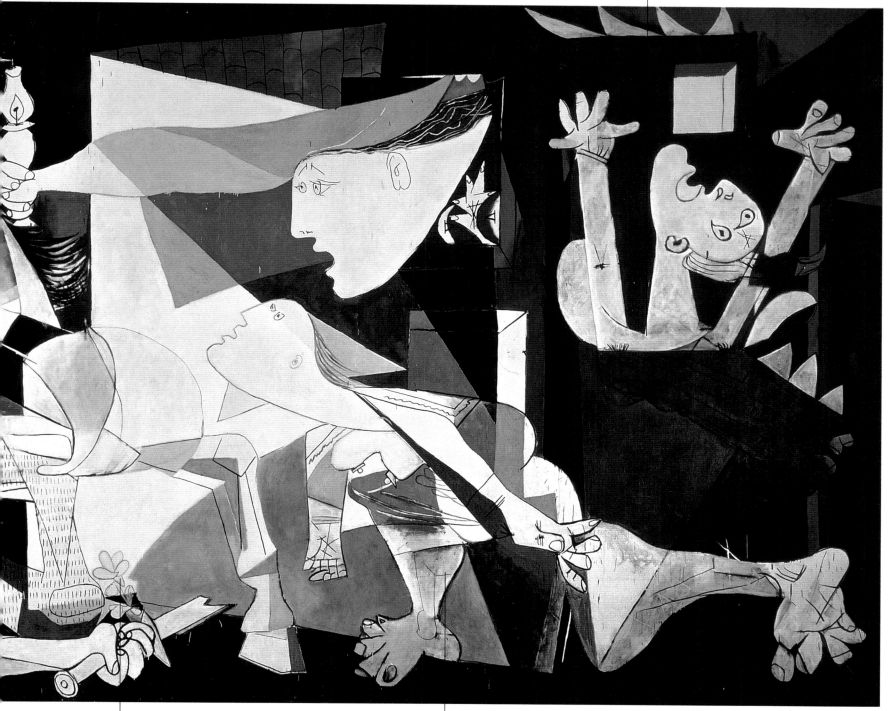

Symbolic flower
There is little overt symbolism in the painting, and Picasso is not following any well defined symbolic language. As in much modern art, the symbolism is private and personal, and can only be unravelled on this basis. Nevertheless, it is difficult not to read the single flower at the centre of the picture as a symbol of hope that new life will continue to grow in spite of man's attempts to destroy it. The flower's poignant delicacy heightens the general horror of this chaotic scene.

A modern crucifixion
Two women gaze at the wounded horse with fear and sorrow, suggesting certain similarities in concept and emotion with images of the suffering of Christ on the Cross, and the presence of the three Maries at the scene. Picasso is perhaps searching for a modern, secular image to express mankind's suffering, but one that will not carry with it any overt Christian symbolism.

Pablo Picasso; *Guernica*; 1937; 350 x 782 cm (11 ft 6 in x 25 ft 8 in); oil on canvas; Museo del Prado, Madrid

GLOSSARY

Adam and Eve On the sixth day God created Adam and Eve, together with all the "beasts of the Earth" (Gen. 1:24–31). God is normally shown breathing life into Adam's nostrils or stretching out His hand to transmit life. Adam was warned not to eat the fruit of the Tree of Knowledge of Good and Evil, which is normally shown as an apple tree. But Eve was tempted by the serpent and mankind fell from grace. Adam and Eve were expelled from Paradise.

Anamorphosis The process of distorting an image in such a way that it is necessary to view it in a specified manner in order to recognize it.

Annunciation The announcement to the Virgin Mary by the Angel Gabriel that she would conceive and bear a son and that He would be called Jesus (Luke 1:28–39). A popular subject in Gothic, Renaissance, and Counter-Reformation art.

Apollo The sun god, and god of reason, archery, and poetry. Usually portrayed as a beautiful youth, often wearing a crown of laurel leaves, driving a four-horse chariot.

Archangel Gabriel The messenger of God. Predominant role in art is as the angel of the Annunciation, appearing before the Virgin Mary. Often depicted holding a lily or, in early Renaissance paintings, a sceptre.

Bacchus (Dionysus) Originally a fertility god, Bacchus became the god of wine, and his cult was associated with frenzied orgies. He is usually shown as a naked youth wearing a crown of vine leaves and ivy, and is frequently drunk. His chariot is usually drawn by leopards or goats. The half-brother of Apollo, Bacchus represents the darker, chaotic side of human nature. He has a large

retinue, which includes satyrs who are often shown with snakes entwined around them – snake handling was an important aspect of the Bacchic ritual.

Baroque A European style of art, architecture, and music that developed in the 17th century from late Renaissance works. In painting, characterized by the depiction of strong human emotions, complex compositions, and striking colour combinations.

Bravura A display of boldness or daring, applied to the painting styles of some artists.

Byzantine Essentially, Christian art produced in the Eastern Roman Empire between the 5th century AD and 1453, when Constantinople fell to the Turks.

Camera obscura A forerunner of the modern-day camera, this apparatus projected an image onto a screen so that outlines could be traced.

Chiaroscuro (Italian: bright-dark) The effects of light and shadow in a painting, particularly when they contrast dramatically.

Complementary colours By mixing together any two primary colours, the complementary colour of the remaining primary colour is obtained, i.e. mix blue and yellow to get green – the complementary colour of red.

Crucifixion The death of Christ on the Cross. Crucifixes, often intended to stand on the altar, were abandoned by the Protestant church in Europe after the Reformation.

Cubism A style of painting and collage developed by Picasso and Braque in early 20th-century Paris, and the first great art movement of the century. Based partly on the work of Cézanne, Cubism rejected the traditional single viewpoint in favour of

more complex multi-layered compositions. In its truest forms, subject matter was restricted to still lifes, and colours were muted.

Cupid (Eros) Appears frequently in paintings, usually as a reminder of the power of love. He is normally shown as a pretty winged boy or a chubby infant.

Divisionism The colour theory developed by Neo-Impressionists led by Seurat, based on colour theories by scientists such as Chevreul, whereby paint was applied in dots of pure colour. Also known as Pointillism.

Doric column In architecture, a column with a square-slab capital that represents the simplest of the Classical Greek styles.

Enlightenment (Age of Reason) Term used to describe a philosophical and literary movement in Europe from the final quarter of the 17th century until the end of the 18th, and characterized by a profound belief in the power of human reason.

Foreground The part of a picture nearest the viewer.

Foreshortening The technique of depicting an object lying at an angle to the picture plane by means of perspective – making it narrower and paler as it recedes.

Fresco Method of wall painting in which powdered pigments mixed with lime water are applied to fresh, wet plaster (true fresco/*buon fresco*), with which they bond, or dry plaster (*fresco secco*), which is more susceptible to flaking.

Fruit symbolism The apple represents the fall of man and his redemption through Christ; the cherry represents Heaven; in Christian art the grape

represents the blood of Christ; and the pomegranate can symbolize chastity, the authority of the Church or the monarch, and the Resurrection.

Garden of Eden Paradise – the garden in which Adam and Eve were placed at the Creation.

Genre painting Paintings depicting scenes from everyday life.

Gothic style Originally a style of architecture that was dominant in the late Medieval period. The dominant style in art from the late 13th century to the end of the 15th century, during which time painting became increasingly naturalistic and technically adept.

Holy Trinity The Christian belief in a triple entity of God the Father, the Son, and Holy Spirit in one Godhead.

Isaiah One of the four "greater prophets", he is associated in Christian art with the theme of the Annunciation, and is often seen holding a book or scroll.

Impasto Thickly applied oil paint.

Impressionism A term deriving from Claude Monet's painting *Impression: Sunrise* (1872) and applied to a group of artists who abandoned traditional academic techniques in favour of a more spontaneous approach to contemporary subjects. The "Impressionists" placed more emphasis on naturalistic tone and colour, and included artists such as Monet, Pissarro, Renoir, and Degas.

Lamentation This term is used to describe the scene following Christ's Crucifixion, when His body was taken down from the Cross and surrounded by mourners.

Last Supper (Eucharist) The last meal that Christ took with His disciples before His arrest, where He told the Twelve that one of them would betray

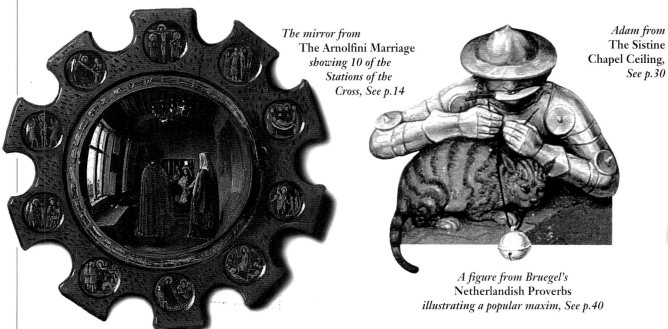

The mirror from
The Arnolfini Marriage
showing 10 of the Stations of the Cross, See p.14

A figure from Bruegel's
Netherlandish Proverbs
illustrating a popular maxim, See p.40

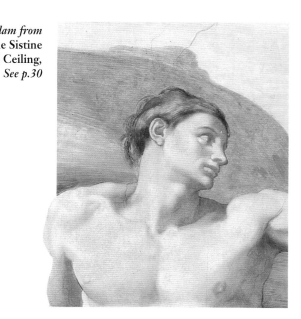

Adam from
The Sistine Chapel Ceiling,
See p.30

Him. Christ consecrated bread and wine at the Last Supper, the key rite in the Christian Communion ceremony. The scene has been widely represented in Christian art from the 6th century.

Laurel leaf An attribute of Apollo. If seen in portrait paintings, a laurel leaf suggests that the sitter is a literary or artistic figure. Also a symbol of triumph and victory.

Lily Symbol of purity. Associated with the Virgin Mary and an attribute of the Angel Gabriel.

Lute Medieval stringed instrument. It is an attribute of Music personified in Renaissance paintings and can be used to represent feminine love and the female form.

Mary Magdalene The woman who anointed Christ's feet. She represents the repentant sinner. Often seen in Christian art from the Middle Ages carrying a jar of ointment. In her role as penitent, she carries a crucifix and skull.

Memento mori An object, such as a skull, intended to remind people of the inevitability of death.

Messiah Jesus Christ – the awaited King of the Jews, sent by God to free them, as predicted by the prophet Isaiah.

Middle ground The area between the foreground and the background of a painting.

Minerva The daughter of Jupiter, Minerva is the virgin goddess of wisdom. Always in armour, she is a goddess of defensive war and war for just causes. Often accompanied by an owl.

Modelling The indication of solid form by shading.

Neoclassicism Artistic movement originating in Rome in the middle of the 18th century that attempted to recreate the Classic art of ancient Greece and Rome.

Orthogonals Diagonal lines drawn from the sub-divided base line of the picture plane to the vanishing point. They represent receding parallels (perpendicular to the picture plane) and draw the viewer's eye into depth.

Perspective Method of representing the illusion of spatial recession on a flat surface. Linear perspective echoes the optical phenomena whereby objects appear smaller, and parallel lines converge, with increasing distance. Aerial perspective mimics the effect whereby distant objects appear pale and blue.

Picture plane The flat surface on which a picture is painted. The vertical plane is imagined as a window pane between the viewer (or artist) and the scene depicted in the picture.

Predella panel A row of small paintings set below the main panel of an altarpiece. Often contains scenes from the lives of the saints represented above.

Primary colours The three colours from which all others are derived – red, blue, and yellow. They cannot be created by mixture but can be combined to create other colours.

Putti Winged infants commonly found in Renaissance and Baroque art. They have the roles of angelic spirits and are the constant companions of Venus.

Realism French movement of the late 19th century that sought to realistically represent contemporary life. A reaction against the Romanticism that preceded it.

Reformation Religious and political movement of 16th-century Europe that began as an attempt to reform the Roman Catholic Church and resulted in the formation of Protestant Churches.

Renaissance The great revival of art, literature, and learning in Europe in the 14th, 15th, and 16th centuries.

Rococo Style of interior decoration originating in France in the early 18th century. Characterized by ornate curves and general "prettiness" – qualities that can also be applied to Rococo paintings.

Romanticism An artistic movement in the first half of the 19th century that emphasized emotion and imagination rather than reason and logic.

Rose Flower associated with the Virgin Mary. A red rose symbolizes martyrdom, a white rose purity. Roses were an attribute of Venus.

Satyr In Greek mythology, the spirits of the woods. The attendants of Bacchus with goat-like features (hairy legs, horns, hooves, and a tail), they were used in Renaissance art to personify lust.

Sfumato A soft, misty effect attained in oil painting mainly through the use of glazes to create delicate transitions of colour and tone.

Skull Symbol of death. Special attribute of St Francis of Assisi. Used as a reminder of the transience of human life in Dutch *Vanitas* paintings.

St Augustine Christian saint and theologian from the 4th century. Usually dressed as a bishop with a mitre, but sometimes wears a monk's habit.

St John the Baptist The messenger of Christ, usually portrayed dressed in animal skin, he almost always carries a reed cross with a slender stem.

St Peter Leader of the Twelve Apostles. Appears in paintings as an old man with short, grey curly hair and a similar beard. He wears a gold cloak over a blue tunic and his principal attribute is a key.

St Sebastian Christian saint of the 3rd century. Often seen in Renaissance art as a standing male nude, bound to a tree and pierced with arrows.

St Stephen First Christian martyr, he was stoned to death. Portrayed as young man with gentle features, carrying stones in his hand or on his head.

Stations of the Cross The 14 places where Christ stopped while carrying His Cross towards Golgotha.

Theseus Legendary Greek hero who was King of Athens. Portrayed as a youth, naked except for a cloak, sandals, and possibly a hat.

Triptych A painting on three panels.

Trompe l'oeil Painting (or part of one) intended to trick the viewer into thinking it is a real object.

Underpaint The preliminary workings on canvas, intended to give some idea of tonal values before colour is added.

Vanishing point In paintings using linear perspective, this is the point on the horizon at which converging lines meet.

Vanitas Dutch still-life paintings that contain symbolism (skulls, candles, bubbles, chronometers) to convey the brevity of life.

Venus (Aphrodite) Goddess of love and fertility. Her many attributes include doves or swans, a scallop shell, and a flaming torch. Often accompanied by Cupid and the Three Graces.

Vine leaves Associated with Bacchus, god of wine. They are also a Christian symbol of the wine of the Eucharist.

Virgin Mary The Mother of Christ, widely represented in art. Traditionally wears a blue cloak and veil – the colour symbolic of Heaven – with a red habit.

God the creator bestowing life on Adam, from **The Sistine Chapel Ceiling,** *See p.30*

A mischievous putto from **A Journey to Cythera,** *See p.60*

Monet's use of impasto in **Autumn Effect at Argenteuil,** *See p.84*

INDEX

FEATURED WORKS

PICTURE CREDITS

Every effort has been made to trace the copyright holders and we apologize in advance for any unintentional omissions. We would be pleased to insert the appropriate acknowledgment in any subsequent edition of this publication.

Key:
t: top, *b*: bottom, *c*: centre, *r*: right, *l*: left

Abbreviations:
AKG: Archiv für Kunst und Geschichte, Berlin
BAL: Bridgeman Art Library, London
HD: The Hulton Deutsch Collection
ML: Musée du Louvre, Paris
MP: Museo del Prado, Madrid
NGL: Reproduced by Courtesy of the Trustees, The National Gallery, London
SC: Scala, Florence

Front cover and inside front flap: *Bacchus and Ariadne*, Titian, NGL

Back cover: clockwise from top left: *The School of Athens* (detail), Raphael, Stanza della Segnatura, Vatican/SC; *Landscape with the Marriage of Isaac and Rebekah* (detail), Claude Lorraine, NGL; *The Supper at Emmaus* (detail), Caravaggio, NGL; *"The Arnolfini Marriage"* (detail), Jan van Eyck, NGL; *The Deposition* (detail), Rogier van der Weyden, MP; *A Dance to the Music of Time* (detail), Nicolas Poussin, Reproduced by Permission of the Trustees of the Wallace Collection; *The Third of May, 1808 in Madrid: The Executions on Príncipe Pío Hill* (detail), Francisco de Goya, MP; *A Bar at the Folies-Bergère* (detail), Edouard Manet, Courtauld Institute Galleries, London; *The Garden of Earthly Delights* (detail), Hieronymus Bosch, MP/Joseph S. Martin, Artothek; *Las Meninas* (detail), Diego Velázquez, MP

Inside back flap: *Photo of author,* Damien Moore

p1: *Still Life: An Allegory of the Vanities of Human Life,* Harmen Steenwyck, NGL

p2: *The Artist's Studio,* Jan Vermeer, Kunsthistorisches Museum, Vienna/AKG **p3:** *The Painter's Studio* (detail), Gustave Courbet, ML/Giraudon

p4: *tl: The Awakening Conscience* (detail), William Holman Hunt, Tate Gallery, London; *tr: Bacchus and Ariadne* (detail), Titian, NGL; *c: Landscape with the Marriage of Isaac and Rebekah* (detail), Claude Lorraine, NGL; *bl: An Experiment on a Bird in the Air Pump* (detail), Joseph Wright of Derby, NGL; *bcr: "The Arnolfini Marriage"* (detail), Jan van Eyck, NGL; *br: "The Ambassadors"* (detail), Hans Holbein the Younger, NGL **p5:** *t: A Sunday on La Grande Jatte* (detail), Georges Seurat, Helen Birch Bartlett Memorial Collection, 1926.224, photograph © 1995, The Art Institute of Chicago, All Rights Reserved; *c: A Dance to the Music of Time* (detail), Nicolas Poussin, Reproduced by Permission of the Trustees of the Wallace Collection; *b: Niccolò Mauruzi da Tolentino at the Battle of San Romano* (detail), Paolo Uccello, NGL

p6: *t: Bacchus and Ariadne,* Titian, NGL; *l: "The Arnolfini Marriage",* Jan van Eyck, NGL; *b: The Supper at Emmaus,* Michelangelo Merisi da Caravaggio, NGL **p7:** *t: Las Meninas,* Diego Velázquez, MP; *b: The Painter's Studio,* Gustave Courbet, ML/Giraudon

p8: *t: Landscape with the Marriage of Isaac and Rebekah,* Claude Lorraine, NGL; *l: "The Ambassadors",* Hans Holbein the Younger, NGL; *b: Snowstorm: Hannibal and his Army Crossing the Alps,* Joseph Mallord William Turner, Tate Gallery, London **p9:** *t: The Third of May, 1808 in Madrid: The Executions on Príncipe Pío Hill,* Francisco de Goya, MP; *b: The Hay Wain,* John Constable, NGL

pp10–11: The Adoration of the Magi
p10: Photograph of the Interior of the Arena Chapel, Padua/SC **pp10–11:** *The Adoration of the Magi,* Giotto, Arena Chapel, Padua/SC **p11:** *The Five Founders of Florentine Art* (detail, portrait of Giotto), Uccello, ML/AKG

pp12–13: The Annunciation
pp12–13: *The Annunciation,* Fra Angelico, Museo Diocesano, Cortona/SC **p13:** *Portrait of Fra Angelico,* Carlo Dolci, Museo di San Marco dell' Angelico, Florence/BAL

pp14–15: The Arnolfini Marriage
pp14–15: *The Marriage of Giovanni (?) Arnolfini and Giovanna Cenami (?) ("The Arnolfini Marriage"),* Jan van Eyck, NGL **p15:** *Portrait of Jan van Eyck,* HD

pp16–17: The Deposition
pp16–17: *The Deposition,* Rogier van der Weyden, MP **p17:** *Portrait of van der Weyden,* Roger of Brussels, HD

pp18–19: The Baptism of Christ
p18–19: *The Baptism of Christ,* Piero della Francesca, NGL **p19:** *The Resurrection* (detail, self-portrait), Piero della Francesca, Pinacoteca Comunale, Sansepolcro/SC

pp20–21: The Battle of San Romano
pp20–21: *Niccolò Mauruzi da Tolentino at the Battle of San Romano,* Paolo Uccello, NGL **p21:** *The Five Founders of Florentine Art,* (detail, self-portrait), Uccello, ML/AKG

pp22–23: The Birth of Venus
pp22–23: *The Birth of Venus,* Sandro Botticelli, Uffizi, Florence/SC **p23:** *The Adoration of the Magi* (detail, self-portrait), Botticelli, Uffizi, Florence/SC

pp24–25: The Garden of Earthly Delights
pp24–25: *The Garden of Earthly Delights,* Hieronymus Bosch, MP/Joseph S. Martin, Artothek **p25:** *Portrait of Bosch,* Bibliothèque Municipale, Arras/SC

pp26–27: The Mona Lisa
pp26–27: *The Mona Lisa,* Leonardo da Vinci, ML/Artothek **p27:** *Portrait of a Woman,* Raphael, ML/© Réunion des Musées Nationaux, Paris; *Self-Portrait,* Leonardo da Vinci, Biblioteca Reale, Turin/AKG

pp28–29: The Tempest
p28: *Portrait of Giorgione,* HD **pp28–29:** *The Tempest,* Giorgione, Accademia, Venice/SC

pp30–31: The Sistine Chapel Ceiling
p30: *Portrait of Michelangelo,* Jacopino del Conte, Casa Buonarroti, Florence/SC **pp30–31:** *The Sistine Chapel Ceiling,* Michelangelo Buonarroti **p31:** *The Sistine Chapel Ceiling* (detail) – *The Creation of Adam* (restored version), Michelangelo, © Nippon Television Network Corporation 1995

pp32–33: The School of Athens
pp32–33: *The School of Athens,* Raphael, Stanza della Segnatura, Vatican/SC **p33:** *Self-Portrait,* Raphael, Uffizi, Florence/BAL

pp34–35: The Isenheim Altarpiece
p34: *Portrait of Grünewald,* HD **pp34–35:** *The Isenheim Altarpiece,* Mathis Grünewald, Musée d'Unterlinden, Colmar/Artothek

pp36–37: Bacchus and Ariadne
pp36–37: *Bacchus and Ariadne,* Titian, NGL **p37:** *Self-Portrait,* Titian, MP/Index/BAL

pp38–39: The Ambassadors
pp38–39: *Jean de Dinteville and Georges de Selve ("The Ambassadors"),* Hans Holbein the Younger, NGL **p39:** *Self-Portrait,* Holbein, Uffizi, Florence/SC

pp40–41: Netherlandish Proverbs
pp40–41: *Netherlandish Proverbs,* Pieter Bruegel the Elder, SMPK, Gemäldegalerie, Berlin/AKG

p41: *Self-Portrait,* Bruegel, Graphische Sammlung Albertina/AKG

pp42–43: The Burial of Count Orgaz
pp42–43: *The Burial of Count Orgaz,* El Greco, Santo Tomé/Joseph S. Martin, Artothek **p43:** *Self-Portrait,* El Greco, HD

pp44–45: The Supper at Emmaus
p44: *Portrait of Caravaggio,* Leoni Ottavio, Biblioteca Marucelliana, Florence/SC **pp44–45:** *The Supper at Emmaus,* Michelangelo Merisi da Caravaggio, NGL

pp46–47: Samson and Delilah
pp46–47: *Samson and Delilah,* Peter Paul Rubens, NGL **p47:** *Self-Portrait,* Rubens, Uffizi, Florence/ BAL

pp48–49: Belshazzar's Feast
pp48–49: *Belshazzar's Feast,* Rembrandt van Rijn, NGL **p49:** *Self-Portrait,* Rembrandt, ML

pp50–51: A Dance to the Music of Time
p50: *Self-Portrait,* Nicolas Poussin, ML/Giraudon/BAL **pp50–51:** *A Dance to the Music of Time,* Poussin, Reproduced by Permission of the Trustees of the Wallace Collection

pp52–53: The Vanities of Human Life
pp52–53: *Still Life: An Allegory of the Vanities of Human Life,* Harmen Steenwyck, NGL

pp54–55: The Marriage of Isaac and Rebekah
p54: *Portrait of Claude,* HD **pp54–55:** *Landscape with the Marriage of Isaac and Rebekah ("The Mill"),* Claude Lorraine, NGL

pp56–57: Las Meninas
pp56–57: *Las Meninas,* Diego Velázquez, MP **p57:** *Probable Self-Portrait,* Velázquez, MP/SC

pp58–59: The Artist's Studio
p58: *Portrait of Vermeer,* Giraudon **pp58–59:** *The Artist's Studio,* Jan Vermeer, Kunsthistorisches Museum, Vienna/AKG

pp60–61: A Journey to Cythera
p60: Sheet Music, Mozart, AKG **pp60–61:** *The Embarkation to Cythera,* Jean Antoine Watteau, Schloss Charlottenburg, Berlin/AKG **p61:** *Portrait of Watteau,* HD

pp62–63: Arrival of the French Ambassador
pp62–63: *The Arrival of the French Ambassador in Venice,* Canaletto, Hemitage, St Petersburg/SC **p63:** *Portrait of Canaletto,* HD

pp64–65: The Governess
p64: *Self-Portrait,* Chardin, ML **pp64–65:** *The Governess,* Jean-Baptiste-Siméon Chardin, National Gallery of Canada, Ottowa

pp66–67: Mr and Mrs Andrews
pp66–67: *Mr and Mrs Andrews,* Thomas Gainsborough, NGL **p67:** *Self-Portrait,* Gainsborough, Royal Academy of Art, London/BAL

pp68–69: The Experiment with an Air Pump
pp68–69: *An Experiment on a Bird in the Air Pump,* Joseph Wright of Derby, NGL **p69:** *Portrait of Joseph Wright,* HD

pp70–71: The Oath of Horatii
pp70–71: *The Oath of Horatii,* Jacques-Louis David, ML/© Réunion des Musées Nationaux, Paris **p71:** *Self-Portrait,* David, ML/Giraudon/BAL

pp72–73: Hannibal Crossing the Alps
pp72–73: *Snowstorm: Hannibal and his Army Crossing the Alps,* Joseph Mallord William Turner, Tate Gallery, London **p73:** *Self-Portrait,* Turner, Tate Gallery, London/BAL

pp74–75: The Third of May 1808
pp74–75: *The Third of May, 1808 in Madrid: The Executions on Príncipe Pío Hill,* Francisco de Goya, MP **p75:** *Self-Portrait,* Goya, Real

Academia de Bellas Artes de San Fernando, Madrid

pp76–77: The Raft of the Medusa
pp76–77: *The Raft of the Medusa,* Théodore Géricault, ML/AKG **p77:** *Self-Portrait,* Géricault, Private Collection, Paris/AKG

pp78–79: The Hay Wain
pp78–79: *The Hay Wain,* John Constable, NGL **p79:** *Portrait of Constable,* Daniel Gardner, Victoria & Albert Museum, London/BAL

pp80–81: The Awakening Conscience
pp80–81: *The Awakening Conscience,* William Holman Hunt, Tate Gallery, London **p81:** Photograph of Hunt, HD

pp82–83: The Painter's Studio
p82: Photograph of Courbet, HD **pp82–83:** *The Painter's Studio,* Gustave Courbet, ML/Giraudon

pp84–85: Autumn Effect at Argenteuil
pp84–85: *Autumn Effect at Argenteuil,* Claude Monet, Courtauld Institute Galleries, London **p85:** Photograph of Monet, Bibliothèque Nationale, Paris

pp86–87: The Dance Class
pp86–87: *The Dance Class,* Edgar Degas, Musée d'Orsay, Paris/Artothek **p87:** Photograph of Degas, Bibliothèque Nationale, Paris

pp88–89: The Luncheon of the Boating Party
pp88–89: *The Luncheon of the Boating Party,* Pierre Auguste Renoir, The Phillips Collection, Washington, D.C. **p89:** Photograph of Renoir, HD

pp90–91: A Bar at the Folies-Bergère
pp90–91: *A Bar at the Folies-Bergère,* Edouard Manet, Courtauld Institute Galleries, London **p91:** Photograph of Manet, Bibliothèque Nationale, Paris

pp92–93: La Grande Jatte
p92: Microphotograph of *A Sunday on La Grande Jatte,* ©1995 The Art Institute of Chicago, photo: I. Fielder **pp92–93:** *A Sunday on La Grande Jatte,* Georges Seurat, Helen Birch Bartlett Memorial Collection, 1926.224, photograph ©1995 The Art Institute of Chicago, All Rights Reserved **p93:** *Portrait of Seurat,* Ernest Laurent, ML, Cabinet des Dessins/© Réunion des Musées Nationaux, Paris

pp94–95: The Bedroom at Arles
pp94–95: *Vincent's Bedroom at Arles,* Vincent van Gogh, Musée d'Orsay, Paris **p95:** *Self-Portrait,* van Gogh, Musée d'Orsay, Paris

pp96–97: Still Life with Plaster Cast
pp96–97: *Still Life with Plaster Cast,* Paul Cézanne, Courtauld Institute Galleries, London **p97:** *Self-Portrait,* Cézanne, Musée d'Orsay, Paris

pp98–99: Guernica
p98: Photograph of the Town of Guernica after the Bombing, David King Collection **pp98–99:** *Guernica,* Pablo Picasso, Museum of Modern Art, New York/ AKG/© DACS 1995 **p99:** Photograph of Picasso, HD

pp100–101: Glossary
p100: *l: "The Arnolfini Marriage"* (detail), Jan van Eyck, NGL; *c: Netherlandish Proverbs* (detail), Pieter Breugel the Elder, SMPK, Gemäldegalerie, Berlin/ AKG; *r: The Creation of Adam* (detail), Michelangelo, © Nippon Television Network Corporation 1995 **p101:** *l: The Creation of Adam* (detail), Michelangelo, © Nippon Television Network 1995; *c: The Embarkation to Cythera* (detail), Jean Antoine Watteau, Schloss Charlottenburg, Berlin/AKG; *r: Autumn Effect at Argenteuil* (detail), Courtauld Institute Galleries, London

Additional photography:
Philippe Sebert: **p49:** *br;* **p64:** *tl;* **pp94–95**.
Alison Harris **p97**.

ACKNOWLEDGMENTS

Author's Acknowledgments
"I am very conscious that one never ceases to look and learn. To those that first introduced me to the pleasures of looking at art and who taught me how to look, my heartfelt thanks. To those who generously share their insights and knowledge, my continuing gratitude."
(Robert Cumming)

Collaborative ventures are a notorious minefield. I would like to say that working on this book has been as much pleasure as hard work, and I would like to pay tribute to the professionalism, enthusiasm,

and dedication of the Dorling Kindersley team. In particular I would like to express my thanks to Damien Moore and Stefan Morris with whom I have worked most closely: whilst working with them I have seen a lot that I had not seen before, and learned a lot that I did not know.

Dorling Kindersley would like to thank:
Dave and Jo Walton, Julia Harris-Voss, Phil Hunt, and Jo Evans for their invaluable editorial assistance. Mark Johnson Davies and Stephen Croucher for their timely design assistance. Ray Rogers for editorial assistance above and beyond the call of duty. Elizabeth Eastman, Dierdre Gilbert, and Sandy Shepherd of The Reader's Digest Association (Canada) Ltd., and Laraine Newberry of Reader's Digest (Australia) Pty. Ltd. for their constructive observations and proofreading. Hilary Bird for her highly efficient indexing service.